READY TO PAINT
WITH TERRY HARRISON

T0059951

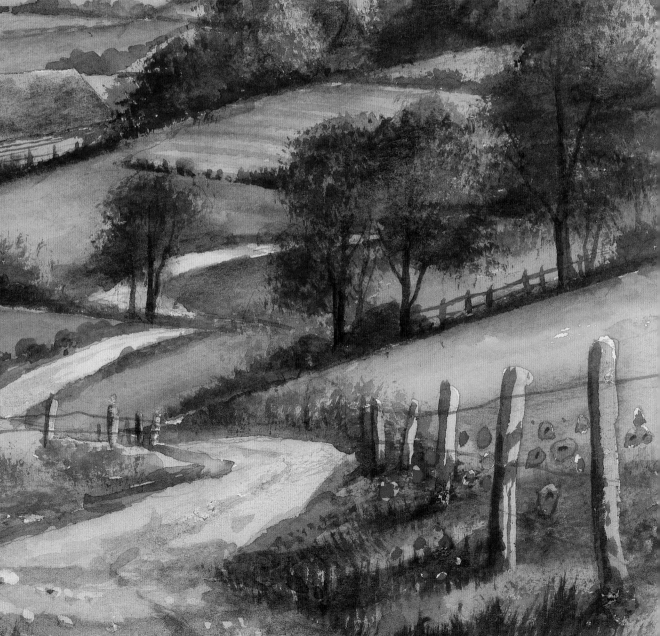

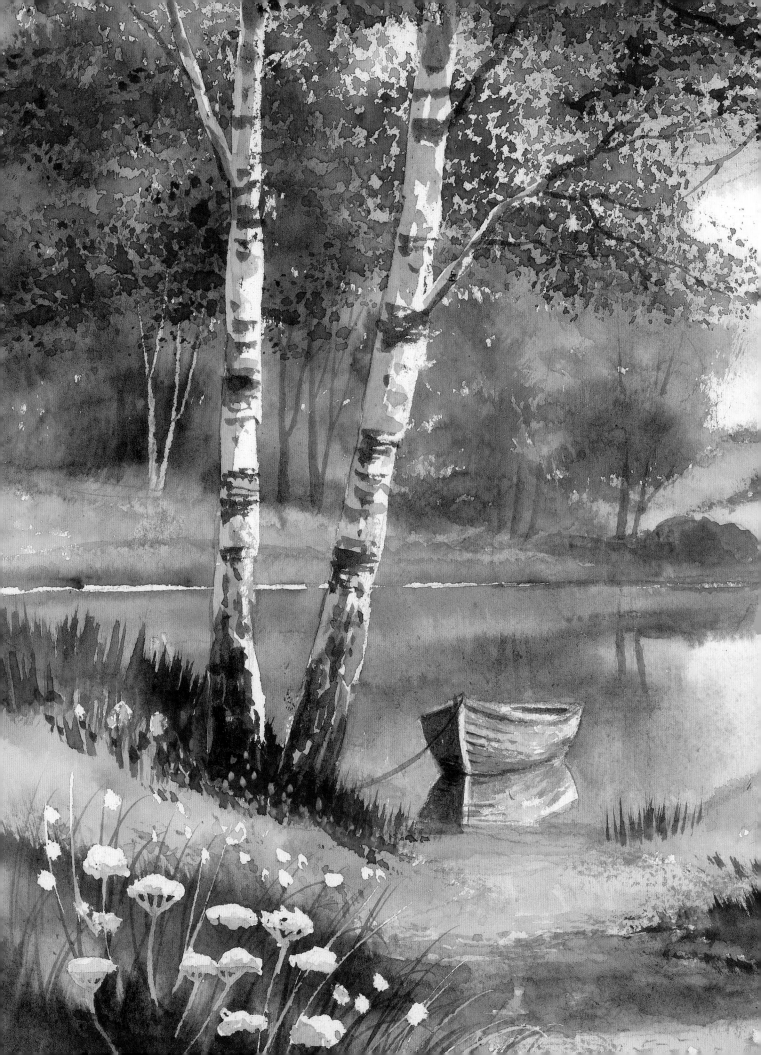

READY TO PAINT
WITH
TERRY HARRISON

Watercolour techniques, tips and
projects for the complete beginner

SEARCH PRESS

First published in 2022

Search Press Limited
Wellwood, North Farm Road,
Tunbridge Wells, Kent TN2 3DR

Includes material from the following books published by
Search Press: *Ready to Paint Watercolour Landscapes*,
2007; *Ready to Paint Watercolour Barns*, 2009; *Ready
to Paint Ireland in Watercolour*, 2009; *Ready to Paint
Country Landscapes in Watercolour*, 2011; *Rustic Buildings
and Barns in Watercolour*, 2009; and *Terry Harrison's
Watercolour Secrets*, 2017.

Text copyright © Terry Harrison 2022
Photographs by Roddy Paine Photographic Studios
and by Debbie Patterson and Paul Bricknell at
Search Press Studios
Photographs and design copyright
© Search Press Ltd 2022

All rights reserved. No part of this book, text, photographs
or illustrations may be reproduced or transmitted in any
form or by any means by print, photoprint, microfilm,
microfiche, photocopier, internet or in any way known or
as yet unknown, or stored in a retrieval system, without
written permission obtained beforehand from Search Press.
Printed in China.

ISBN: 978-1-80092-015-6
ebook ISBN: 978-1-80093-005-6

The Publishers and author can accept no responsibility for
any consequences arising from the information, advice or
instructions given in this publication.

No use of the artwork for commercial purposes is
permitted without the prior permission of both artist and
Publishers. Readers are permitted to reproduce or copy
the paintings in this book only for private and personal
study/practice.

Suppliers
For details of suppliers, please visit the
Search Press website: www.searchpress.com

You are invited to the author's website:
www.terryharrisonart.com

Publisher's note
All the step-by-step photographs in this book feature the
author, Terry Harrison, demonstrating watercolour.
No models have been used.

Opposite: **Mill in Winter**

CONTENTS

INTRODUCTION 6

MATERIALS 8

TECHNIQUES 12

FIELDS 20
POPPY FIELD 22
THE OPEN GATE 30
BLOSSOM MEADOW 38

WOODLANDS 46
BLUEBELL WOOD 48
FOOTBRIDGE IN THE WOODS 54
NEW FOREST BRIDGE 62

WINTER LANDSCAPES 70
SNOW TRACKS 73
VILLAGE IN THE SNOW 78
BARN IN THE SNOW 86

BUILDINGS 94
SUMMER DOORWAY 96
DUNGUAIRE CASTLE 104
DUBLIN DOORWAY 112
CHICKEN BARN 120

SEASCAPES 128
KEEM BAY 130
THE CLIFFS OF MOHER 136

INDEX 144

INTRODUCTION

Terry Harrison, one of Search Press's most popular authors, sadly died far too soon in 2017. His wife and fellow artist and author, Fiona Peart, wrote to his many fans, 'His legacy will live on in all your paintings inspired by him and all the wonderful memories he has given us.' It will also endure in the huge wealth of knowledge he passed on in his many best-selling Search Press books.

Terry's trademark was his no-nonsense approach to teaching painting. He became a graphic artist after graduating from Farnham Art School, but gave up his job in 1984 to paint full-time. So began his new career, demonstrating to artists' groups and teaching on painting holidays. Terry's humour and warmth were much appreciated, but it was the success of the advice he shared that made him so popular with artists, from beginners to more accomplished painters. A hugely talented artist himself, he was unfailingly generous with his tips and techniques for making the painting process easier and more accessible.

This book includes fifteen of Terry's most appealing watercolour landscape demonstrations, with subjects from fields to the sea and from bluebell woods to doorways. For each one, an outline drawing is supplied in the centre of the book, and there is a bonus outline for the painting on the right. Just transfer this onto watercolour paper, read Terry's advice on the materials and techniques to use, and you're ready to go.

Terry's own range of brushes is still available on his website, but you can also use alternatives from other ranges, which are detailed in the materials chapter.

OUTLINE
16

Over the Hedgerow
45 x 33cm (17¾ x 13in)

This distant village scene with rustic buildings clustered around the church is framed by the overhanging tree and the shadow it casts over the road. Bathed in bright sunlight are a host of summer flowers that add colour and warmth to the scene.

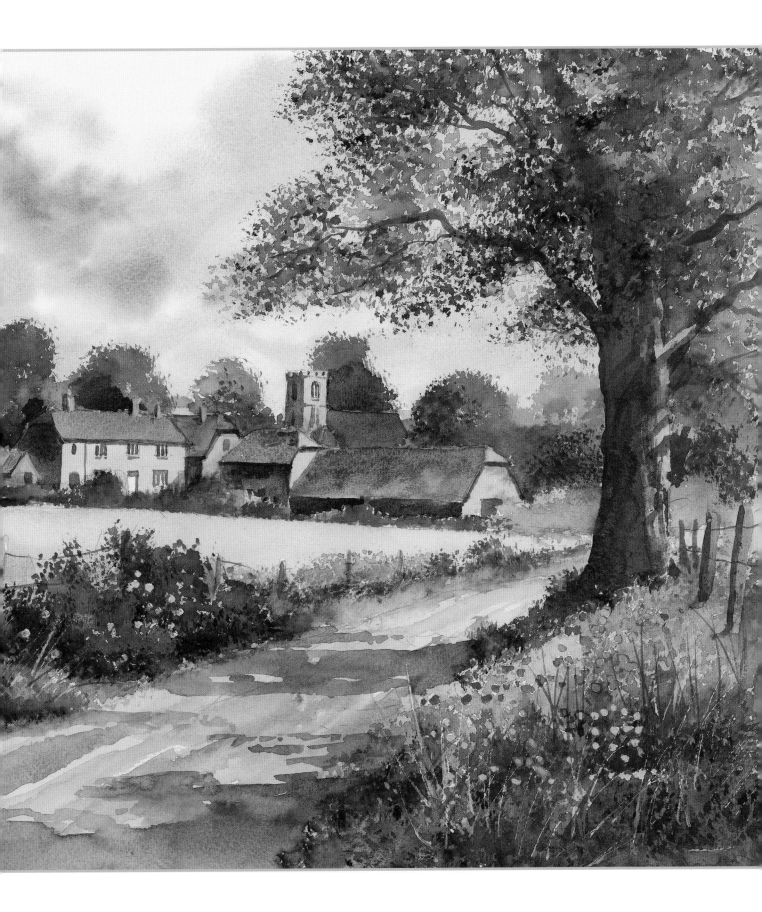

MATERIALS

Paper

You can buy watercolour paper in three surfaces: Hot Pressed or smooth; Not, which has a bit of texture, and Rough which, as its name suggests, is more highly textured. I have used Rough paper for all the demonstrations in this book, as it is useful for some of the textured effects I need for landscapes.

Watercolour paper also comes in different weights, and the lighter weights tend to cockle when you apply watercolour washes. One way to prevent this is to stretch paper by soaking it and taping it to your painting board, so that when it dries, it is stretched flat. I prefer to use a heavier paper that is much less likely to cockle when wet. All the demonstrations in this book were done on 300gsm (140lb) watercolour paper.

Paints

There are two grades of watercolour paint: artists' quality and students' quality. Many beginners opt for the students' quality because they are cheaper. I would advise you to buy the best paints you can afford. Artists' quality watercolours have a higher pigment content, and they flow better and produce more vibrant results.

The other choice is whether to buy tubes or pans. When working in the studio, painting large washes and using bigger brushes, it is best to use tube colours. Pans can be more suitable if you are painting outdoors, as they come in compact sets that are more convenient outside. I have used artists' quality tube colours for all the demonstrations in this book.

You do not need a huge selection of colours for landscape subjects. I use a limited palette and mix all the colours from this range. For the paintings in this book, I used French ultramarine, burnt umber, raw sienna, cadmium yellow, burnt sienna, cadmium red, permanent rose, cobalt blue and alizarin crimson. In a couple of paintings, I added colours I use less frequently: ultramarine violet and permanent sap green. I also used some of my own brand of colours: three greens and a shadow colour, but you can replace these with your favourite brands. They are: country olive (or olive green), midnight green (or Hooker's green), sunlit green (or green gold) and shadow (or French ultramarine, burnt sienna and permanent rose).

Brushes

I have used brushes from my own range for some of the projects in this book, and Winsor & Newton brushes in others. Where I have specified my own brushes, you can use brushes from other ranges, as long as you look out for the qualities described. My **golden leaf** is my preferred brush for large washes, as it holds a lot of paint, but you could use a squirrel mop or a no. 16 round. My **fan gogh** is a thick fan-shaped brush; you could use another fan brush. I also use my **fan stippler** for certain textural effects; you could substitute a hog fan brush. The **19mm (¾in) flat** brush was used in some projects for painting water and dragging down reflections. My **large, medium and small detail** brushes are good for general use – no. 12, no. 8 and no. 4 round brushes could be used instead. My **foliage** brush is useful for stippling, but you could use a small bristle brush instead. My **wizard** brush is a blend of natural hair, twenty per cent of which is slightly longer than the rest, forming small points. It is good for grasses and reflections. I use my **half-rigger**, which is like a rigger but shorter, for fine detail. I have also used a **10mm (⅜in) one-stroke** brush; and in some of the projects, I have used a **13mm (½in) flat** with a clear acrylic resin handle, which is useful for scraping out paint. Finally, I use a special **masking fluid brush** to avoid spoiling my good brushes.

From left to right: my foliage brush, half-rigger, masking fluid brush, small, medium and large detail brushes, 19mm (¾in) flat, fan gogh and golden leaf brush.

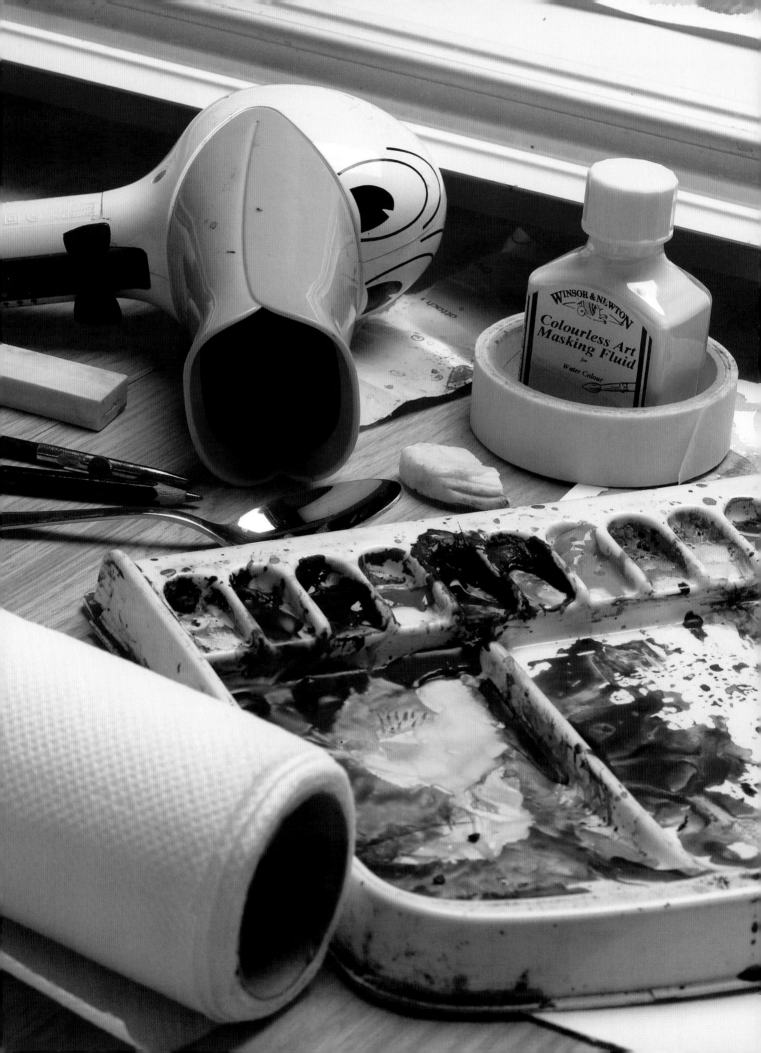

WINSOR & NEWTON

Colourless Art
Masking Fluid

for

Water Colour

Other materials

Board and tape I attach my watercolour paper to a painting board with masking tape.

Paints I lay out my tube colours in a plastic palette and mix washes in the wells.

Paper mask Use spare watercolour paper or pieces cut from a magazine to make a paper mask.

Masking fluid This is used to keep areas white. It is applied with a brush or with a ruling pen for straighter lines. Wet the brush and coat it with soap before using masking fluid, and the fluid will wash out easily after use. You can also use a small natural sponge to apply masking fluid to create a textured effect.

Pencil and eraser These are used when transferring the image, and you can also use the handle of a spoon.

Hairdryer A hairdryer can be used to speed up the drying process.

Kitchen paper Keep some to hand – it's useful both for mopping up spills and for lifting out paint while it is wet.

Plastic card Great for special effects: this is used to scrape away paint to create certain effects, for instance for the texture of rocks and cliffs.

Clean water In my studio, I use a bucket to wash out my brushes, because the more water you use, the cleaner your brushes become. There is not much point in trying to clean them in a small jam jar. Also, the water stays cleaner for longer in a bucket, so it won't make your colours muddy. The alternative is to use two water pots, one for washing your brushes and the second for mixing your colours with clean water. Never leave brushes standing in water, as this will bend the tip of the brush, and the water will soak up into the wooden handle. The wood then expands and the paint on the handle cracks and peels off.

TECHNIQUES

These pages explain the basic techniques needed for almost all watercolour painting. There are extra techniques useful for more specific subjects included at the start of each chapter.

An example of cockling.

Preparing paper for painting

Cockling occurs when you apply a wash to the paper surface: the fibres in the paper soak up the water and expand. If the paper is unevenly wetted, the fibres expand at different rates and cockling occurs. This is why artists are recommended to stretch paper by soaking it, taping it to a drawing board and allowing it to dry. The paper shrinks as it dries, but because it is taped at the edges, it dries fully stretched. I find, however, that some cockling will still occur when you apply washes, and that stretching paper affects the paper, as some of the size is removed. For these reasons I don't bother to stretch paper.

The simplest way to flatten a painting that has cockled is to turn it face down, wet the back of it (don't over-wet it), allow the water to soak in, and when the paper is fully expanded, put a drawing board over it and weigh it down with a pile of books. Let the painting dry overnight and it will dry completely flat.

Another solution to cockling is to use a heavy paper. I use a 300gsm (140lb) paper, but to avoid cockling altogether, use an even heavier paper.

One further way to avoid cockling is to tape the paper down just inside the picture area, rather than round the very edges. Tape just the top of the paper to the board with masking tape (see above). Then tape round the picture area, which will ensure nice, straight edges and will also prevent the paper from cockling as a result of all the wet washes.

Washes

A graded wash sky

1 Wet the sky area first with clean water and the golden leaf brush. Load the brush evenly with a wash of ultramarine. Start at the top and paint from side to side.

2 As you continue down the paper, the sky gets lighter as there is less colour on the brush. The wet into wet technique disperses any streaks. As you can see, this technique creates a good wash for a clear sky.

A variegated wash

1 Start with a flat wash of one colour, then clean the brush, pick up a second colour and merge it with the bead of paint at the bottom of the first colour. The second colour will merge into the first as you continue to paint horizontal strokes down the paper. Wash the brush again and pick up the clean second colour from the palette so that this appears unmixed at the bottom of the wash.

Wet into wet techniques

To achieve these techniques, both washes must be wet. If you are applying wet paint into a semi-wet background, the paint you are applying will not flow smoothly into the first colour, but will create unwanted effects such as 'cauliflowers' and hard edges.

Dropping a second colour into a wash

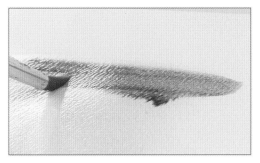 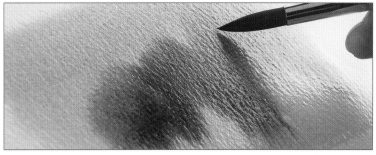

1 Wet the paper first. This slows down the drying time of the first colour so that you have plenty of time to work before the paint dries. Paint on the first colour, here a sky blue.

2 Pick up the second colour and dab it on to the paper on top of the first. The second colour spreads into the first, creating a soft, cloud-like effect.

A wet into wet sky

The wet into wet technique is great for clouds, as it produces soft-edged results. As you will see later in the book, it is also excellent for creating the effect of massed foliage in woodland, and for textural effects on buildings.

1 Use a large brush, such as the golden leaf brush, to paint a thin wash of raw sienna across the whole sky area.

2 Mix ultramarine and burnt umber for the cloud colour. Pick it up on the large detail brush and paint diagonal cloud shapes across the sky while the raw sienna is still wet.

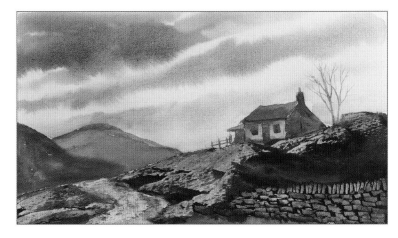

3 Allow the painting to dry naturally before continuing to paint the rest of the scene. The clouds will continue softening into the background sky colour as the paint dries.

Wet on dry techniques

This technique is suitable for adding detail to a painting. If the background colour is still wet, the colour you are adding will bleed into it, creating unwanted wet into wet effects.

Here a tree is painted into a wet background, causing it to spread and soften, losing detail and clarity.

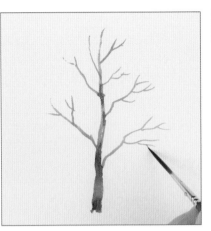

Here the tree is painted with the same half-rigger brush, but on a dry background, which allows for a more controlled, detailed technique.

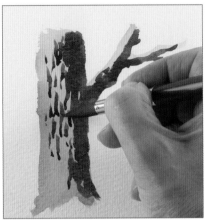

The wet on dry technique is also good for creating texture on a tree trunk, as shown here. Since the first colour is dry, I am able to add clear, hard marks with the second colour.

Painting details on a pan-tiled roof

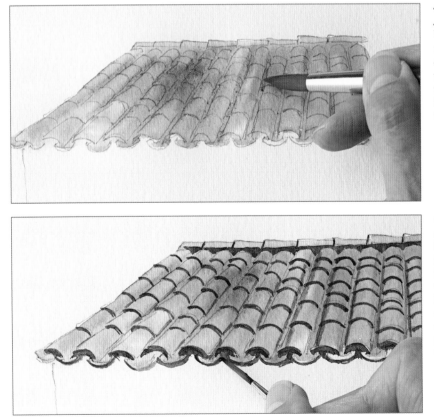

1 This roof was initially created using wet into wet techniques. A wash of Winsor orange was painted on using a no. 12 round brush. Then cobalt blue was dropped in wet into wet to create the weathered effect of old pan tiles. Still working wet into wet, the gulleys between the tiles were painted in cobalt blue. This was then allowed to dry naturally.

2 Once this background was dry, I used the rigger brush and a strong mix of burnt umber and ultramarine to paint the details: first the divisions between the ridge tiles and the shadow beneath them. Then I painted the pan tiles with little half-moon shapes and the vertical shadows between the tiles with a slightly darker mix of the same colours. Finally I painted the reversed tiles under the roof which carry the water away.

Dry brushwork

This technique can be used to create interesting textures. The paint is picked up on a 'thirsty' brush which is only slightly damp, not wet. The brush is dragged across the surface of Rough paper, where it leaves a speckled effect. You need to keep using kitchen paper to soak up the excess water from the brush as you paint.

Painting texture on tree bark

This painting shows how effective the dry brush technique is when painting tree trunks. The detail was created by the dry brush, so don't over-wet the brush. Make sure the surface is dry before you begin.

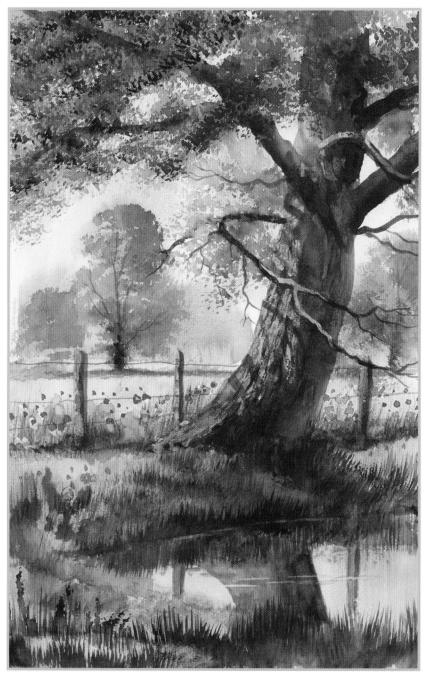

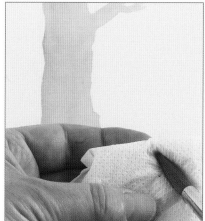

1 Paint the tree trunk with an initial wash, and allow it to dry. Wash the brush with clean water, then dab it on kitchen paper to soak up the excess water.

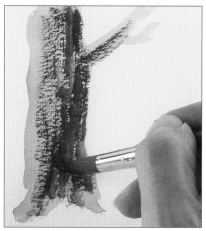

2 Load the brush with the second colour and drag it over the surface of the paper on top of the dried wash, to create a speckled effect. You can then darken the shaded side further.

Masking

Masking is all about keeping certain parts of the paper white, allowing you to paint freely over the masked area. When using masking fluid, do not use it on damp paper, as it soaks into the paper and dries. Then. when you remove it, it tears the paper surface. Do not leave masking fluid on for longer than two or three days, as it becomes too hard and is difficult to remove. The same thing can happen if you dry the masking fluid with a hairdryer. Masking fluid can also ruin your good brushes. To avoid this, wet the brush and rub it in ordinary soap before dipping it in the masking fluid. The masking fluid will then wash out easily when you have finished using it. If masking fluid dries on your brush, washing with soap simply will not remove it, but you can clean the brush with lighter fluid. In this section, I also show you how to use a paper mask.

Applying masking fluid with a brush

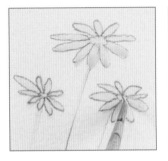 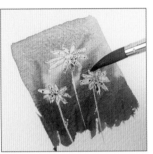 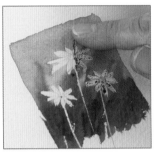 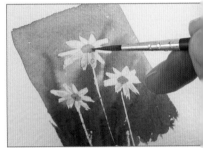

1 Brush on the masking fluid where you want the paper to stay white.

2 Wait for it to dry naturally, then paint your colours over the top.

3 Allow the paints to dry, then rub off the masking fluid with a clean finger.

4 You can then paint another colour on to the white areas. I have added pale ultramarine shading and cadmium yellow centres to these daisies.

Applying masking fluid with a ruling pen

When using a ruling pen, do not have the gap in the nib too wide, or the masking fluid will come out in blobs.

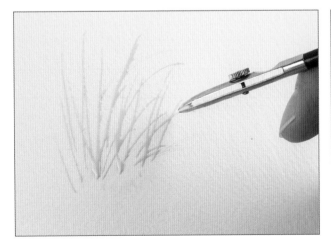 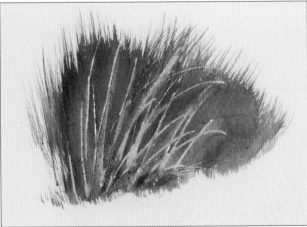

1 Load the ruling pen by dipping it in the masking fluid. Do not overload it or the fluid will flood out. Paint the grasses.

2 When the masking fluid is dry, flick up grasses using the darker green mix. Allow to dry, then rub off the masking fluid. You can now apply a lighter green mix and some yellow to the white areas.

Applying masking fluid using kitchen paper

Kitchen paper can be used to apply masking fluid to trees, creating the effect of snow clinging to branches.

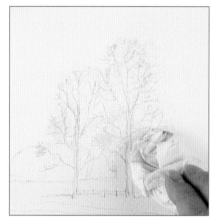

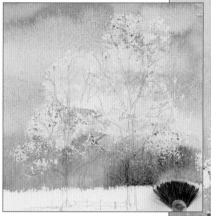

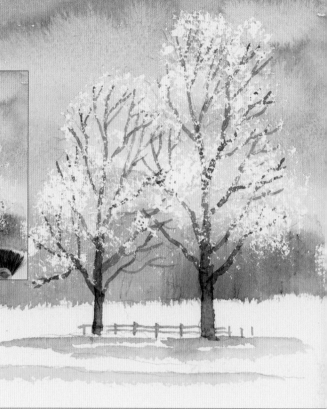

1 Draw the scene. Dip a scrunched-up piece of kitchen paper in masking fluid and dab it onto the trees, gently tapping over the drawing. Allow to dry.

2 Use the large detail brush and ultramarine to paint the sky over the masking fluid. While the sky is wet, use the fan gogh brush to paint a grey mix of ultramarine and burnt umber in the lower part of the sky.

3 Use the large brush and ultramarine to paint shade on the snow in the foreground. Allow to dry. Use the half-rigger with a dark mix of burnt umber and ultramarine to paint in the trunks and branches. Allow to dry, then rub off the masking fluid.

Using a paper mask to paint hedgerows

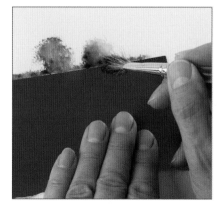

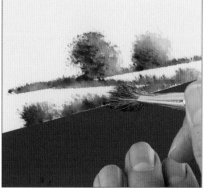

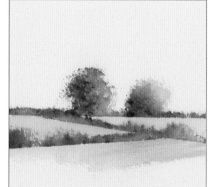

1 Take a piece of magazine paper (glossy, coated paper) with a straight edge and hold it firmly on top of your watercolour paper. Paint a hedgerow and bushes just above the paper mask as shown.

2 Carefully move the mask and change the angle, then paint another hedgerow coming further forwards. Continue in this way.

3 Fill in the fields between the hedgerows with different colours, making the colours warmer as they come further forwards, to create the effect of a patchwork of fields stretching into the distance.

Lifting out

Because watercolour is water soluble, you can re-wet the paint and remove it in many different ways, for example with kitchen paper or a damp brush. Be aware that some paints are staining colours and are more difficult to remove, so practise lifting out paint on a separate piece of paper.

Using a damp brush

Allow the painting to dry. Wet a flat brush and remove excess water on kitchen paper. Now use the straight line of the brush end to lift out a trunk and branches from the painted foliage background. You can go on to add shade as with the other tree.

Using kitchen paper

Sometimes an object such as a tree can look too dominant and too far forwards. To repair this effect, allow the trunk to dry, then wet it with clean water on a brush to loosen the colour. Blot the wet trunk with kitchen paper to lift out colour.

Kitchen paper highlights

When painting a wet into wet sky, you can lift out cloud highlights using scrunched up kitchen paper at the tops of the clouds as shown.

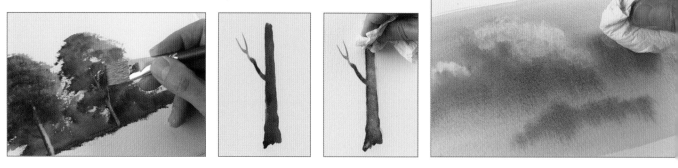

Using a coin wrapped in kitchen paper for sunsets

Here I have created a sunset sky wet into wet, then I have used this technique to lift out the sun itself.

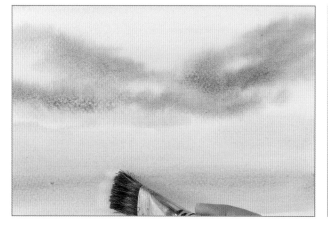

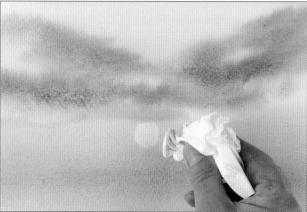

1 Wet the sky area with the golden leaf brush and clean water, then paint cadmium yellow with a little raw sienna across the lower part in horizontal strokes. While this is wet, paint permanent rose at the top and bottom of the yellow area. Paint horizontal strokes of cobalt blue at the top of the sky and bring this down into the wet pink. Still working into the wet background, paint clouds with shadow colour. Mix cadmium yellow with permanent rose and paint this at the bottom of the wet sky.

2 Wrap a coin in kitchen paper and use this to lift out a circle for the sun.

Transferring the image

Before starting each project, choose the outline you need from the middle or back of the book. Transferring the image couldn't be simpler: place a sheet of graphite paper face-down on top of your watercolour paper. Next, pull the outline out of the book and place it face-up on top of the graphite paper. Tape down the top of the outline only, then use a burnisher to go over the lines. You can use the outline again and again.

If you prefer to leave your book and all the outlines intact, use tracing paper to copy the outline, then go through the steps shown below to transfer the image to your watercolour paper. I have used a burnisher to transfer the image, but if you do not have one, you can use a spoon handle or the lid of a ballpoint pen.

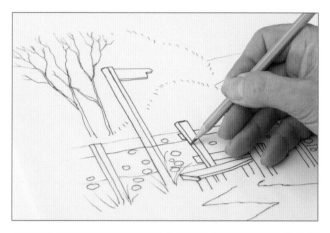

1 Place your tracing face-down on some scrap paper. Go over the lines on the back using a 4B or 2B pencil. This is a section from the *Poppy Field* project on page 22. You will be able to reuse this tracing several times without going over the pencil lines again.

2 Tape a sheet of watercolour paper down on a board, and place the tracing face-up on top. Tape down the top of the tracing only. Use a burnisher to go over the lines.

3 You can lift up the tracing from the bottom as you work, to see how the transfer of the image is going.

Fields

In this section you will paint a poppy field with a stile, a scene in which an open gate invites you into another field, and a meadow full of blossom. In the first project, you will use the technique shown on page 17, creating a patchwork of fields by painting hedgerows using a paper mask. On these two pages are some more tips and techniques that will help with the projects.

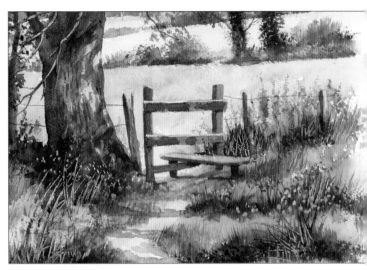

Painting a stile

One of my favourite subjects to paint is a country stile. It is not a complicated structure and there are so many different varieties to choose from. One thing to remember when painting a stile is that it is a means of climbing over a fence and the reason for the fence is to keep animals in a field, so don't forget to complete the fence!

Painting wet into wet poppies

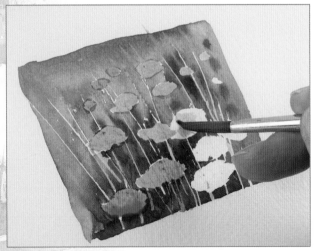

1 Remove the masking fluid ready to paint the poppies. Drop in a fairly pale mix of cadmium red.

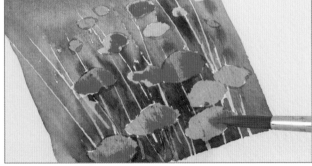

2 While the paint is wet, drop in a thicker mix of cadmium red.

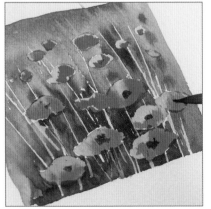

3 Allow the poppies to dry and paint in the centres using shadow colour, such as a purplish grey. Do not paint centres in all the poppies since some will be facing in a different direction.

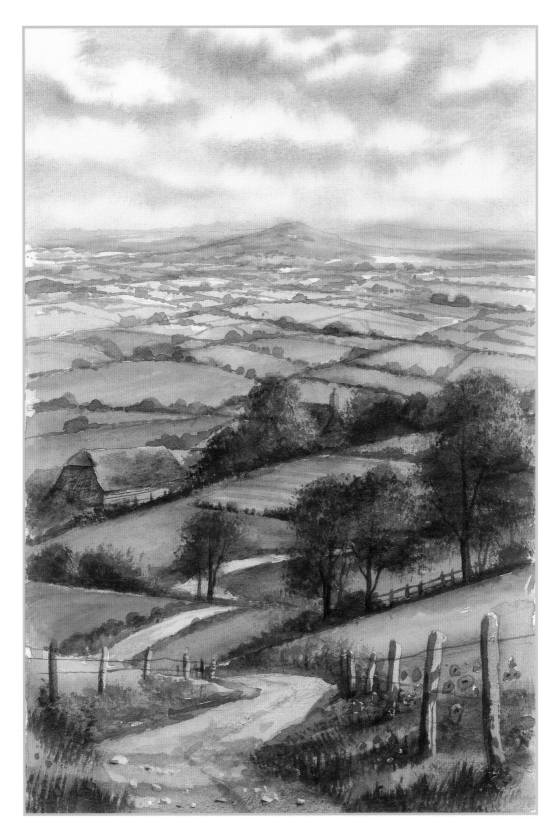

Depth and distance

In this painting, I have used the fields to help create a sense of distance in the painting by having the fields in the far distance small and pale and bluish in tone. The fields in the foreground are much larger and stronger in colour. The fields are painted obliquely, creating a criss-cross shape that leads the eye into the distance, and the farm track also leads into the painting, disappearing and reappearing in among the fields. The addition of the buildings establishes the scale of the scene.

Poppy Field

This is a typical 'Terry Harrison' scene; the sort I just love to paint. The subject matter is so paintable, with soft, rolling countryside, a patchwork of fields and a splash of bright colour in the foreground, framed by one of my favourite subjects, a footpath, stile and signpost.

YOU WILL NEED

300gsm (140lb) Rough watercolour paper

Colours: ultramarine, burnt umber, country olive, midnight green, sunlit green, raw sienna, burnt sienna, shadow, cadmium red

Brushes: golden leaf, foliage, medium detail, half-rigger, fan stippler, fan gogh, wizard

Masking tape

Masking fluid, masking brush and ruling pen

Kitchen paper

Magazine page

1 Transfer the image on to watercolour paper and tape the paper to your drawing board. Attach low-tack masking tape to the edges of the image. This will help to give the painting nice, clean edges.

2 Dip a small, nylon masking fluid brush in soap to coat it. This will make the masking fluid easy to remove when you have finished work. Mask all the woodwork in the painting as shown. Then mask the flowers; you can add more than are shown on the tracing. Use a ruling pen dipped in masking fluid to flick up grasses. Dip the pen in about 6mm (¼in) and do not overload it or it will create blobs.

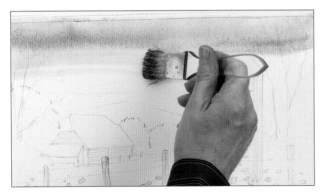
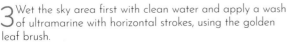

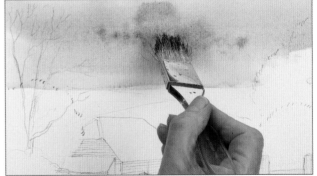

3 Wet the sky area first with clean water and apply a wash of ultramarine with horizontal strokes, using the golden leaf brush.

4 Drop in clouds while the paint is still wet using the same brush and a mix of burnt umber and ultramarine.

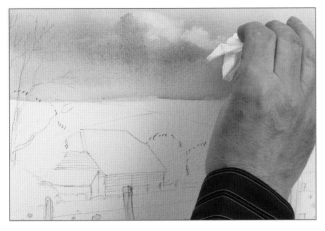

5 Use a piece of kitchen paper to lift out paint, creating highlights in the clouds.

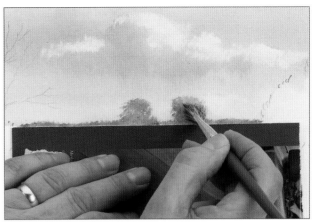

6 Use a page from a magazine to mask off an area along the horizon. Dip the foliage brush in a fairly weak mix of country olive paint and stipple along the edge as shown. Add tree shapes.

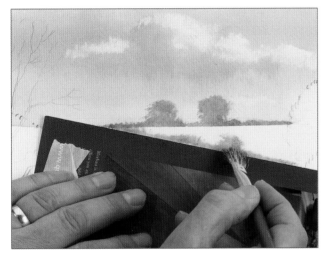

7 Change the angle of the magazine page to paint hedgerows.

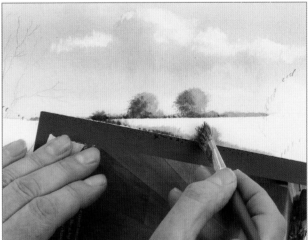

8 Still painting wet in wet, add shadows to the trees and hedgerows using midnight green. Allow the painting to dry.

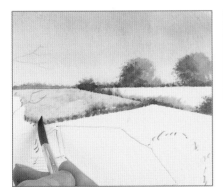

9 Use the medium detail brush and a very thin wash of midnight green to add colour to the first field.

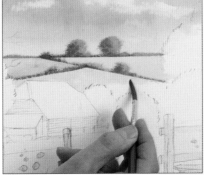

10 Paint the second field with a thin wash of sunlit green and the third, in front, with raw sienna.

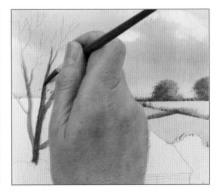

11 Still with the same brush, paint in the trees using a greeny mix of country olive and burnt umber. You can add branches if you like.

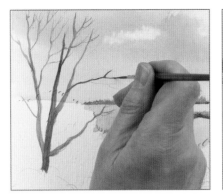

12 Use a half-rigger brush to paint twigs.

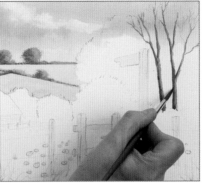

13 Paint the trees on the right in the same way. Shade the left-hand side with a stronger mix of country olive and burnt umber.

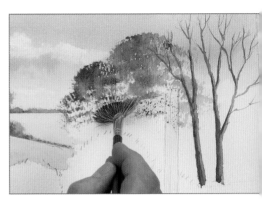

14 Take the fan stippler brush and double-load it, picking up country olive paint on the left-hand side and sunlit green on the right. Paint the trees behind the signpost with a dabbing motion.

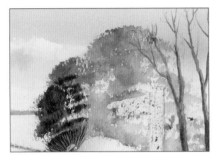

15 Add midnight green on the left-hand side of the trees behind the signpost.

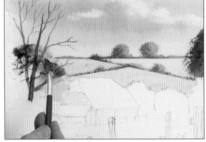

16 Still using the fan stippler, paint raw sienna on the sunlit side of the left-hand tree and midnight green on the left.

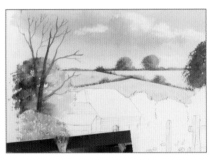

17 Mask off the field using a magazine page. Use the foliage brush to stipple pale country olive paint to create a bush in front of the left-hand tree.

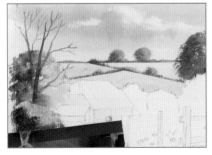

18 Use a darker mix of country olive to shade the left-hand side and underside of the bush.

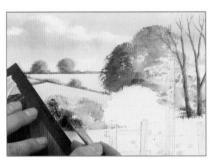

19 Mask the barn roof with the magazine page. Paint the bushes to the right as before. Darken the shaded left-hand side with midnight green.

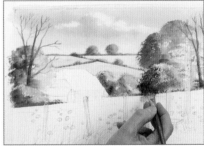

20 Continue painting bushes to the right, using sunlit green with a hint of burnt sienna on the right and midnight green to shade the left-hand side.

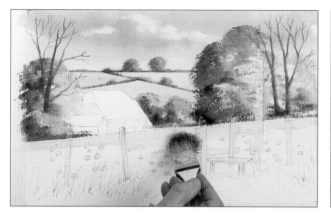

21 Use the golden leaf brush and a light wash of raw sienna to paint the back of the cornfield.

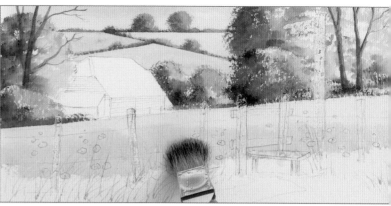

22 Paint a stronger mix of the same colour as you come towards the foreground.

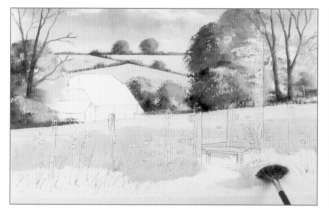

23 Paint sunlit green along the fence line and on the other side of the footpath using the fan gogh brush.

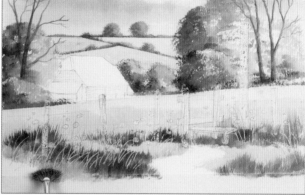

24 Flick up grasses in the foreground using the same brush and country olive. Use a lighter mix of country olive at the bottom left.

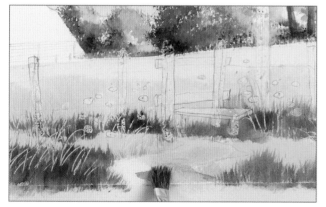

25 Use the wizard brush to paint the footpath with raw sienna further back and add burnt sienna towards the foreground.

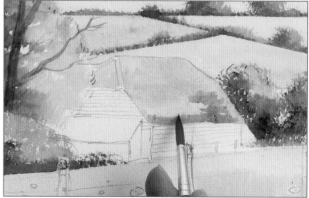

26 Paint the barn roof with the medium detail brush and a thin wash of burnt sienna. Drop in shadow colour wet in wet to suggest roof tiles.

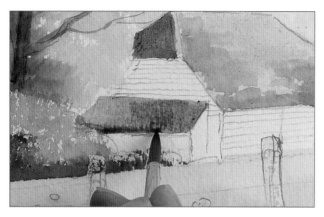

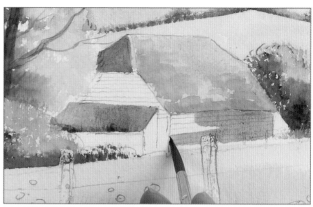

27 Paint a stronger mix of burnt sienna on the lean-to roof. Drop in a touch of ultramarine wet into wet. This colour causes an interesting textural effect called granulation.

28 Paint on a mix of burnt umber and country olive for the front of the barn.

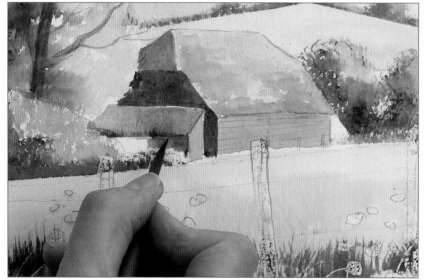

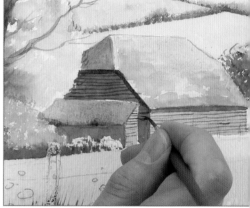

29 Paint the face of the lean-to with a stronger mix of the same colours. Allow the painting to dry.

30 Use a half-rigger and the same strong mix to paint the shadow under the roof. Carefully paint broken lines for the weatherboarding wet on dry. Strengthen the mix further to paint the weatherboarding on the end gable.

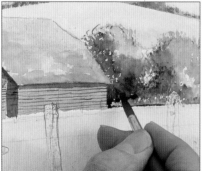

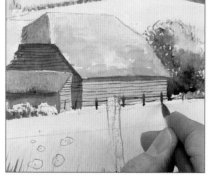

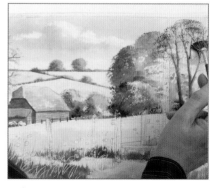

31 Use midnight green to darken the white triangle left by masking.

32 Paint the fence using the same colour.

33 Double-load the fan stippler brush with sunlit green on the right and midnight green on the left and lightly stipple foliage over the larger trees, leaving some gaps.

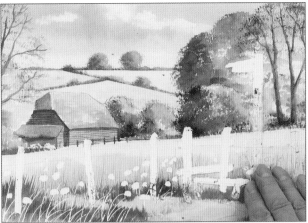

34 Pick up a little raw sienna and burnt sienna on the fan gogh brush and flick up standing corn in the field.

35 When the paint is dry, remove the masking fluid by rubbing with clean fingers.

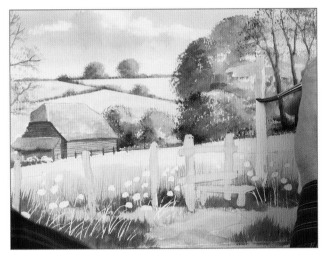

36 Paint all the woodwork with the medium detail brush and a thin wash of raw sienna and sunlit green.

37 Wash sunlit green over the grasses, avoiding the flower heads. Allow the painting to dry.

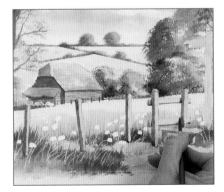

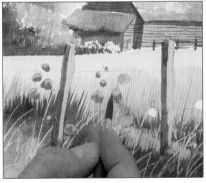

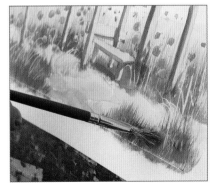

38 Use country olive and burnt umber to paint the shaded side of the woodwork, and the shadows cast by the posts on the horizontals of the stile.

39 Paint the poppies by applying a light wash of cadmium red, then dropping in a deeper mix of the same colour wet into wet.

40 Use midnight green and the fan gogh brush to create more texture in the grasses.

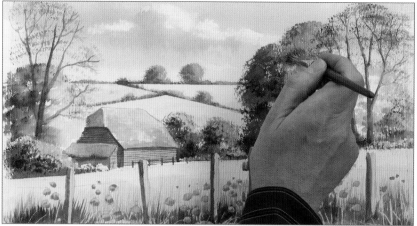

41 Change to the foliage brush and use midnight green to stipple foliage on the trees.

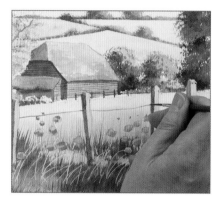

42 Use the half-rigger and burnt umber with a touch of country olive to paint in the fence wire.

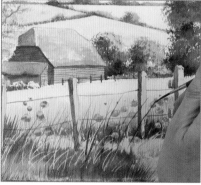

43 Still using the half-rigger, flick up tall grasses among the poppies with country olive.

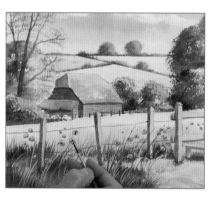

44 Put in the centres of the poppies using the colour shadow and the tip of the half-rigger.

45 Remove the masking tape to reveal the edges of the painting. Pull the tape away from the painting.

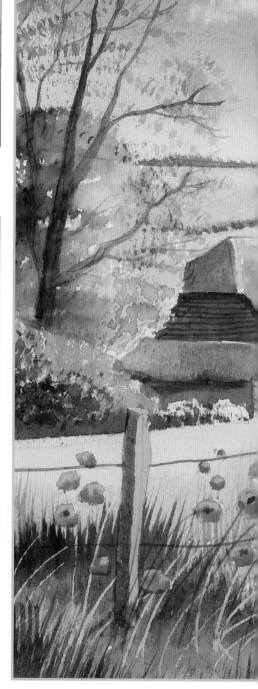

The finished painting.

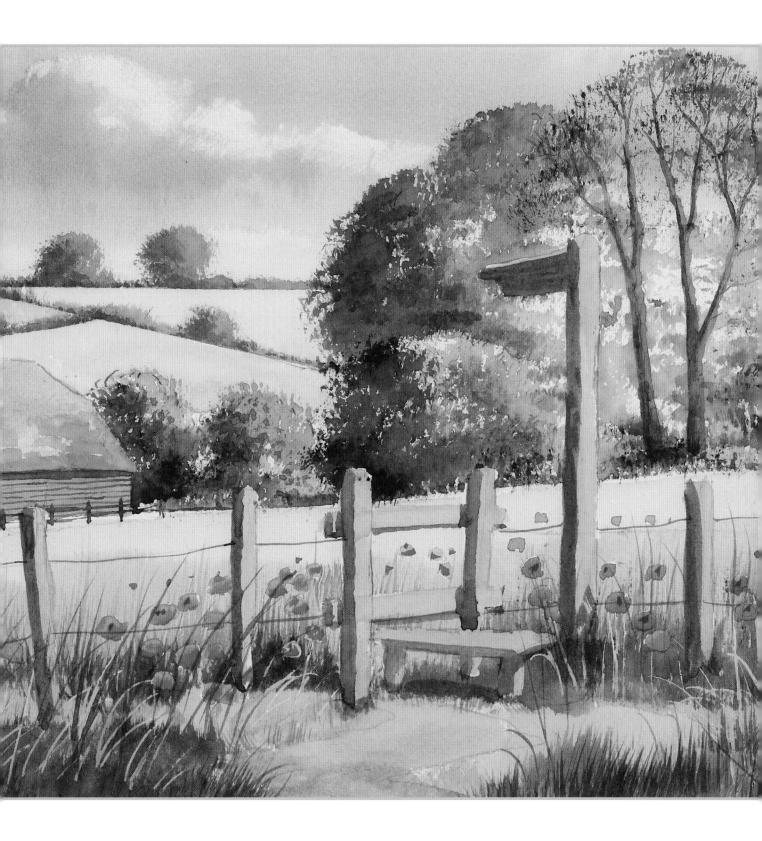

The Open Gate

OUTLINE
2

If you are looking for a subject to fill the foreground and lead the viewer into a painting, an open gate is ideal. A stile is another way of inviting the viewer further into a painting. This summer landscape gives you an opportunity to use the paper mask technique for distant trees and hedgerows. The middle distant trees frame the farmhouse and are painted using the golden leaf brush. The woodwork of the fence and the gate in the foreground is masked with masking fluid, and the greens behind the fence and gate are painted very dark, so that when the masking fluid is removed, a strong contrast is created.

Having a road in the centre of the painting leads you towards the focal point, but it could divide the composition into two halves. To overcome this, place some shadows across the road at the bottom of the painting to link one side with the other.

YOU WILL NEED
.

300gsm (140lb) Rough watercolour paper

Colours: ultramarine, burnt umber, raw sienna, burnt sienna, shadow, midnight green, cobalt blue, country olive, sunlit green, cadmium red

Brushes: golden leaf, large detail, foliage, medium detail, half-rigger, small detail

Masking fluid, masking brush and ruling pen

Paper mask

1 Transfer the scene on to watercolour paper. Apply masking fluid to the fence, flower heads and gate with a brush, then use a ruling pen to create grasses and stalks in the foreground.

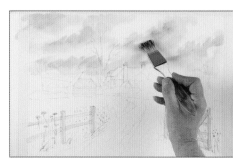

2 Use the golden leaf brush to wet the sky area with clean water, then paint on ultramarine, leaving spaces for clouds. Mix ultramarine and burnt umber and paint cloud shadows while the painting is still wet.

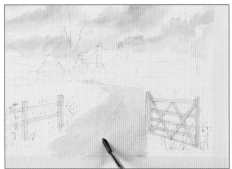

3 Use the large detail brush to wet the track area with clean water, then drop in very pale raw sienna from the far end, strengthening the mix as you come forwards. Drop in burnt sienna and raw sienna in the foreground.

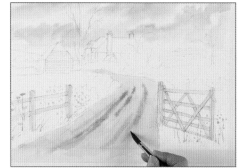

4 Still working wet in wet, indicate the furrows in the track with shadow colour. Allow to dry.

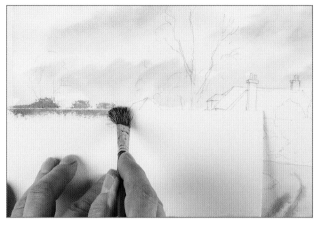

5 Make a pale mix of midnight green and cobalt blue and stipple along the edge of a paper mask with the foliage brush to suggest trees on the horizon.

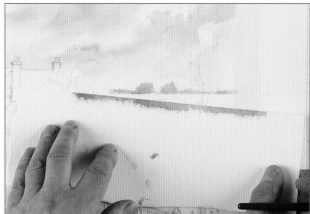

6 Paint the right-hand part of the horizon in the same way, then move the paper mask at an angle so that you can stipple hedgerows bordering fields coming forwards.

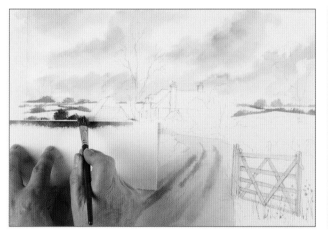

7 Keep changing the angle of the paper mask and as you come forwards, use a stronger mix of country olive and cobalt blue.

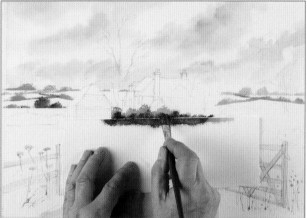

8 Stipple the hedge in front of the house with a light mix of country olive and cobalt blue, then while this is wet, stipple a darker colour at the base of the hedge with midnight green. Continue this hedge in the same way to the left and right.

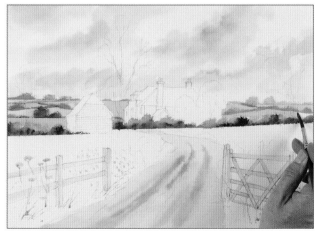

9 Use the medium detail brush to drop individual colours into the fields, starting with pale midnight green in the distance, then sunlit green, then raw sienna.

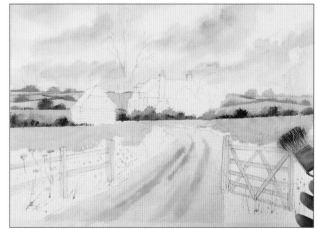

10 Use the golden leaf brush with a mix of raw sienna and sunlit green to paint the field in the middle distance. Add burnt sienna on the right.

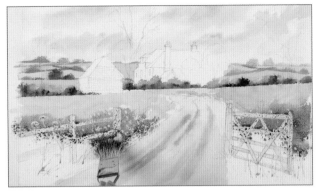

11 Mix country olive and sunlit green and paint this over the masked gate and fence area.

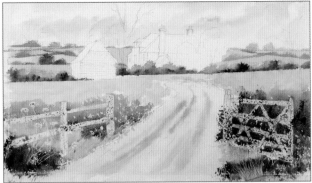

12 Paint midnight green further forwards, leaving gaps on both sides, then fill the gaps with sunlit green, suggesting a patch of sunlight.

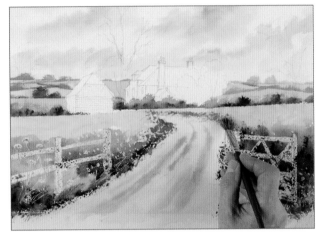

13 Stipple along the edge of the track into the distance with midnight green. Change to the foliage brush and stipple country olive along the right-hand edge of the track.

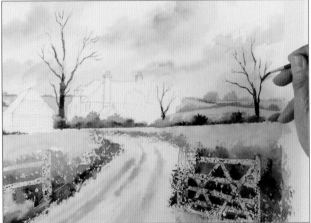

14 Use the half-rigger and midnight green to paint the trunks and branches of the trees.

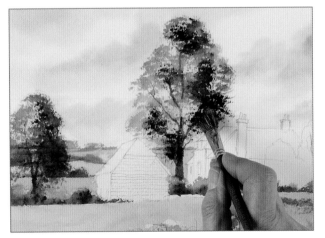

15 Stipple the trees using the foliage brush, starting with sunlit green and then adding midnight green for the shaded right-hand sides.

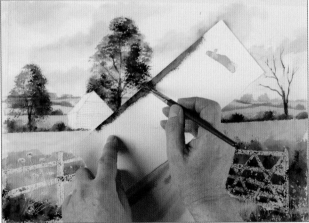

16 Place a paper mask over the edge of the barn roof and stipple behind it, then do the same for the roof of the house. Use the small detail brush to tidy the edges.

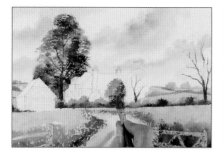

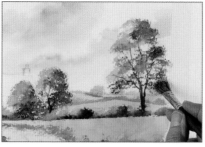

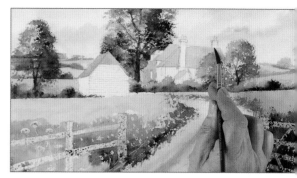

17 Mix a blue-green from cobalt blue and sunlit green and paint a tree in front of the house. Add midnight green on the right-hand side.

18 Stipple the foliage of the trees on the right with raw sienna and sunlit green on their lit left-hand sides, then with midnight green and burnt sienna on the right.

19 Make a pale mix of burnt sienna and paint the roofs with the medium detail brush.

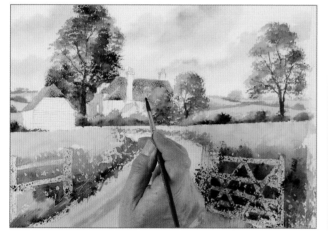

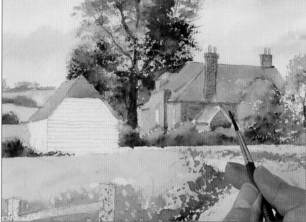

20 While this is still wet, drop in the shadow colour, which will darken the roofs and add texture.

21 Use the small detail brush and a darker mix of burnt sienna to paint the shaded parts of the house.

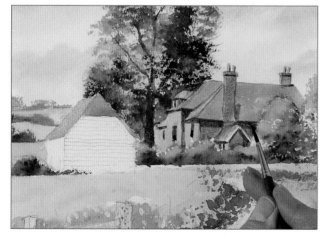

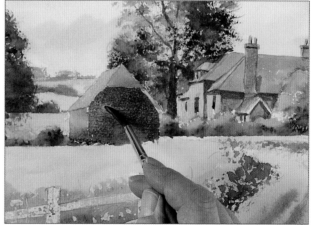

22 Make a dark mix of ultramarine and burnt umber and paint the windows and other architectural details of the house.

23 Paint the lit side of the barn with a pale mix of burnt umber and the medium detail brush, then paint the front with the same mix and drop in a mix of burnt umber and country olive while the first wash is wet. Allow to dry.

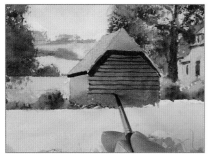

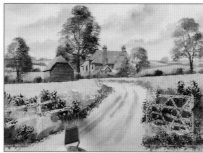

24 Use the small detail brush and a mix of ultramarine and burnt umber to paint the shadow under the eaves and the weatherboarding wet on dry.

25 Change to the golden leaf brush and stipple plants over the masked gate and fence with midnight green.

26 Paint grasses in the foreground with the half-rigger and midnight green.

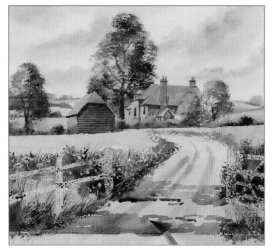

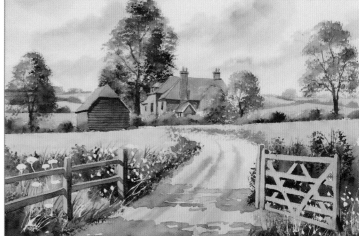

27 Use the large detail brush and shadow colour to paint shadows across the track from trees that are outside the scene. Allow to dry.

28 Remove the masking fluid by rubbing with your fingers. Make a pale mix of burnt sienna and ultramarine and use the large detail brush to paint the fence and gate. Allow to dry. Use the medium detail brush to paint shade with a darker mix.

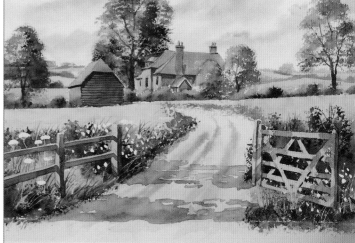

29 Make a mix of ultramarine and burnt umber and paint dappled shadow over the gate.

30 Wash over the grasses that were masked with sunlit green.

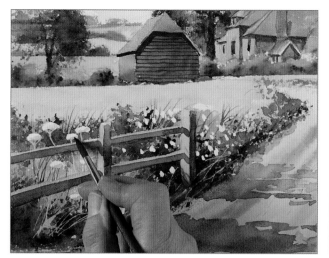

31 Shade the undersides of the cow parsley flowers with a thin wash of cobalt blue.

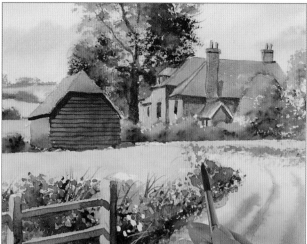

32 Paint the flowers that were masked with cadmium red to create poppies, then paint more in the distance with the tip of the brush.

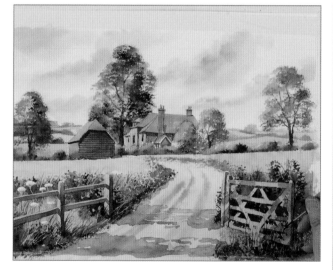

33 Add darker grasses in the foreground with the half-rigger and midnight green.

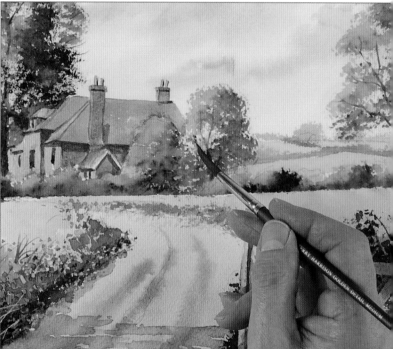

34 Paint a glaze of sunlit green over the dried paint of the blue-green tree in front of the house, and over white gaps in the other trees. A glaze is a wash of a transparent colour applied onto a dried background.

Overleaf
The finished painting.

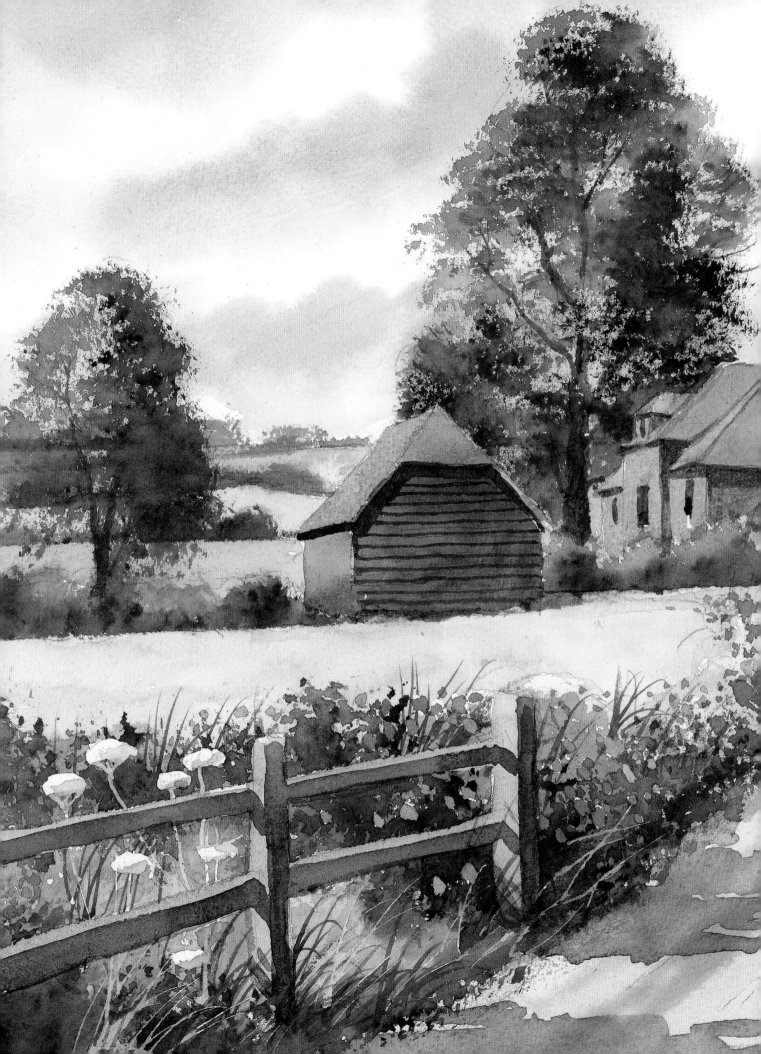

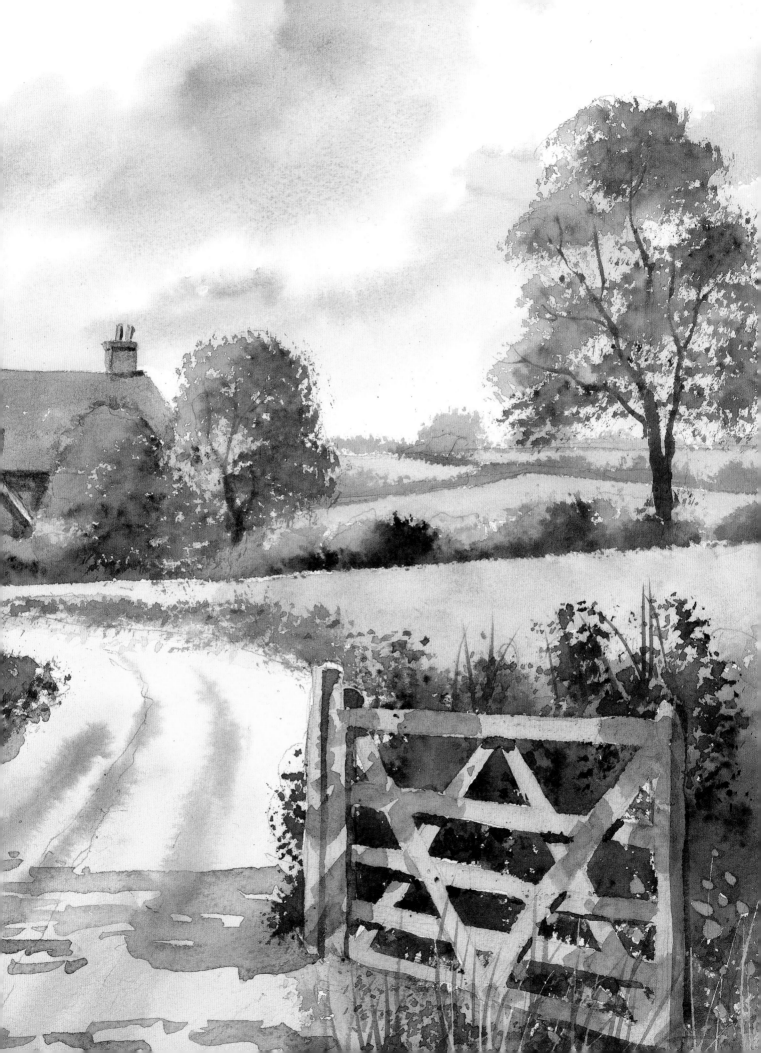

Blossom Meadow

OUTLINE
3

YOU WILL NEED
.
300gsm (140lb) Rough
watercolour paper
Colours: ultramarine, raw sienna,
burnt sienna, cobalt blue,
midnight green, sunlit green,
country olive, burnt umber,
cadmium yellow, permanent rose
Brushes: golden leaf, large detail,
medium detail, foliage,
small detail, half-rigger,
19mm (¾in) flat
Masking fluid, masking brush
and ruling pen
Paper mask

This riverside footpath reminds me of many treks along riverbanks, looking for a subject to paint. Here, I was suddenly treated to a scene that has everything I look for in a painting. The tree in blossom is the focal point, and the lazy river leads you into the painting and the distant meadows with a glimpse of the faraway hills beyond.

This project gives you the opportunity to create distance in a painting with plenty of light bluey tones for the faraway trees and hedgerows, and the pale, soft shades of the hills on the horizon. Masking fluid is used on the blossom and on the foreground flowers and grasses.

1 Mask the blossom and flower heads on the ground with a brush, then use the ruling pen to apply masking fluid to the grasses.

2 Wet the sky area with the golden leaf brush and clean water, then paint it with ultramarine, leaving white paper for clouds. While this is wet, drop a thin wash of raw sienna into the clouds.

3 Paint the footpath with the large detail brush and raw sienna. Allow to dry.

4 Paint the distant hill on the far right with the medium detail brush and pale ultramarine, then to the left of this paint ultramarine and drop in burnt sienna. Further forwards, paint a pale mix of cobalt blue and midnight green.

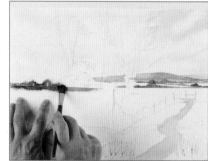

5 Use a paper mask to create a straight hedgerow and stipple a stronger mix of midnight green and cobalt blue above this with the foliage brush. Repeat on the left of the painting, creating trees and bushes in the hedgerow.

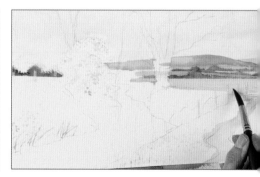

6 Use the medium detail brush to drop various colours into the distant fields: sunlit green in some and watered down country olive in others. Change to the large detail brush and paint raw sienna coming forwards.

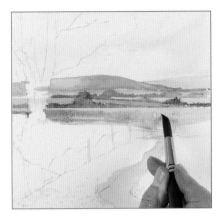

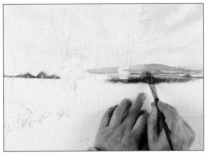

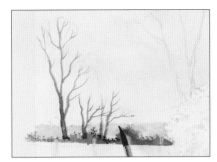

7 While this field is wet, drop in country olive. Allow to dry.

8 Mask the bottom of the hedgerow with the paper mask and use the foliage brush to stipple the lower part of it with midnight green.

9 Use the small detail brush to paint tree trunks and branches with midnight green. Allow to dry, then paint the distant hills behind the trees with a pale wash of cobalt blue.

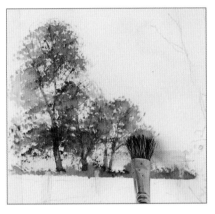

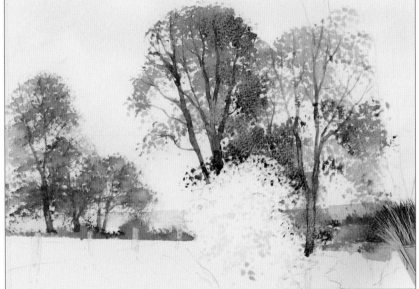

10 Using the foliage brush, stipple a mix of sunlit green and cobalt blue on to the trees, then midnight green.

11 Paint the trunks and branches of the trees to the right of these with the half-rigger and burnt umber and midnight green, then stipple on foliage with the golden leaf brush and ultramarine with country olive. Mix midnight green and ultramarine to stipple on darker foliage.

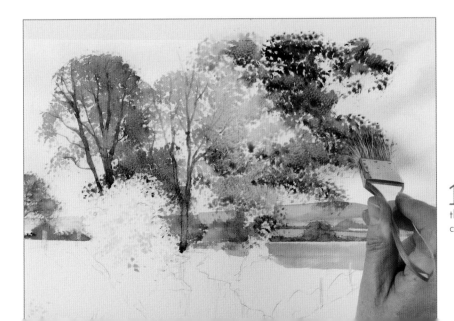

12 Stipple the lighter tree to the right with sunlit green, then continue to the right of this with midnight green and country olive. Allow to dry.

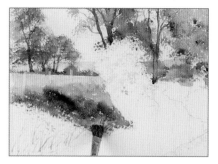

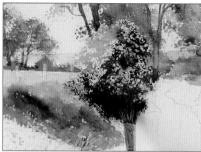

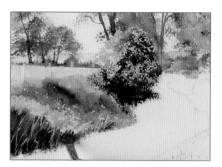

13 Use the foliage brush to paint the field on the left of the painting with raw sienna, then country olive further forwards, then stipple midnight green wet into wet down the river bank.

14 Stipple sunlit green foliage at the top of the tree in blossom, then stipple with midnight green on the shaded side, over the masking fluid.

15 Stipple pale country olive on the left-hand edge of the river bank, then stipple and flick up midnight green on the far left, wet into wet. Allow to dry.

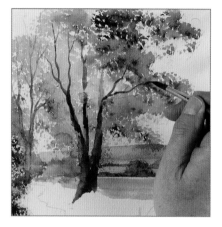

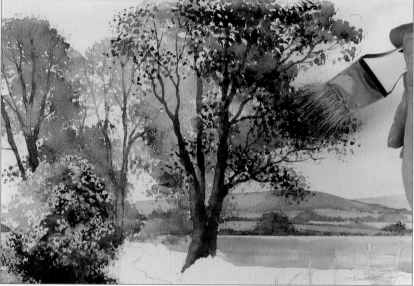

16 Using the medium detail brush, paint the main tree trunk and branches, going up into the foliage, with country olive and burnt umber. Shade the right-hand side with a darker mix and add more branches.

17 Stipple more foliage with the golden leaf brush and midnight green.

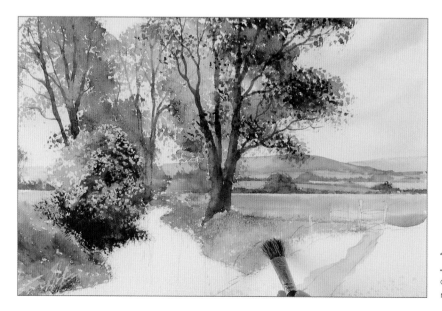

18 Paint grass under the main tree with the foliage brush and pale country olive, then add paler grasses with raw sienna.

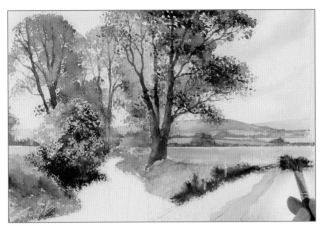

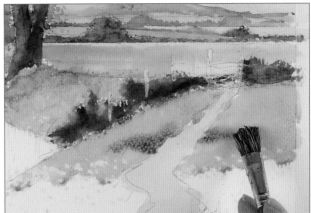

19 Paint a mix of country olive and midnight green along the base of the fence, suggesting grasses.

20 Make a pale mix of raw sienna and country olive and paint this on either side of the path, then drop in a stronger mix of country olive.

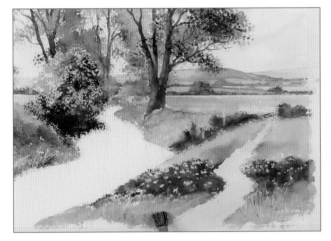

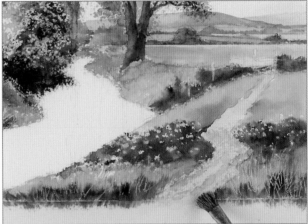

21 Paint on either side of the path, over the masked flower heads, with country olive and burnt umber, then paint with sunlit green and raw sienna further forwards.

22 Flick up grasses in the foreground with midnight green, then stipple very pale burnt umber on to the path.

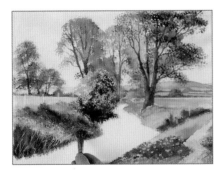

23 Flick up and stipple midnight green down the river bank on the left, to add texture.

24 Stipple more texture on either side of the path in the same way.

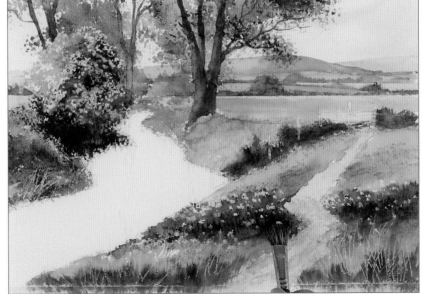

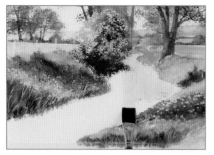

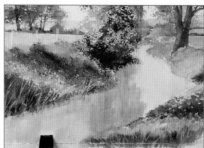

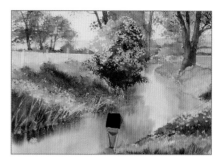

25 Use the 19mm (¾in) flat brush to drag a pale wash of cobalt blue downwards to paint the water.

26 Add country olive to the mix and drag this down to create reflections, then continue with cobalt blue on the left.

27 Drag down a little cobalt blue and country olive on the right-hand side, then use midnight green to reflect the darker area at the water's edge.

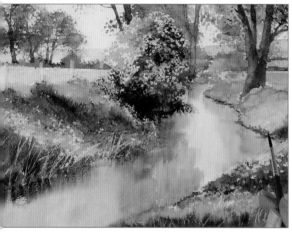

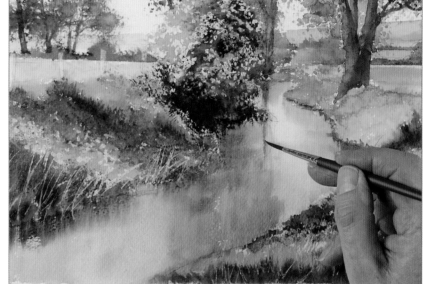

28 Use the small detail brush and midnight green to paint the dark reflections at the edge of the right-hand bank.

29 Paint reflections of the main tree and the more distant tree with country olive and burnt umber. Allow to dry.

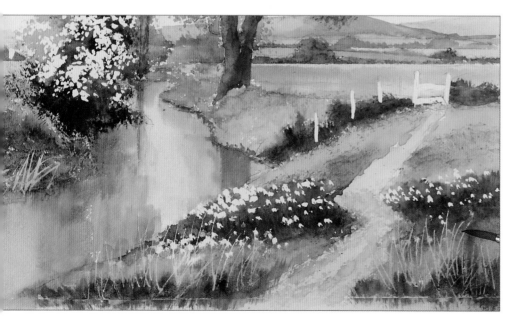

30 Rub off the masking fluid and paint the grasses with a wash of sunlit green on the medium detail brush.

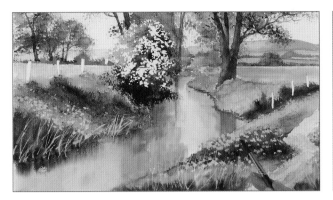

31 Paint the flower heads on both banks with cadmium yellow.

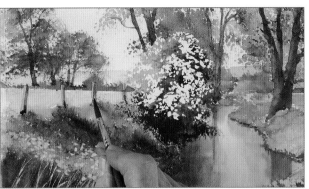

32 Make a pale mix of burnt umber and ultramarine and paint the fence posts and stile. Allow them to dry, then shade the right-hand sides with a darker mix.

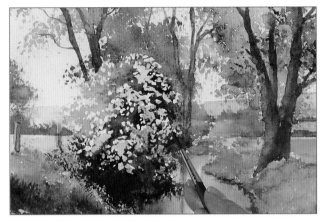

33 Paint the blossom with permanent rose, using a stronger mix in places.

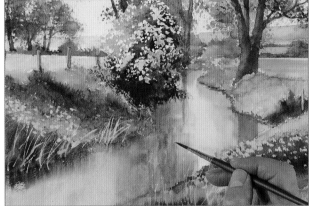

34 Paint the reflection of the blossom with permanent rose, and drag the colour down.

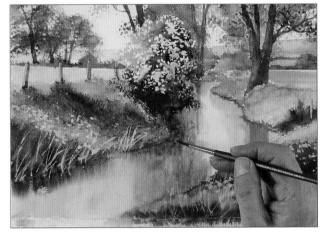

35 Use midnight green to paint the darker part of the reflection of the blossom bush and the edge of the bank.

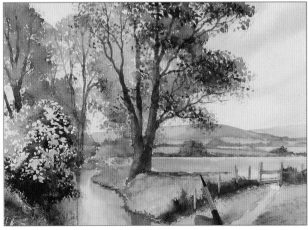

36 Paint the cast shadow from the main tree with the small detail brush and midnight green.

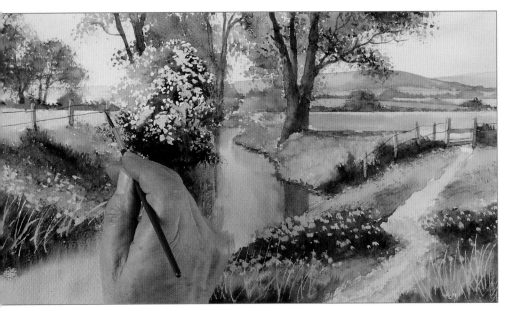

37 Use the half-rigger to paint the fence wires with burnt umber.

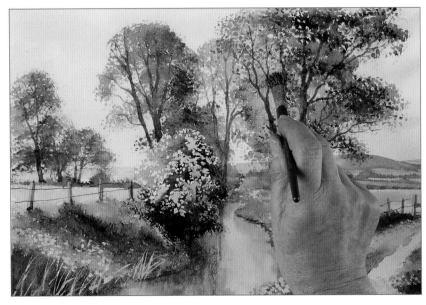

38 Finally use the foliage brush and midnight green to stipple more texture on the trees.

The finished painting.

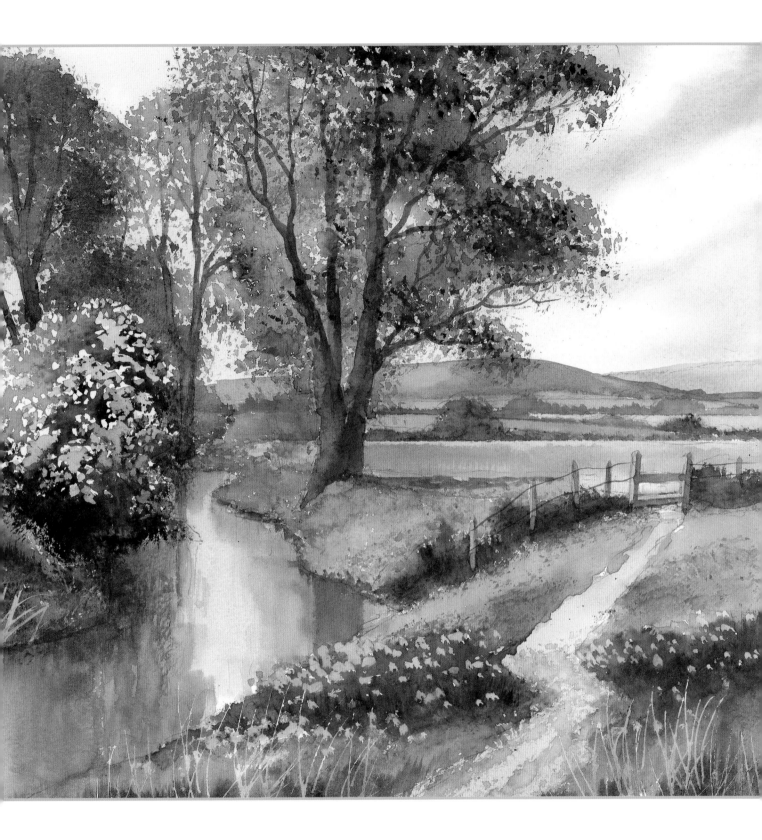

Woodlands

Here you will find a bluebell wood in spring, a summer woodland with a footbridge over water, and England's beautiful New Forest in fiery autumn colours. This seasonal variation will prevent all your paintings from turning out too green! The wet into wet technique is used to suggest massed foliage. Two of the projects feature reflections, so there is advice below to help you. The *Bluebell Wood* project shows how trees can be painted to suggest recession, and in the *Footbridge in the Woods* project, you will learn how to paint convincing silver birches.

Dragging down reflections

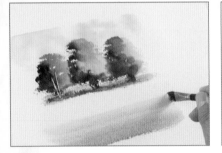 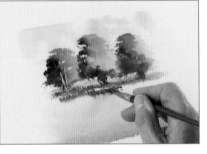 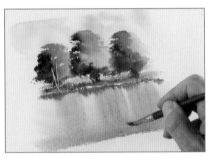

1 Paint the bank and trees, then wet the water area with clean water and the wizard brush. Paint a thin wash of ultramarine from the bottom. The water on the paper means that the wash will fade towards the top.

2 Paint reflections of the bank colours and drag them down slightly into the water, working wet into wet.

3 Pick up the lighter tree colours and drag them down into the water as before, wet into wet.

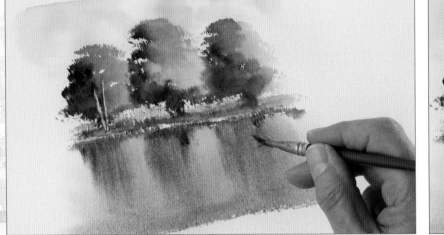 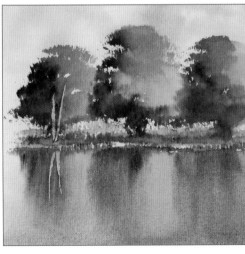

4 While the paint is still wet, drag some darker greens down into the water to reflect the trees and other details above.

The finished scene.

Varying the tone of trees to add depth

In this painting, *Winter Walk*, trees create a sense of depth and you are drawn deep into the landscape. The tree in the foreground is the largest and the strongest in colour. From the foreground to the middle distance, then to the far distance, the trees reduce in size and become paler in tone and cooler in colour.

Bluebell Wood

OUTLINE 4

YOU WILL NEED

300gsm (140lb) Rough watercolour paper

Colours: cobalt blue, cadmium yellow, sunlit green, midnight green, permanent rose, country olive, raw sienna, burnt umber, burnt sienna, shadow

Brushes: golden leaf, foliage, wizard, half-rigger, fan stippler, medium detail, fan gogh

Masking tape

Bluebell woods have a mystique about them, which makes them so appealing to paint. Bluebells bloom for such a short period of time, but our memories of a walk in a bluebell wood remain for a lifetime. To capture that mood is a bonus for an artist. I hope this demonstration will bring back happy memories.

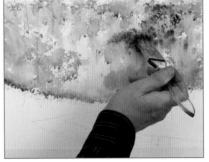

1 Transfer the image and apply masking tape to the edges. Use the golden leaf brush to stipple on a light cobalt blue mix.

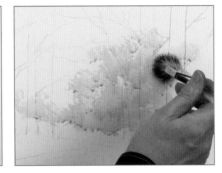

2 Add cadmium yellow, working wet into wet.

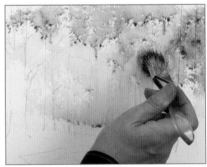

3 Still working wet into wet, stipple sunlit green mixed with cobalt blue on top.

4 Add more cobalt blue and sunlit green along the bottom.

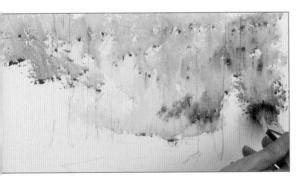

5 While the painting is still wet, stipple on midnight green mixed with cobalt blue.

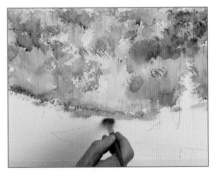

6 Mix a light bluebell-coloured wash using permanent rose and cobalt blue and apply it to the background first using the foliage brush.

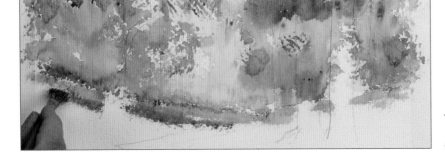

7 Working quickly wet into wet, apply a slightly stronger mix of the bluebell colour further forwards.

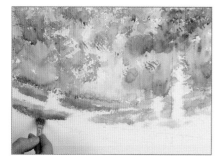

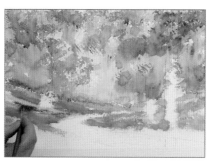

8 Stipple on a stronger mix still further forwards, leaving gaps as shown. Allow the painting to dry naturally.

9 Stipple on a light mix of sunlit green wet on dry between the blue. Then add country olive wet into wet.

10 Add a mix of raw sienna and sunlit green towards the foreground.

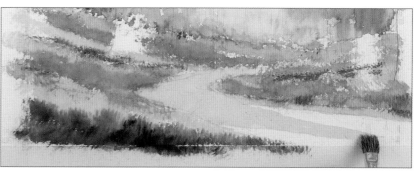

11 Stipple on midnight green at the bottom of the painting.

12 Use the wizard brush and raw sienna to paint the footpath, making it light in the distance and stronger further forwards.

13 Change to the half-rigger and mix cobalt blue with sunlit green to paint the distant trees. Use the outline as a guide if your original pencil lines have been obscured by paint.

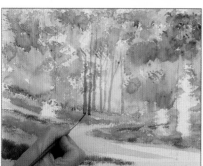

14 Paint the trees slightly further forwards, starting lower down and using a mix of cobalt blue and country olive.

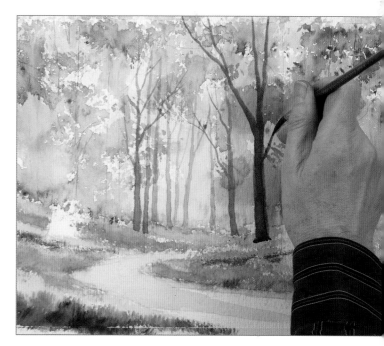

15 Next paint the trees in the middle ground with a mix of country olive and burnt umber.

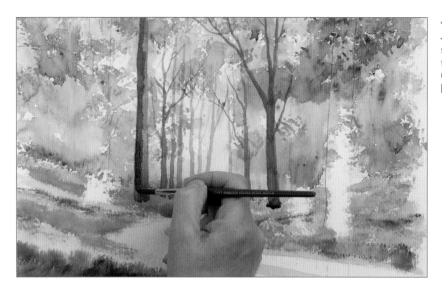

16 Make a darker mix of the same colours and paint the left-hand sides of the middle ground trees to create the illusion of light coming from the right. Continue adding trees and shading the left-hand sides.

17 Make a dark mix of country olive and burnt umber and use the fan stippler to stipple ivy on to the main left-hand tree. Push the brush into the paper.

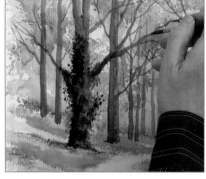

18 Paint the rest of the trunk and the branches with country olive and burnt umber and the medium detail brush.

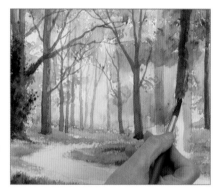

19 Take the large detail brush and a mix of raw sienna and sunlit green to paint the right-hand sides of two trees on the right.

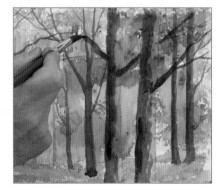

20 Add branches using the same colour mix.

21 Paint the puddle area on the path with a thin wash of cobalt blue and the medium detail brush. Allow it to dry.

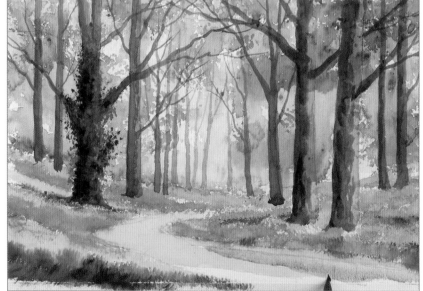

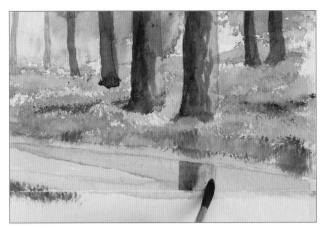

22 Paint the reflections of trees with country olive for the shaded sides and sunlit green for the right-hand sides.

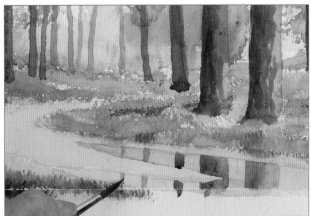

23 Paint the reflections of distant trees with a very pale mix of cobalt blue and country olive.

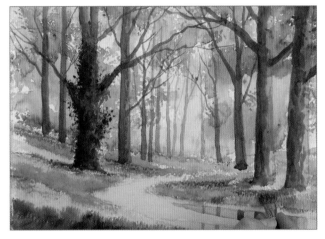

24 Mix cobalt blue and permanent rose and add texture by stippling into the areas of bluebells beneath the trees.

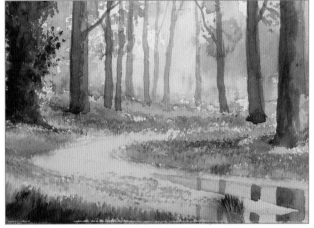

25 Use the foliage brush and a thin mix of burnt sienna to paint texture on the path.

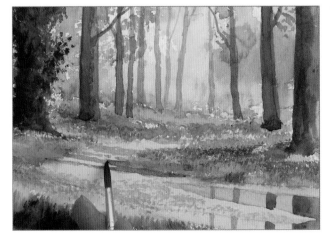

26 Change to the medium detail brush and use a thin mix of shadow to paint tree shadows across the path.

27 Load the fan gogh brush with a dry mix of midnight green and flick up grasses on the bottom left of the painting.

28 Load the golden leaf brush with a dry mix of country olive and stipple more foliage at the top of the painting.

29 Use the fan gogh brush to stipple midnight green paint under the trees.

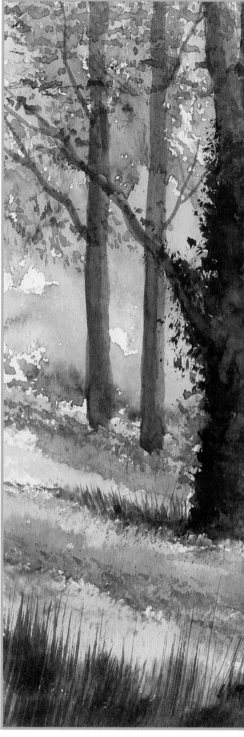

The finished painting.

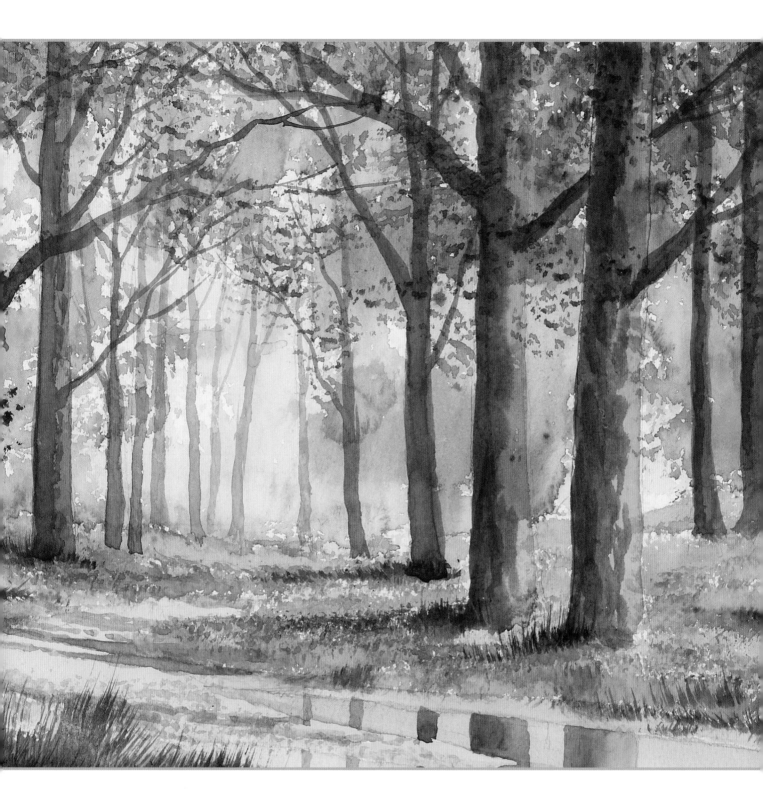

Footbridge in the Woods

OUTLINE 5

This subject captures the moment when, while out walking in the woods, you happen on a tranquil scene, interrupted only by the sound of birds and rippling water. Then you whip out your paints and dash off a masterpiece!

This scene has a strong focal point and the composition leads you through the picture and off into the distance. There is also a large area of reflections.

YOU WILL NEED

300gsm (140lb) Rough watercolour paper

Colours: cobalt blue, midnight green, sunlit green, raw sienna, cadmium yellow, country olive, burnt sienna, burnt umber, ultramarine, permanent rose, yellow ochre

Brushes: golden leaf, foliage, wizard, medium detail, half-rigger, 19mm (¾in) flat, fan gogh

Masking tape

Masking fluid, masking brush and ruling pen

Kitchen paper

Magazine page

1 Transfer the scene and mask the edges with masking tape. Paint masking fluid on the trees, flowers, bridge and bridge reflection.

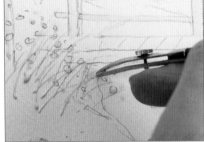

2 Use the ruling pen and masking fluid to mask the grasses and the stalks of the cow parsley.

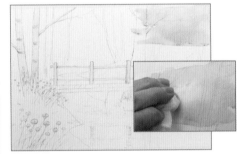

3 Use the golden leaf brush to paint a wash of cobalt blue in the sky area. Scrunch up a piece of kitchen paper and use it to lift out colour from the wet wash to create clouds.

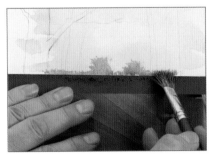

4 Mask off the horizon with a magazine page and use the foliage brush and diluted midnight green to stipple on a hedge and trees.

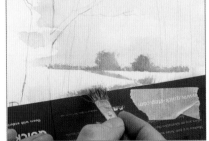

5 Use the magazine page at different angles to create more hedgerows coming forwards.

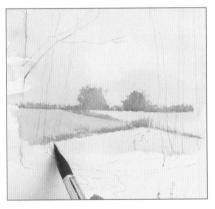

6 Paint the fields with pale washes of midnight green on the left and sunlit green on the right using the medium detail brush. Paint the next field with a thin wash of raw sienna.

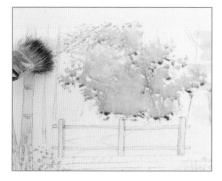

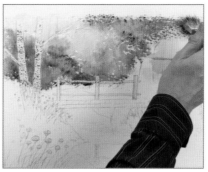

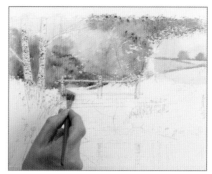

7 Take the golden leaf brush and a mix of cobalt blue and sunlit green and stipple in the foliage, leaving a gap in the middle. Then stipple cadmium yellow and fill the gap.

8 Stipple country olive over the masked silver birch trees and on the right.

9 Change to the wizard brush and paint country olive down to the water's edge.

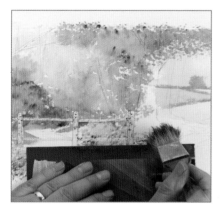

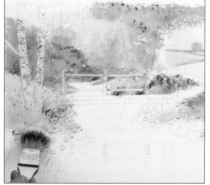

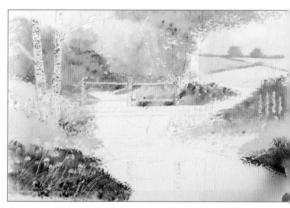

10 Mask off the footbridge with a magazine page and use the golden leaf brush with raw sienna and sunlit green to stipple foliage above it.

11 Stipple with sunlit green on the grassy banks of the stream.

12 Paint midnight green mixed with country olive over the foreground on the right and left of the stream. Allow to dry.

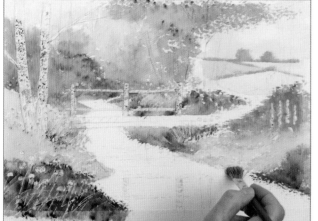

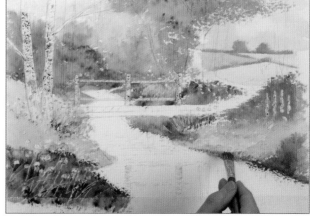

13 Use the foliage brush with raw sienna to paint the sunlit areas on either side of the stream, working wet on dry.

14 Drop in burnt sienna wet into wet along the water's edge.

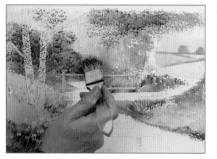 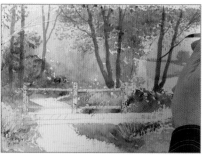 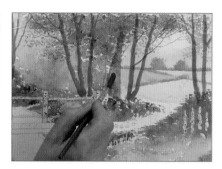

15 Now that the background is dry, stipple on a dry mix of country olive with the golden leaf brush to build up the distant foliage.

16 Use the medium detail brush and burnt umber mixed with country olive to paint the distant trees.

17 Paint the large tree trunk on the right with a mix of raw sienna and sunlit green.

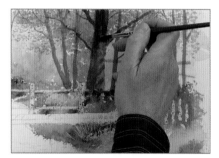 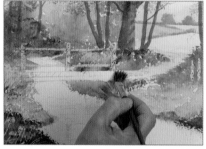 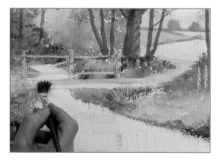

18 Paint the shaded side of the tree wet into wet using burnt umber and country olive. Add texture.

19 Paint the footpath up to the bridge with the wizard brush and raw sienna.

20 Add burnt umber to the mix to paint the footbridge itself.

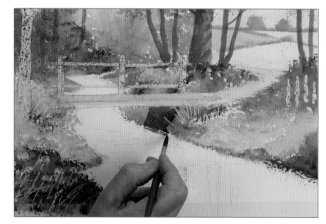 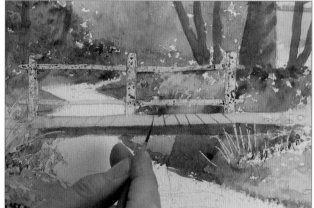

21 Use the medium detail brush to paint country olive under the bridge. Allow it to dry.

22 Paint the front of the footbridge with a mix of burnt umber and country olive, then change to the half-rigger to paint the planking.

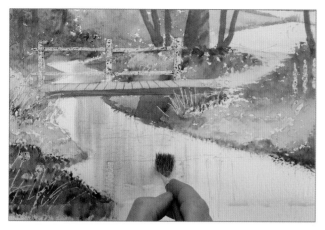
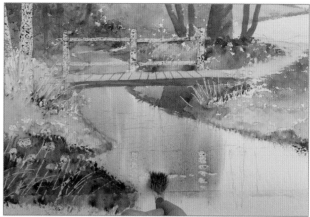

23 Wet the stream area with clean water and then pick up cobalt blue and country olive on the wizard brush and drag it downwards.

24 Make a greener mix of country olive with a touch of cobalt blue and drag it down the water area, working wet into wet.

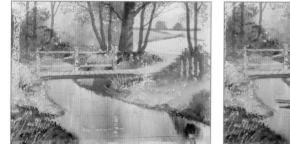
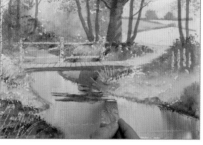
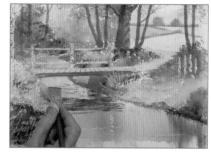

25 Add cobalt blue and then midnight green on the right, dragging down the colours wet into wet.

26 Take the 19mm (¾in) flat brush and country olive and paint the reflection of the dark underside of the bridge with a side to side motion.

27 Make a light mix of cobalt blue and country olive and paint the smaller ripples beyond the bridge reflection.

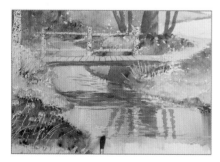
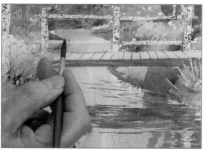

28 Paint reflections of the trees behind the bridge using the medium detail brush and country olive with burnt umber. Break up the reflections to suggest a rippled water surface.

29 Use country olive to darken the stream bank, highlighting the contrast with the water.

30 Change to the fan gogh and create areas of darkness under the silver birch and behind the foreground flowers by flicking up grasses with country olive.

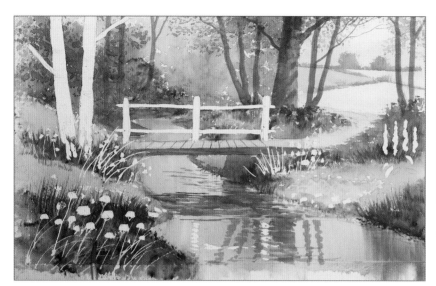

32 Paint the bridge rails with a thin mix of raw sienna and burnt umber.

31 Allow the painting to dry naturally. Remove the masking fluid by rubbing with clean fingers. Paint the grasses and stems with sunlit green and the medium detail brush.

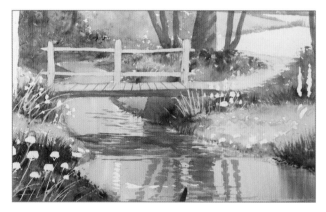

33 Paint the reflection of the sunlit bridge with the same colour.

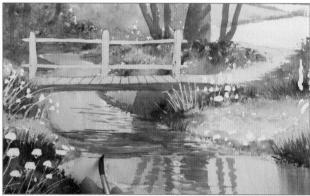

34 Use burnt umber and country olive for the reflection of the shaded front of the bridge.

35 Paint the left-hand side of the silver birch with a mix of cobalt blue and a little burnt umber. Make horizontal brushstrokes to suggest the patchy bark.

36 While the paint is wet, drip in burnt umber. Allow to dry.

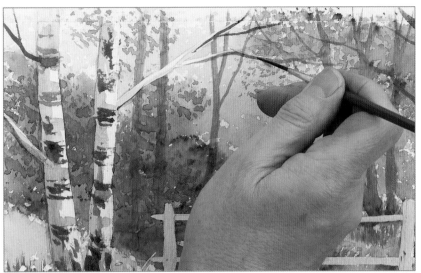

37 Mix ultramarine and burnt umber. Hold the half-rigger almost flat and drag it sideways wet on dry to produce the ragged markings on the bark.

38 Paint the fine branches with the same brush and colour.

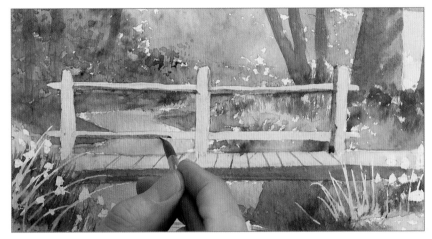

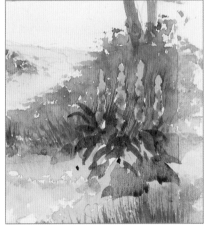

39 Mix burnt umber and country olive and use the medium detail brush to shade the bridge posts and rails.

40 Paint the foxgloves with a permanent rose wash, then while this is wet, drop in a touch of cobalt blue and permanent rose. Paint the leaves with midnight green.

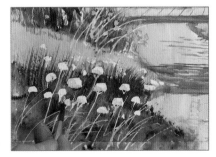

41 Use permanent rose for the middle ground flowers.

42 Paint the flowers to the right of the footbridge with cadmium yellow.

43 Make a thin mix of yellow ochre and touch it in to the shaded sides of the cow parsley flowers, leaving some white.

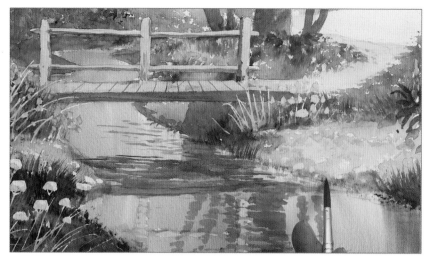

44 Paint raw sienna over the white parts left on the bank.

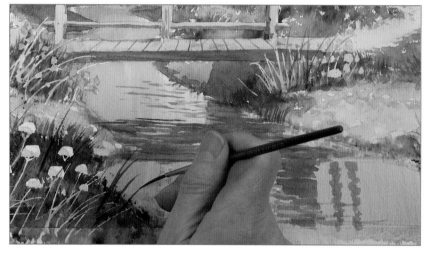

45 Add a few grasses using the half-rigger and midnight green.

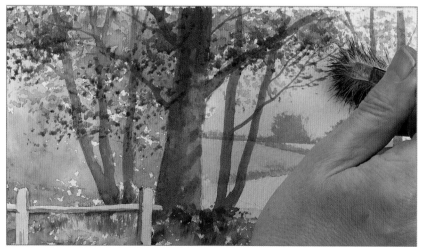

46 Pick up a little country olive on the golden leaf brush and lightly stipple foliage at the top of the painting.

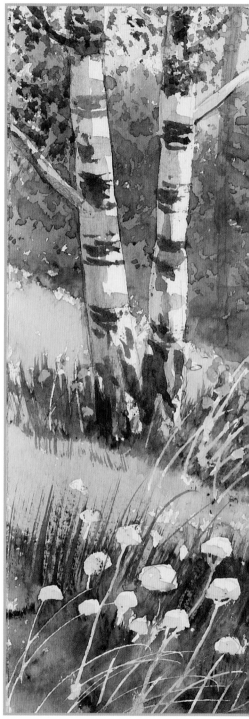

The finished painting.

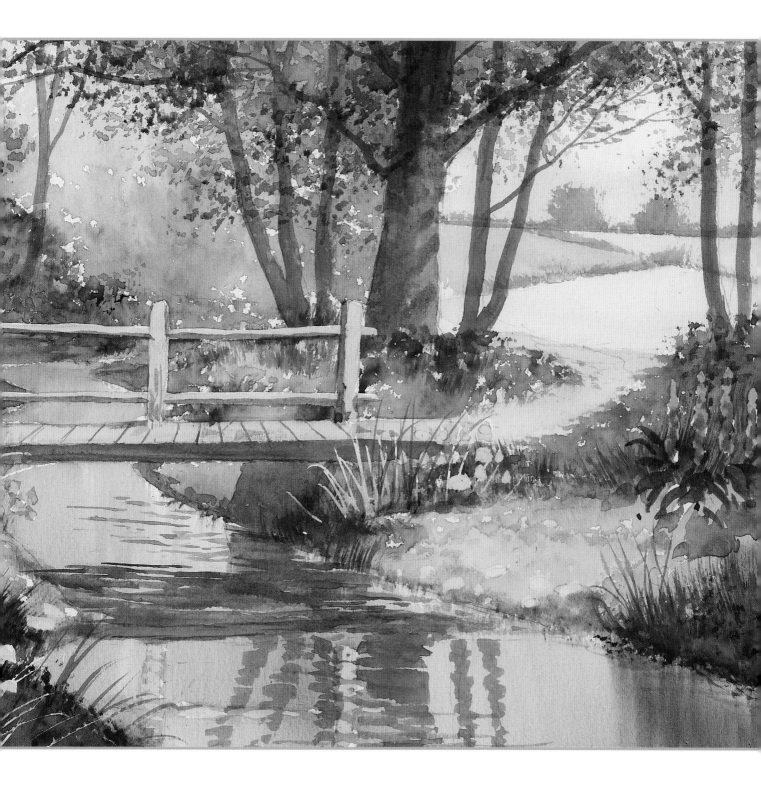

New Forest Bridge

Autumn in the New Forest is a magical time of year; the colours are amazing. This footbridge was in a part of the forest called Pig's Bush, which is an unfortunate name for such a beautiful location. The bridge shown here has since been replaced with a newer version, but the original is a much more appealing subject to paint.

Most of the tree trunks are quite dark and are silhouetted against the golds and light reds of the foliage background. The shadow across the track at the bottom of the painting helps to frame the focal point of the bridge. This scene can easily be transformed into a summer landscape by using greens for the foliage: sunlit green replaces the gold colours, country olive replaces the reds, and midnight green is a substitute for the dark browns.

YOU WILL NEED

300gsm (140lb) Rough watercolour paper

Colours: ultramarine, cadmium yellow, raw sienna, cadmium red, cobalt blue, alizarin crimson, burnt sienna, sunlit green, burnt umber, country olive, shadow

Brushes: golden leaf, foliage brush, large detail, medium detail, half-rigger, fan gogh

Masking fluid, masking brush and ruling pen

Paper mask

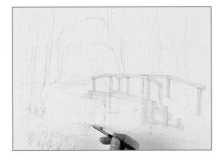

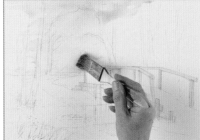

1 Apply masking fluid to the bridge, the ripples in the water and the lit sides of some tree trunks with the brush, then use the ruling pen to mask the grasses.

2 Use the golden leaf brush and clean water to wet a small area of sky, and drop in ultramarine to create a patch of blue.

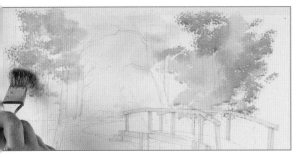

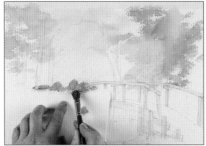

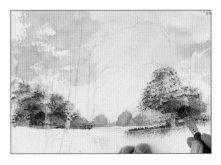

3 Stipple a bright area of foliage on the right-hand side with cadmium yellow and raw sienna, then while this is wet, stipple cadmium red and cadmium yellow on top, then on the left of the painting. Allow to dry.

4 Use a paper mask and the foliage brush with a mix of cobalt blue and a touch of alizarin crimson to stipple distant trees. While this is wet, stipple cadmium red and cadmium yellow on to the sunlit left-hand sides of these trees.

5 In the same way, stipple the lower parts of the left-hand woods with cobalt blue, alizarin crimson and burnt sienna, then mask the bridge rail and stipple the same mix on the right.

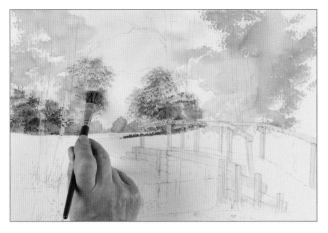

6 Stipple into the distant trees with a mix of cadmium yellow with a touch of cadmium red, then repeat with burnt sienna.

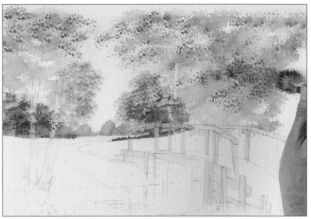

7 Stipple across the foliage using the golden leaf brush with cadmium yellow, then with more burnt sienna.

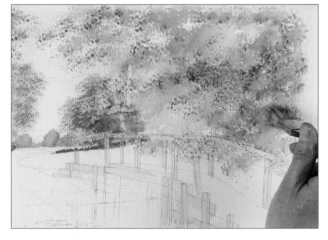

8 Still working wet into wet, stipple sunlit green lower down on the right.

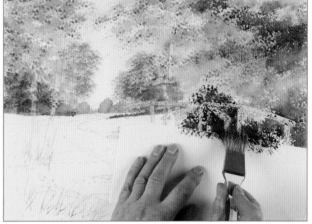

9 Mix a dark purple-brown from burnt umber, alizarin crimson and ultramarine. Mask the body of the bridge with paper and stipple behind it.

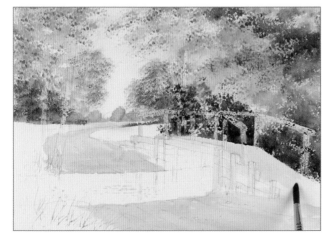

10 Use the large detail brush to paint the track and the path over the bridge with a wash of raw sienna. Allow to dry.

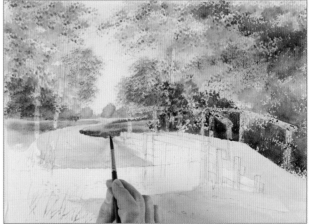

11 Paint the middle ground with the medium detail brush and burnt sienna, and while it is wet, drop in burnt umber.

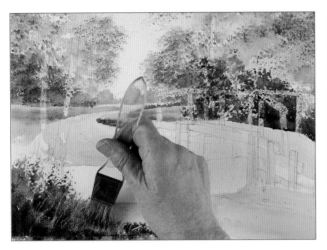

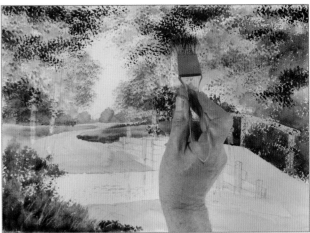

12 Use the golden leaf brush to stipple and flick up undergrowth in the left-hand corner with burnt sienna, then while this is wet, paint a dark mix of ultramarine, alizarin crimson and burnt umber at the very bottom.

13 Stipple more of the same dark mix around the painting to add texture, particularly round the edges to frame it.

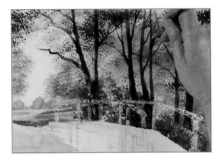

14 Mix ultramarine and burnt umber and use the medium detail brush to paint trunks and branches. Refer to the outline if you have obscured some of the pencil lines with paint.

15 Use the half-rigger to paint the trunks and branches of the distant trees with a paler mix of the same colours.

16 Add country olive to the mix and paint the foreground trees with the medium detail brush, painting over the masking fluid. Allow to dry.

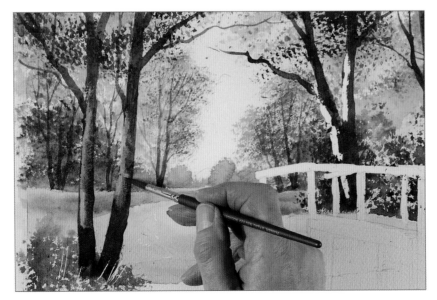

17 Rub off the masking fluid, apart from the ripples in the water. Mix raw sienna and sunlit green and paint over the masked out, highlighted parts of the trees. While this is wet, drop in some of the colour used in the previous step. This will blend and soften the edges of the highlights.

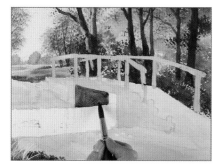

18 Use the large detail brush with a pale mix of sunlit green and burnt umber to paint the woodwork of the bridge. Paint the inside part in deep shade with a dark mix of ultramarine, burnt umber and country olive. Allow to dry.

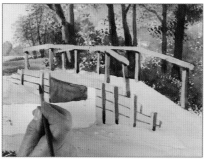

19 Paint the shaded detail and the planking of the bridge wet on dry with the same mix and the medium detail brush.

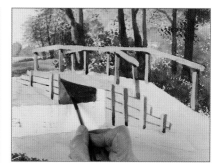

20 Make a very dark mix of ultramarine and burnt umber and paint the shadow under the bridge.

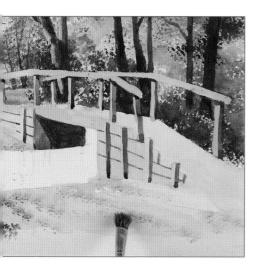

21 Stipple texture on the track with the foliage brush and burnt umber.

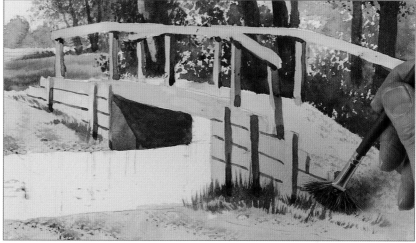

22 Use the fan gogh brush and a mix of burnt umber and country olive to paint grasses at the base of the bridge.

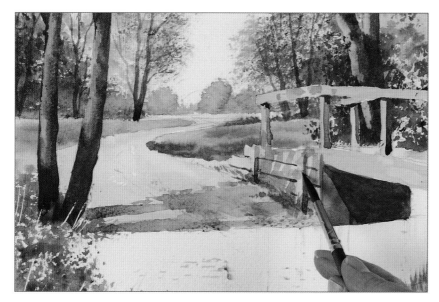

23 Change to the medium detail brush and shadow colour and paint shadows across the track and up the bridge.

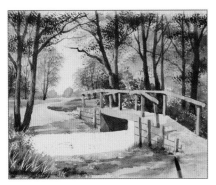

24 Use the large detail brush to paint a shadow across the foreground, supposedly from a tree outside the picture. Make it dappled to imply foliage.

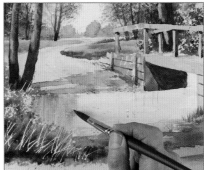

25 Paint the water with the large detail brush and a pale wash of ultramarine, then while this is wet, paint reflections with raw sienna and burnt sienna.

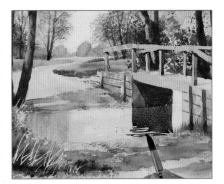

26 Mix ultramarine, burnt umber and country olive and paint the reflection of the bridge's dark underside, and ripples. Allow to dry.

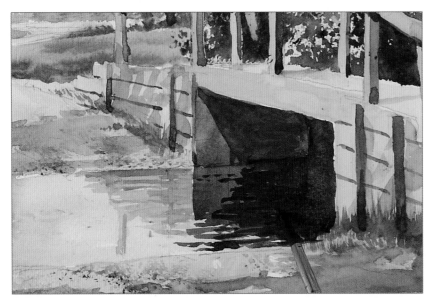

27 Dilute the mix and use the medium detail brush to paint lighter reflections and ripples. Then paint the back of the bridge showing through the arch with burnt umber and ultramarine, and add a reflection and ripples.

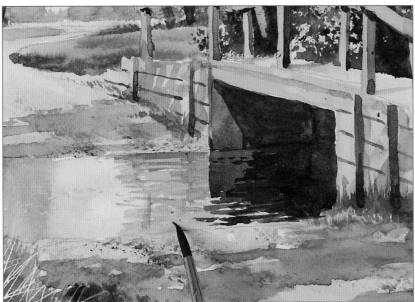

28 Add a pale hint of raw sienna and burnt sienna to the rippled reflections.

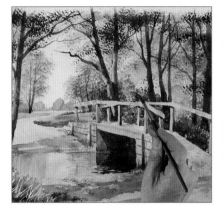

29 Paint some of the remaining white areas in the foliage with a wash of cadmium yellow on the medium detail brush.

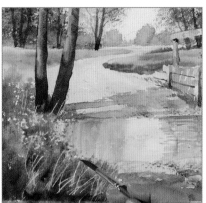

30 Paint a very pale wash of burnt sienna over the masked grasses.

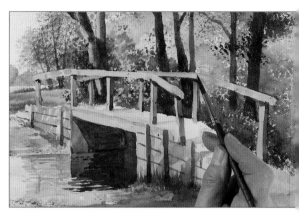

31 Darken the handrail and uprights at the back of the bridge with very pale burnt umber.

32 The reflection of the foreground tree should just be visible behind the grasses, so paint this in with ultramarine and burnt umber, then paint the reflection of the bridge upright. Allow to dry. Remove the masking fluid from the water to expose rippled highlights.

33 Paint smaller branches and twigs across the sky area with the half-rigger and a mix of burnt umber and ultramarine.

Overleaf
The finished painting.

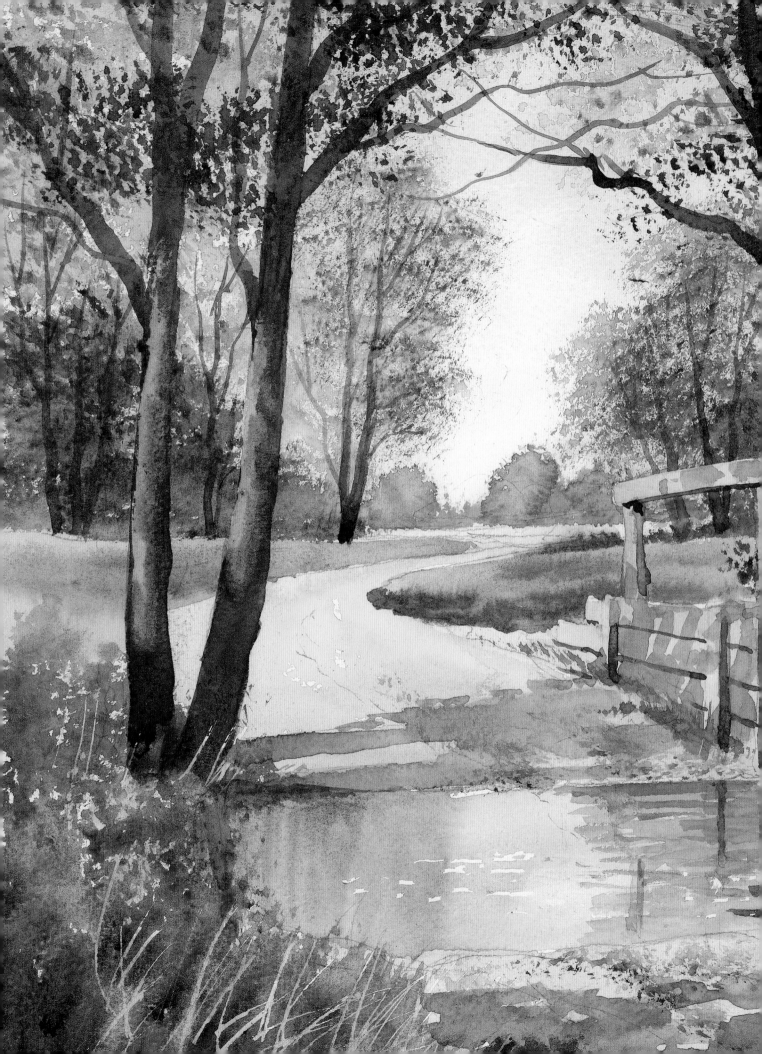

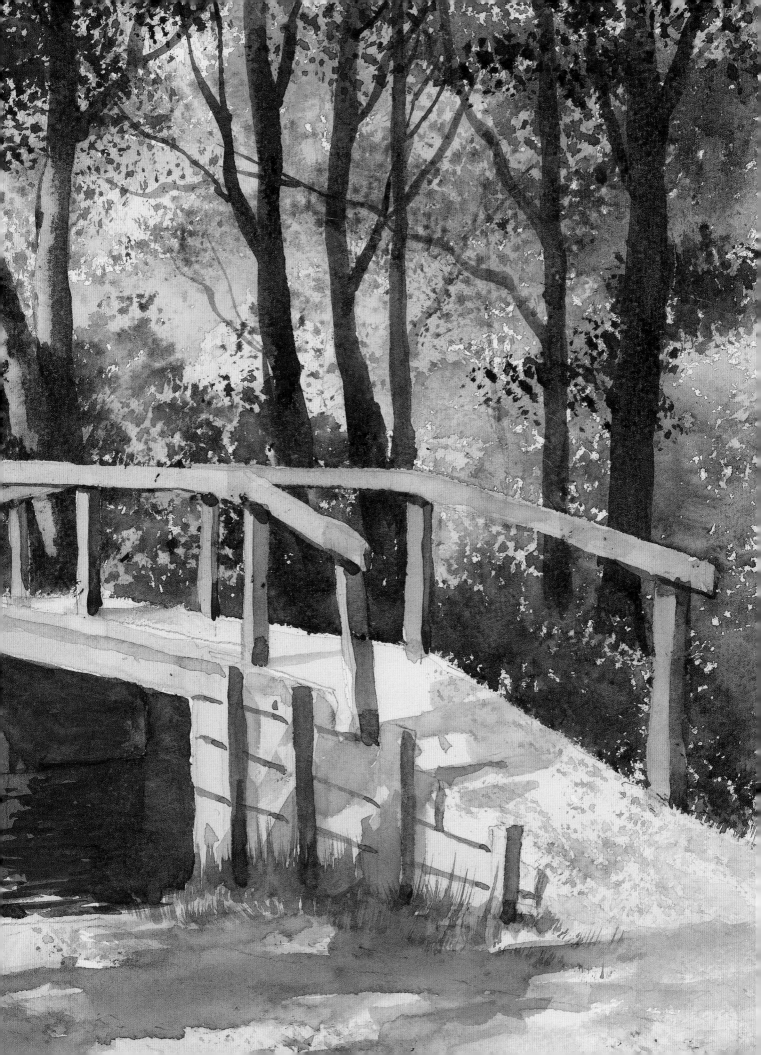

Winter landscapes

For snowy landscapes in watercolour, you need to use the white of the paper and the darkness of your darker tones to create the dazzling impact of such scenes. In *Snow Tracks*, you will create snow in the trees by applying masking fluid with kitchen paper. You will also paint bluish shadows on the snow clinging to fences to give it form. *Village in the Snow* glows with sunset colours and lit windows, showing that you don't have to stick to cool colours for a snow scene. In *Barn in the Snow*, the warm colours of the sunlit barn lift an otherwise chilly scene.

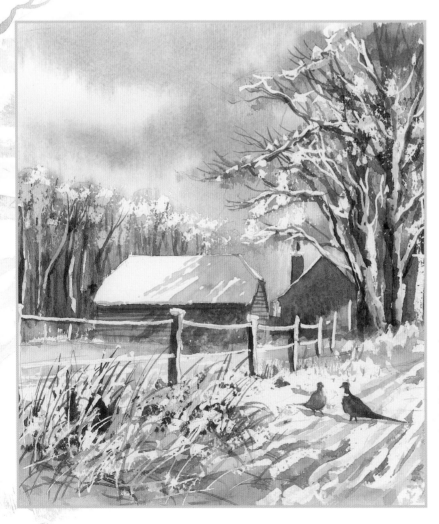

Masking fluid snow

Masking fluid can be used to great effect when painting snow. Here I applied the masking fluid with a sponge for the treetops, and with a small brush for the snow that had settled on the branches and trunks. I used a ruling pen to apply the masking fluid to the fence and the grasses in the foreground. Some of the ruts and texture in the foreground were painted with masking fluid. After removing the masking fluid, a light wash of cobalt blue was applied to create some shadows, the rest was then left as white paper.

Grass growing through snow

To help break up a large area of white foreground, grass can be painted in with the fan gogh brush or a half-rigger. Another tip is to use a px (clear acrylic resin) brush handle to scrape out some grasses whilst the paint is still wet. This technique was also used to scrape out the tree trunks on the left.

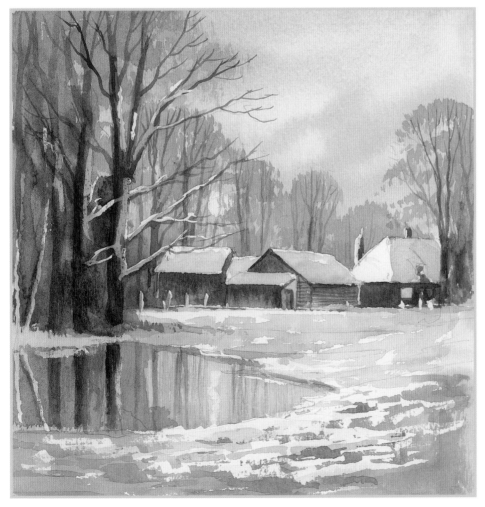

Warming up a snow scene

A snow scene does not necessarily have to be cold, frosty and unpleasant. If you paint a scene at sunset, this gives you the opportunity to introduce a whole variety of warm colours. Here I applied masking fluid in the same way as in the other examples, but I added the colours of the sunset reflected in the snow.

Adding volume to masking fluid snow

1 Draw the scene. Use kitchen paper to dab masking fluid onto the trees, then a masking fluid brush to mask the tops of the fence, stile and signpost.

2 When most of the painting is finished and dried, rub off the masking fluid to reveal the snow on the woodwork. Add shadow with the small detail brush and cobalt blue to make it look three-dimensional.

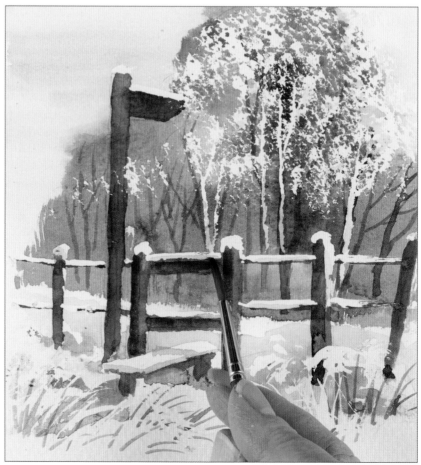

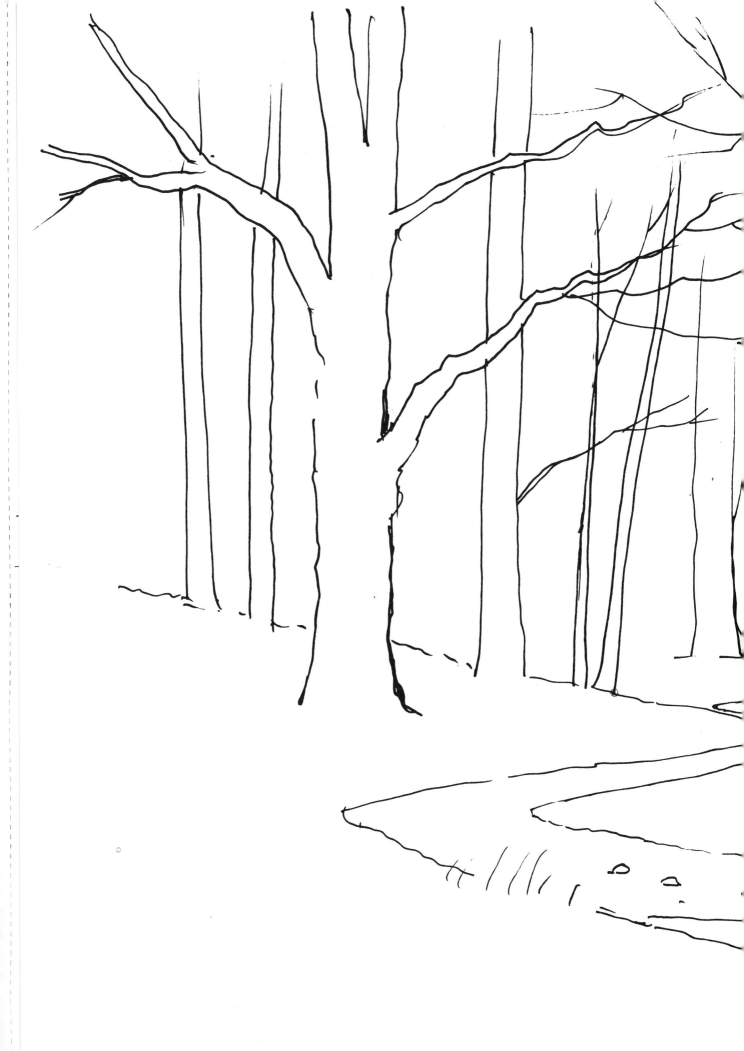

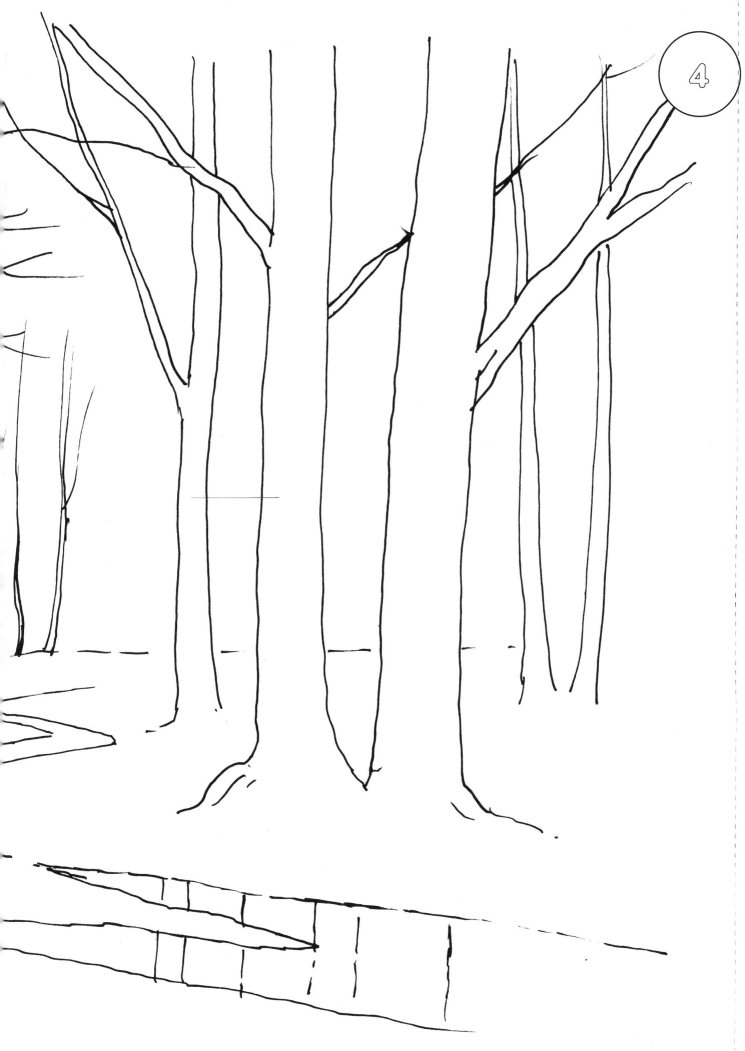

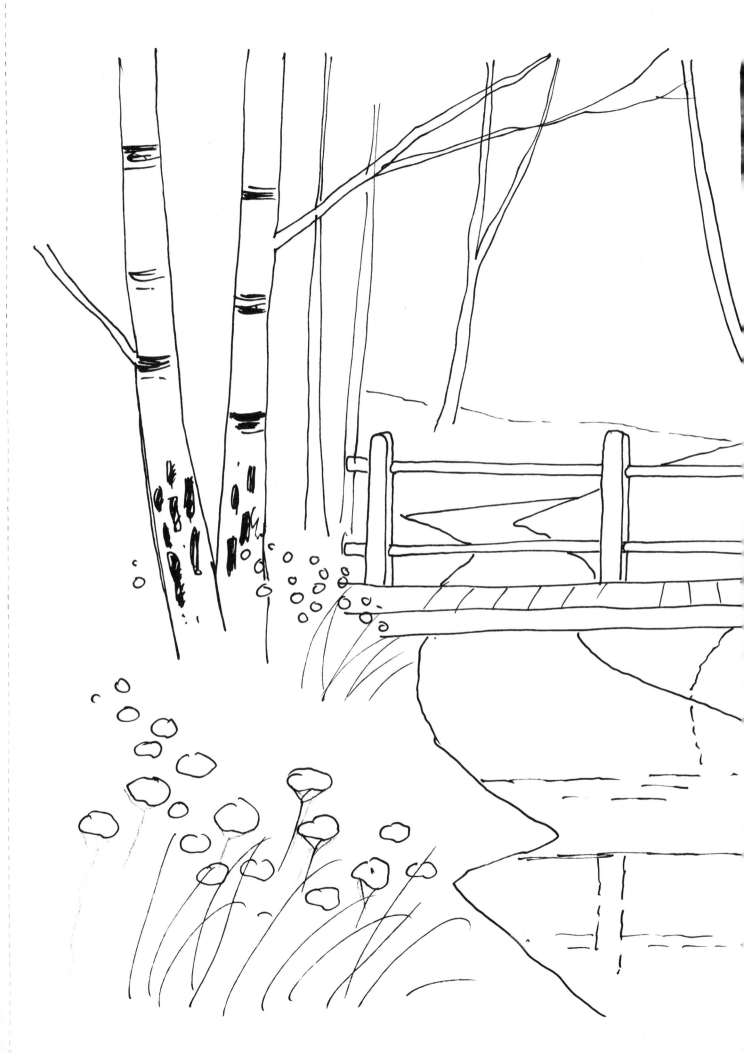

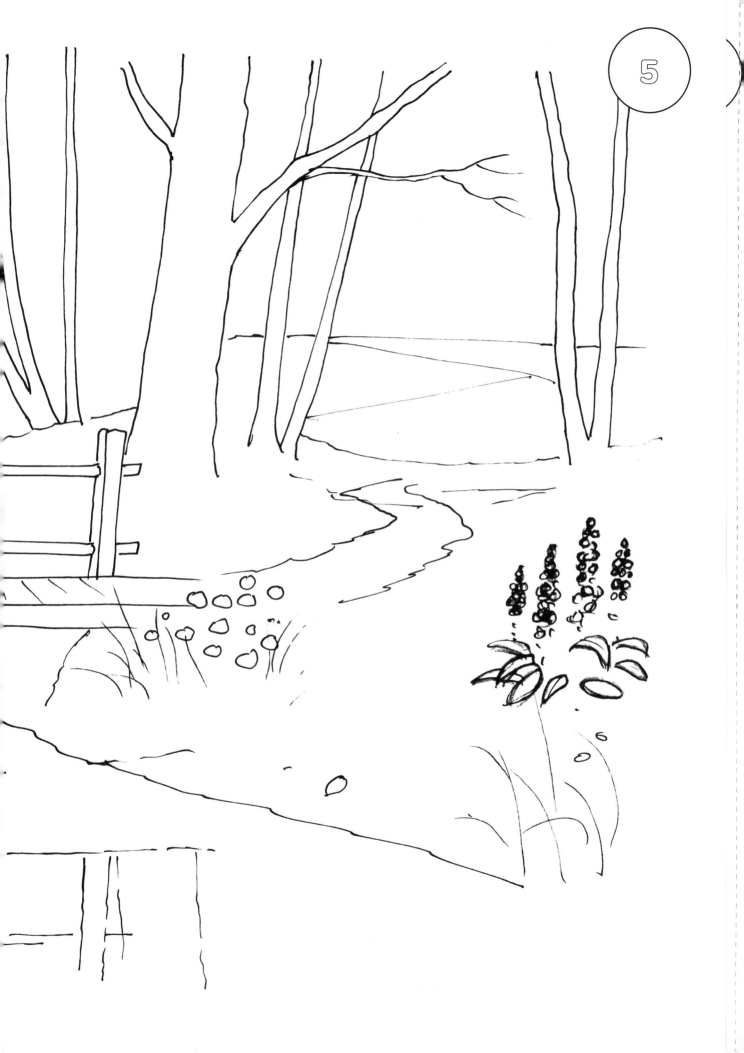

Snow Tracks

OUTLINE 7

YOU WILL NEED
......................

300gsm (140lb) Rough watercolour paper

Colours: ultramarine, burnt umber, burnt sienna, shadow, cobalt blue

Brushes: golden leaf, large detail, medium detail, foliage brush, half-rigger, fan gogh (fan brush)

Masking fluid, masking brush and ruling pen

Kitchen paper

Paper mask

Masking fluid is the perfect medium to use when painting snow scenes, but take care when applying it, as it dries very quickly and can ruin your brushes. Use a synthetic brush for masking fluid and coat it in soap before use; then it will wash off when you have finished.

The dusting of snow on the trees is achieved using a pad of kitchen paper, as shown on page 72. Practise this before starting the painting, and if it is not quite right, wait for it to dry, rub it off, then start again.

1 Apply masking fluid to the fence, the tracks in the snow and some of the branches with a brush, then use a ruling pen to apply it to other, finer branches. Pick up some masking fluid on scrunched up kitchen paper and apply this for snow in the tree tops.

2 Wet the sky area with the golden leaf brush and clean water, being careful not to go over the roof lines, then drop in ultramarine. While this is wet, add clouds with ultramarine and burnt umber. Go over the masked tree area. Allow to dry.

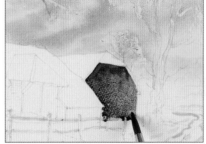

3 Paint the top of the gable end of the barn with the large detail brush and a strong, dark mix of ultramarine and burnt umber, then while this is wet, paint a pale, browner mix lower down.

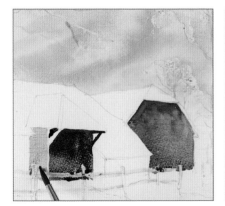

4 Paint the barn door with the same mix, then drop in the darker version at the top. Make a pale mix of ultramarine and burnt umber and use the medium detail brush to paint the side of the porch.

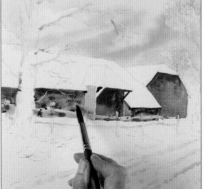

5 Paint the redder parts of the barn with burnt sienna, then drop in shadow colour wet into wet.

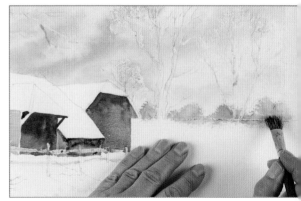

6 Use a paper mask to mask the horizon and use the foliage brush to stipple distant trees and bushes with cobalt blue and shadow colour.

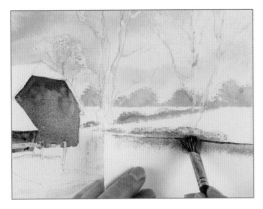

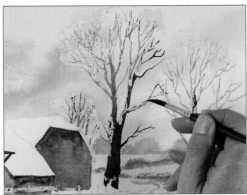

7 Place the paper mask at various angles as you come forwards and paint the hedgerows with a stronger mix of the same colours, adding burnt umber for warmth.

8 Use the medium detail brush and a dark mix of burnt umber and ultramarine to paint the trunks and branches of the trees, going over the masking fluid in places.

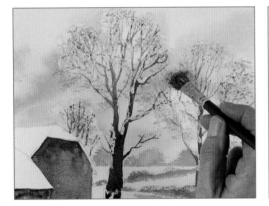

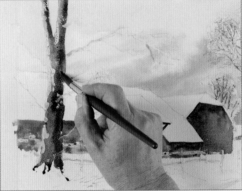

9 Make a fairly blue mix of ultramarine and burnt umber and lightly stipple winter foliage over the masking fluid using the foliage brush.

10 Paint the trunk of the large tree on the left with the large detail brush and a pale mix of burnt umber and ultramarine, then while this is wet, drop in a darker mix on the right to create a three-dimensional look.

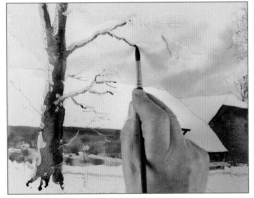

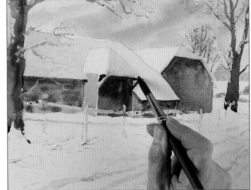

11 Use the medium detail brush and the dark mix to paint the branches under the masked-out snow.

12 Paint a wash of cobalt blue over the shadowed parts of the snowy roofs with the large detail brush. Make the gable end triangles a slightly stronger blue.

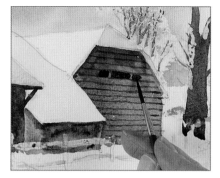

13 Use a half-rigger and a mix of ultramarine and burnt umber to paint the barn's planking, adding dark shapes to suggest broken planks.

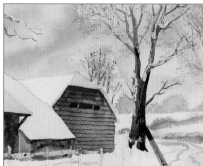

14 Give form to the tree to the right of the barn by adding shadow with the medium detail brush and ultramarine and burnt umber.

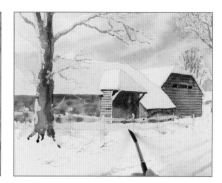

15 Paint a wash of cobalt blue on the snow in front of the barn, over the masking fluid, indicating the shape of the snow and the land.

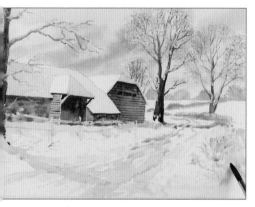

16 Mix pale cobalt blue with a touch of burnt sienna and paint the shadows in the tracks in the snow, then with cobalt blue, paint shadows from the trees across the path, and in the undergrowth on the right.

17 Paint the fence posts with ultramarine and burnt umber, starting with the uprights and then painting the horizontal bars under the masking fluid.

18 Use the fan gogh brush with burnt umber to flick up the grasses showing through the snow.

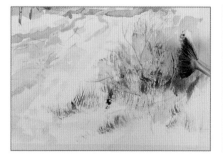

19 Add grasses and texture on the right-hand side of the painting, holding the fan gogh brush vertically to suggest dried seed heads.

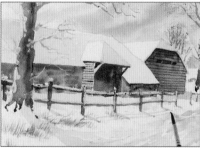

20 Use the medium detail brush and cobalt blue to paint the shadows of the fence posts.

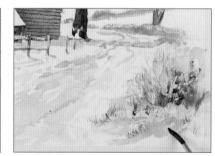

21 Add texture in the undergrowth on the right with a darker wash of cobalt blue.

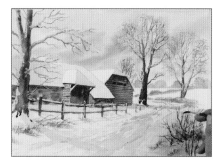

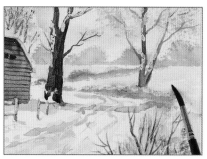

22 Paint more branches and twigs in the tree on the left with the half-rigger and ultramarine and burnt umber, then paint twigs in the undergrowth on the right in the same way.

23 Change to the medium detail brush and paint a pale wash of cobalt blue in the distant fields.

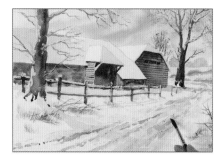

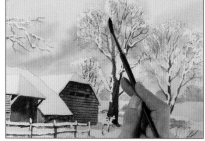

24 Mix cobalt blue with burnt sienna and paint stronger shadows in the tracks in the snow. Allow to dry.

25 Remove the masking fluid. Use the large detail brush to paint a wash of cobalt blue over the snow in the trees, leaving white at the top.

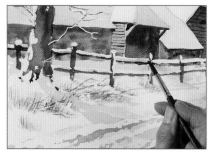

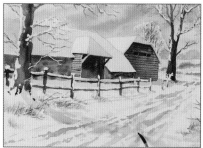

26 Shade under the snow on the fence in the same way.

27 Continue the shadow of the tree across the foreground.

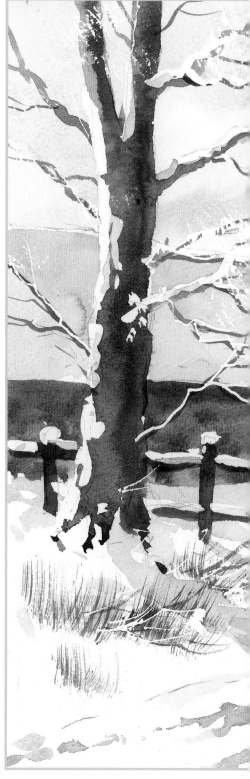

The finished painting.

76

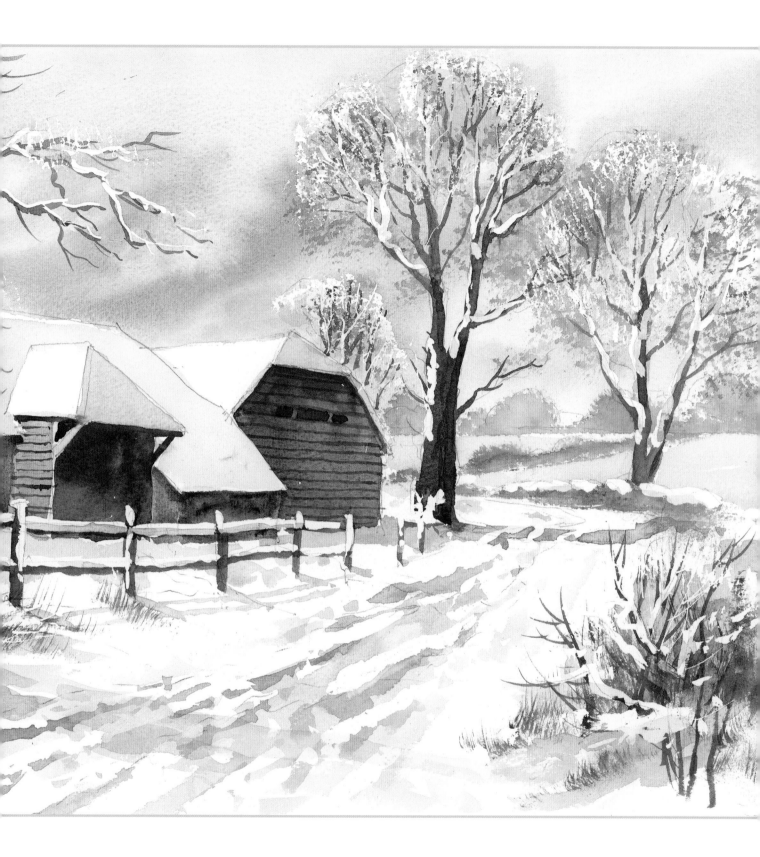

Village in the Snow

I have chosen to paint this snow scene at sunset. The reason for this is that I am not a fan of cold, moody paintings. I much prefer warm, friendly and inviting subjects. The post box adds a splash of strong colour in the foreground, emphasizing the warm colour range of the scene.

YOU WILL NEED

300gsm (140lb) Rough watercolour paper

Colours: cadmium yellow, permanent rose, cadmium red, cobalt blue, shadow, cadmium yellow, alizarin crimson, burnt sienna, burnt umber, ultramarine, midnight green, country olive

Brushes: golden leaf, medium detail, small detail, fan stippler, half-rigger

Masking tape

Masking fluid, masking brush and ruling pen

Small round coin

Kitchen paper

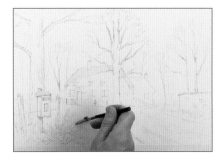

1 Transfer the image on to watercolour paper and mask off the edges with masking tape. Use masking fluid on a brush to mask the roof and branches, the top of the post box and the wall. Then use a ruling pen to mask the grasses and wire.

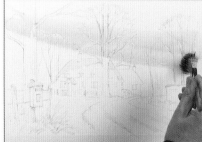

2 Wet the sky area with the golden leaf brush and clean water. Then paint on a wash of cadmium yellow with a touch of permanent rose.

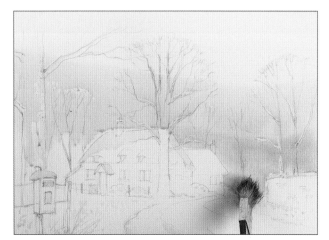

3 Add cadmium red, working wet into wet.

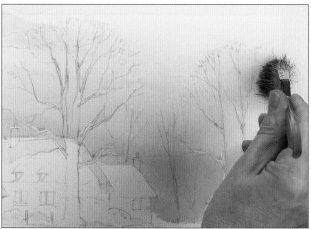

4 Paint a very pale wash of cadmium red wet into wet across the middle of the sky.

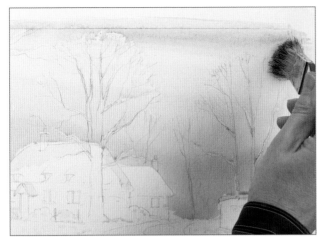

5 Still working quickly wet in wet, paint a wash of cobalt blue across the top of the sky.

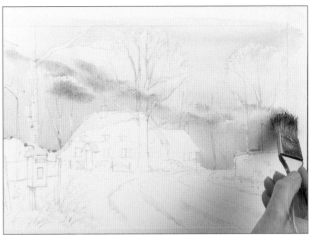

6 While the paint is wet, drop in the colour shadow to create clouds.

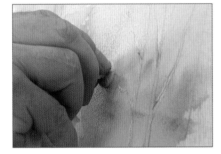

7 Wrap a small coin in kitchen paper as shown and press it against the paper where you want the sun to be.

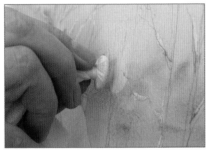

8 Lift the wrapped coin to reveal a pale sun.

9 Make a very pale wash of permanent rose and cadmium yellow and paint the sky colours reflected in the snow.

10 Touch in shadows wet into wet with a mix of cobalt blue and a little alizarin crimson.

11 Still using the golden leaf brush, lightly stipple a little burnt sienna to suggest brown undergrowth. Allow to dry.

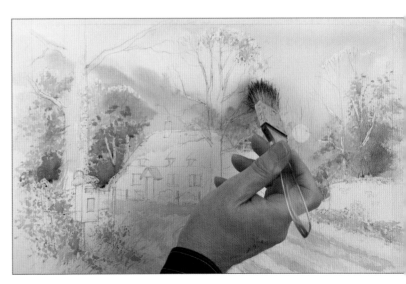

12 Use a pale mix of the colour shadow to touch in foliage in the treetops. Allow to dry.

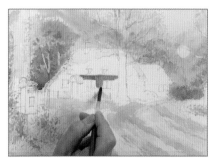

13 Paint the face of the cottage with the medium detail brush and burnt sienna.

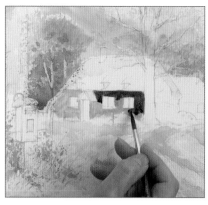

14 Drop in the colour shadow wet into wet.

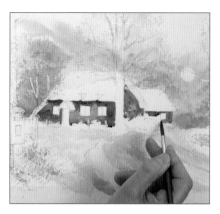

15 Use a mix of burnt umber and shadow to paint the darker side of the cottage.

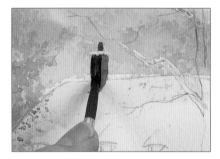

16 Paint the chimney pot with burnt umber and shadow and allow it to dry. Then paint the shaded side with a stronger mix of the same colours.

17 Paint the lit windows with a thin mix of cadmium yellow.

18 Paint in the architectural details with the small detail brush and ultramarine and burnt umber.

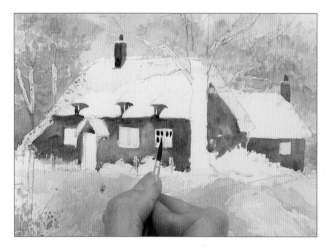

19 Use the same brush and mix to paint the dark windows.

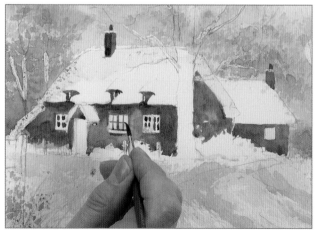

20 Paint in the frames of the light windows.

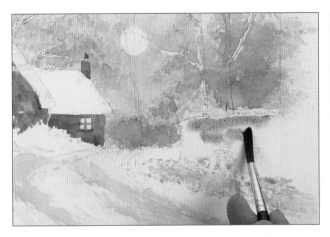

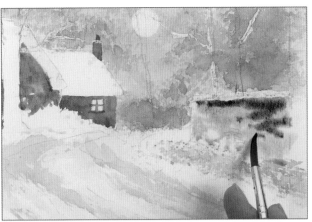

21 Wet the wall with clean water and use the medium detail brush to paint on a wash of burnt sienna.

22 Drop in shadow colour wet into wet.

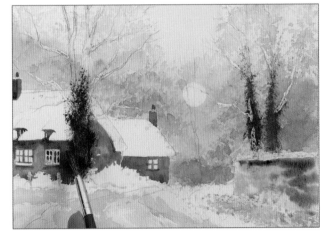

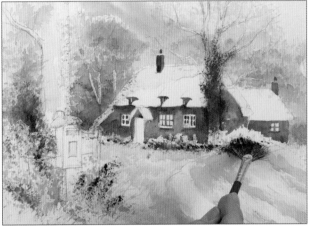

23 Use the fan stippler and midnight green with a touch of burnt umber to stipple ivy climbing the two main trees.

24 Use the same brush and Hooker's green to add greenery around the post box and in front of the cottage.

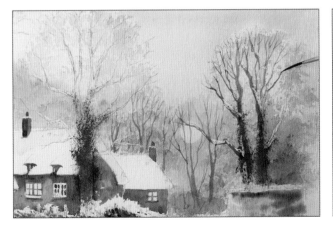

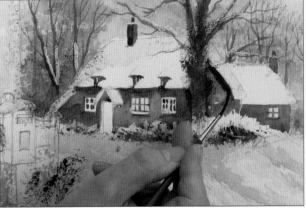

25 Use the half-rigger and a mix of burnt sienna and shadow to paint the distant trees. The twigs bring together the foliage effect and fool the eye into seeing a fine lacework of branches and twigs.

26 Paint a dark shadow under the eaves with a stronger mix of the same colours.

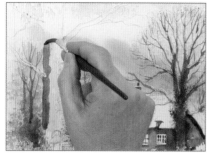

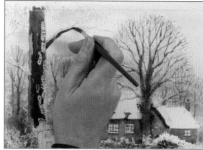

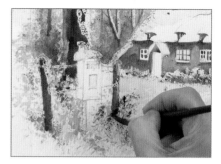

27 Change to the medium detail brush and paint cobalt blue down the shadowed side of the tree to the left of the cottage.

28 Paint the rest of the tree trunk and branches beneath the masking fluid snow with a mix of burnt umber and country olive.

29 Use the same colour to paint the posts.

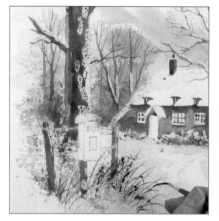

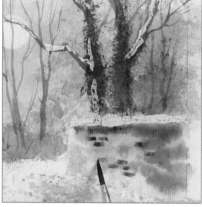

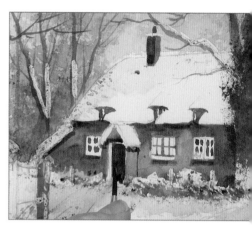

30 Paint dark blade of grass among the masked grasses using the half-rigger and burnt umber.

31 Paint bricks in the wall with the small detail brush and burnt sienna paint.

32 Paint the door of the cottage and under the windowsills with burnt umber and shadow.

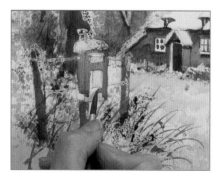

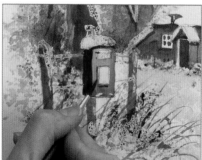

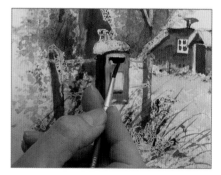

33 Change to the medium detail brush and paint the post box with cadmium red. Allow it to dry.

34 Use the small detail brush and shadow mixed with cadmium red to paint the shaded side, the shadow under the snow and the details.

35 Paint the dark inside of the post box with ultramarine and burnt umber.

36 Paint a pale wash of shadow colour across the foreground. This prevents the eye from drifting off the bottom of the picture. Allow the painting to dry.

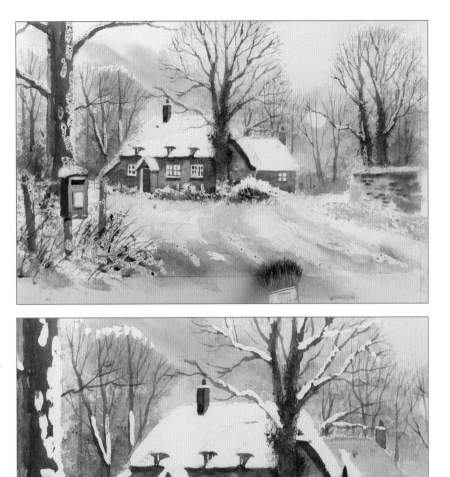

37 Rub off all the masking fluid with clean fingers. Paint the shadowed part of the snowy roof with shadow and cobalt blue and the medium detail brush.

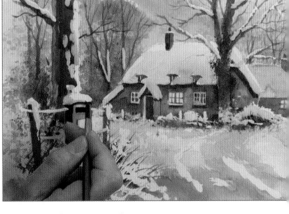

38 Make a lighter mix of the same colour and paint the front-facing roof.

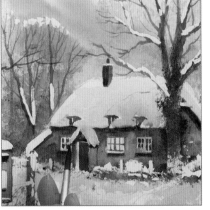

39 Paint the same thin wash over the white of the window frames.

40 Use the same wash to create shadows in the snow and to shade the underside of the snow on the wall, post box and trees.

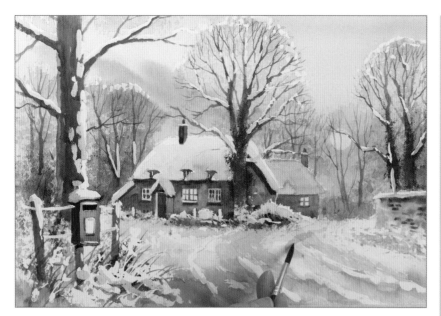

41 Add tracks on the path with a mix of cobalt blue and shadow and the medium detail brush.

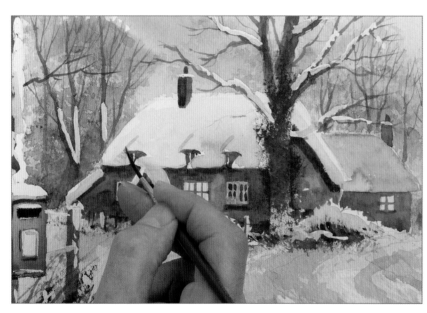

42 Mix burnt umber and shadow to paint the fence and the dormer windows with the half-rigger.

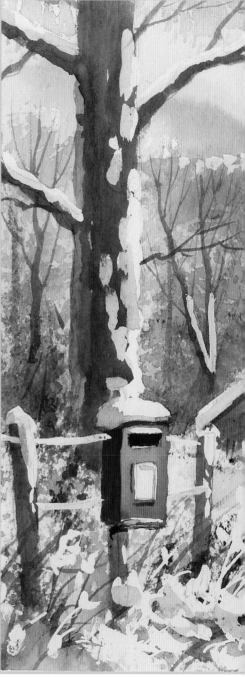

The finished painting.

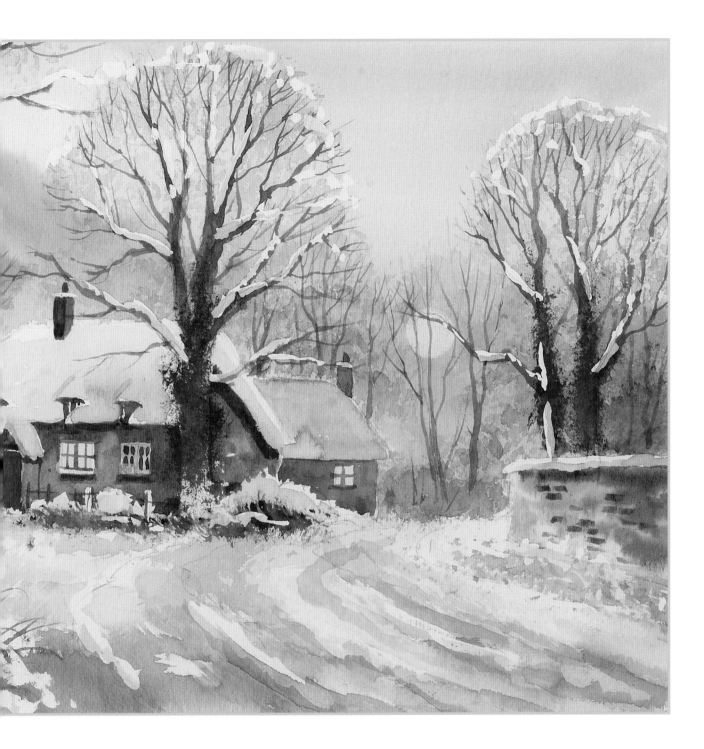

Barn in the Snow

OUTLINE

9

This is a good example of a type of barn found in Hampshire or Surrey in the south of England. Remember to keep the dark areas dark, and the snow areas very pale and light; it is the contrast that helps to give this painting its impact. The warm colours of the sunlit barn also contrast with the cooler colours of the surrounding landscape.

YOU WILL NEED

300gsm (140lb) Rough watercolour paper

Colours: ultramarine, burnt umber, raw sienna, burnt sienna, ultramarine violet, green gold, cobalt blue

Brushes: large squirrel mop, no. 12 round, 10mm (⅜in) one-stroke, no. 8 round, fan brush, rigger

Masking fluid, masking brush and ruling pen

Magazine paper

1 Transfer the image on to watercolour paper. Apply masking fluid with the brush wherever the snow lies: the top of the fence, the tree-tops and the cart tracks. Allow to dry.

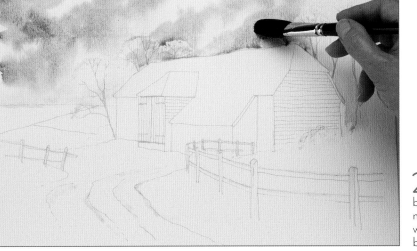

2 Use the large squirrel mop brush to paint clean water over the sky area, being careful to paint round the barn, not over it. Brush ultramarine into the wet area. Drop a mix of ultramarine and burnt umber into the sky, wet into wet.

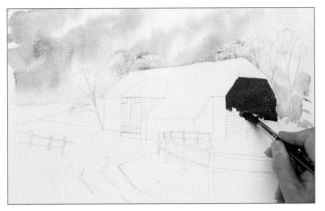

3 Change to the no. 12 round brush and paint the end of the barn with a dark mix of burnt umber and ultramarine.

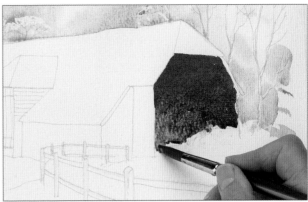

4 Drop in raw sienna at the bottom of the dark area. This will spread into the darker brown and create texture.

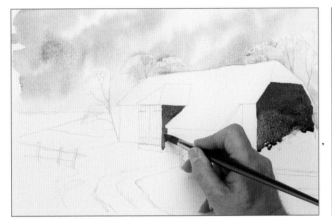

5 Use the same brush and mix for the shaded side of the porch.

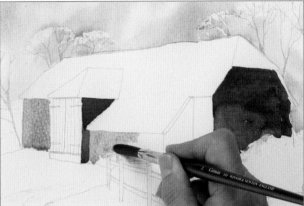

6 Paint burnt sienna on to the lit sides of the barn.

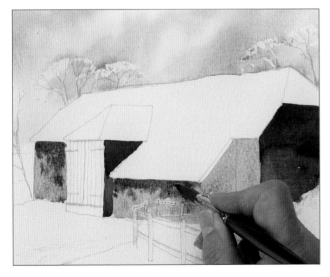

7 The burnt sienna will look too bright, so while it is still wet, drop in a mix of raw sienna and ultramarine violet under the eaves.

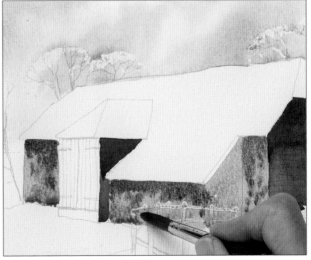

8 Drop in green gold lower down and let it bleed up into the first colour for a rustic look.

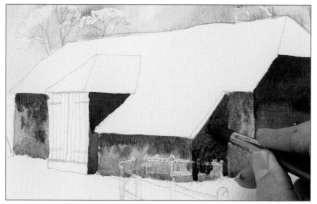

9 Make a dark mix of burnt sienna and ultramarine violet for the shadowed side of the lean-to.

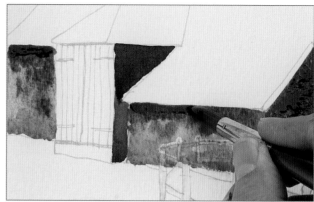

10 Run a line of the same colour along the eaves to add shadow.

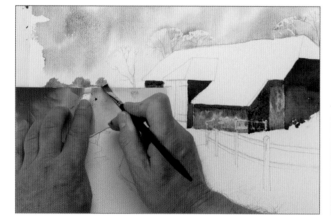

11 Use a paper mask to create distant hedgerows. Take a piece of paper from a magazine and use the straight edge to mask a line along the horizon. Use the one-stroke brush with a mix of ultramarine violet and cobalt blue to stipple and dab paint over the mask to create a distant hedgerow.

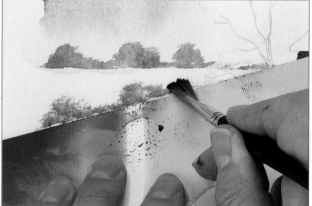

12 Add a touch of burnt sienna to the mix, move the paper mask at an angle and create a slightly warmer looking hedgerow coming forwards.

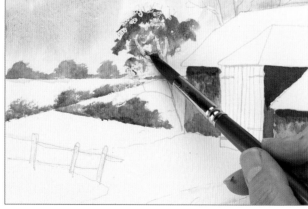

13 Mix ultramarine and burnt umber with ultramarine violet and use the no. 12 brush and the dry brush technique to paint the tree to the left of the barn.

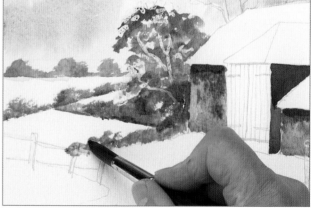

14 Continue painting in the same way along the hedgerow.

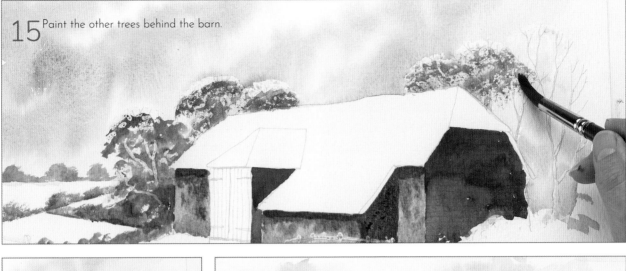

15 Paint the other trees behind the barn.

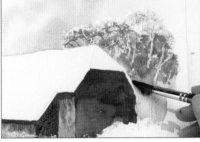

16 Lower down the right-hand tree, add burnt sienna to the mix to warm it.

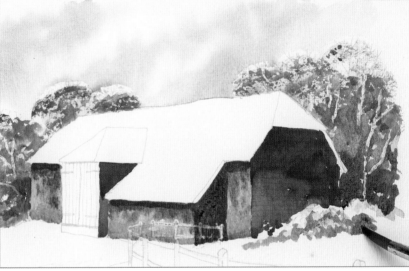

17 Mix burnt umber and ultramarine with a little ultramarine violet to paint undergrowth, leaving the white of the paper to suggest some snow on top.

18 Paint the barn door with the no. 8 round brush and a thin mix of ultramarine and burnt umber. While this is wet, run a stronger mix under the roof and down into the first colour.

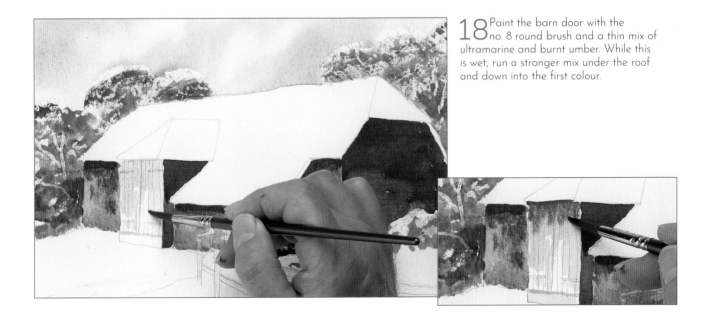

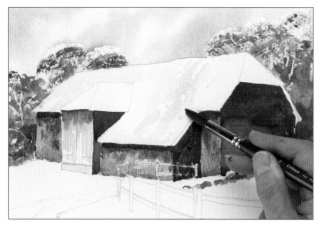

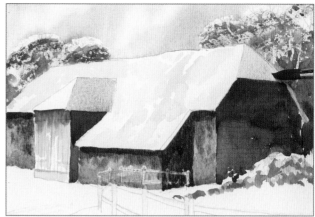

19 Use the no. 12 brush to paint the snow on the roof with a pale wash of cobalt blue. Paint round the porch roof and leave white patches.

20 Paint the side of the porch roof with cobalt blue and a touch of ultramarine violet. Paint the gable end on the far right of the barn in the same way.

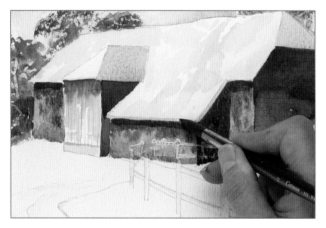

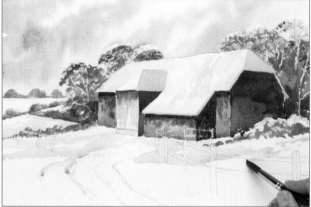

21 Paint the same colour along the underside of the snow on the roof.

22 Paint a thin wash of cobalt blue over the snowy foreground, going over the masked fence.

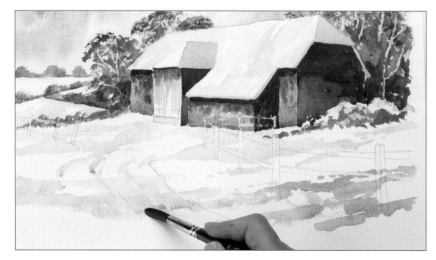

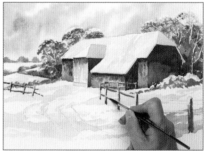

24 Use the no. 8 round brush and a mix of ultramarine and burnt umber to run dark paint under the masking fluid on the fence, creating shadow.

23 Paint a stronger mix of cobalt blue and ultramarine violet in the foreground. Create a broken wash of this mix across the bottom of the painting.

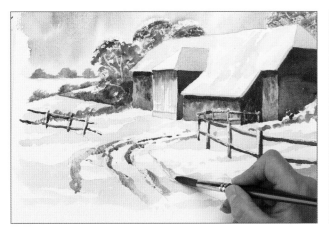

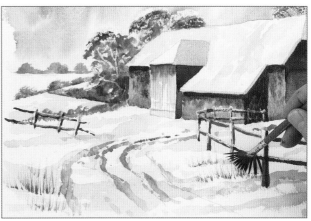

25 Paint the tracks in the snow on the path with the no. 12 round and a mix of ultramarine violet and burnt sienna.

26 Use the fan brush and burnt umber to flick up grasses on either side of the path.

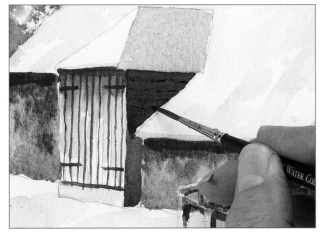

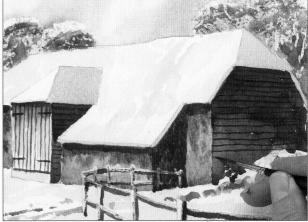

27 Paint the details on the barn door with the rigger brush and a dark mix of ultramarine and burnt umber. Add the panels of the weatherboarding at the side of the porch.

28 Paint the weatherboarding on the right-hand wall in the same way.

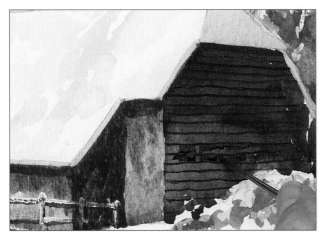

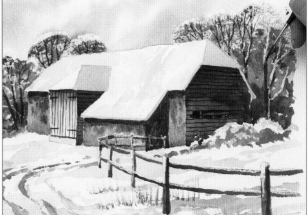

29 Still using the rigger and the ultramarine and burnt umber mix, add some broken boards in the wall that are not shown in the outline.

30 Using the same brush and mix, paint in shaded parts of the tree trunks and branches.

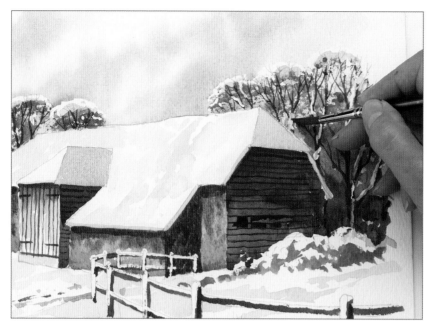

31 Remove the masking fluid with clean fingers. Make a thin wash of cobalt blue and touch it into the underside of the snow on the trees with the no. 8 round brush.

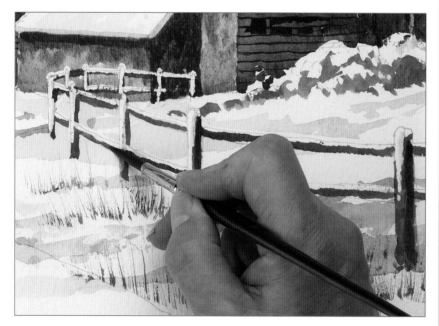

32 Add the same blue wash to the underside of the snow on the fence to give it form.

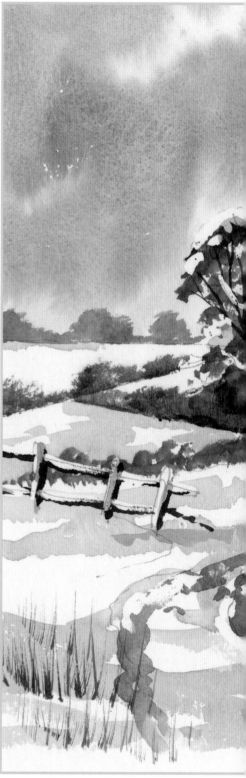

The finished painting.

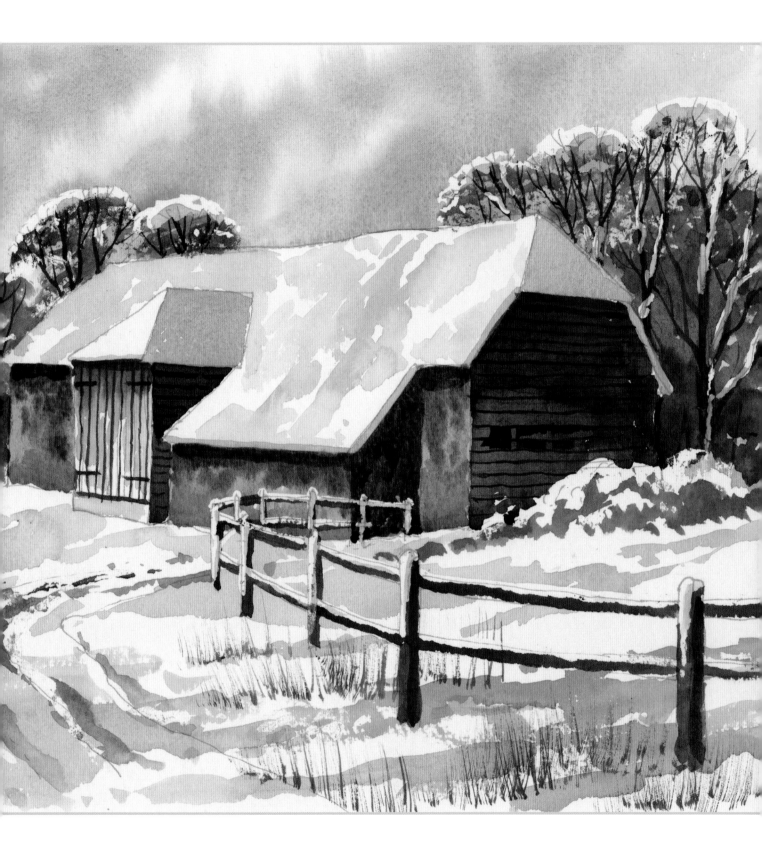

Buildings

In this section you will paint a variety of buildings from a stone castle to a rustic chicken barn, plus two doors, one rustic and one elegant, with lots of masked detail. You will learn how the wet into wet technique creates texture for buildings and how detail can be added wet on dry.

Wet into wet texture

Allowing your colours to mix and merge together on your painting rather than in your palette can create a rustic-looking building. The washes are mixed wet into wet and allowed to dry with an uneven, mottled look.

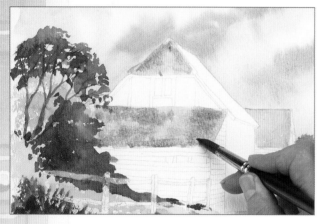

1 Paint the roofs facing the viewer with a pale wash of burnt sienna. Drop in ultramarine violet wet into wet to create texture.

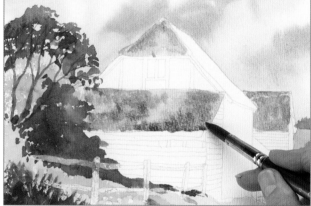

2 While the wash is wet, drop in olive green to give the roof a mossy look.

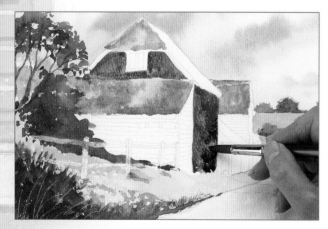

3 Paint the brickwork of the barn with burnt sienna and burnt umber, then while this is wet, mix in ultramarine and drop this into the side wall.

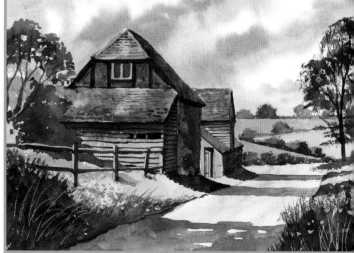

The finished painting.

94

Painting a rustic stone wall

Paint the background and allow it to dry. Stipple on texture using the foliage brush, then paint in a dark shadow under each stone using the half-rigger.

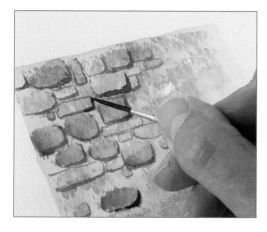

Painting a detailed brick wall

To make the bricks appear three-dimensional, paint a thin, dark shadow on the underside of each brick.

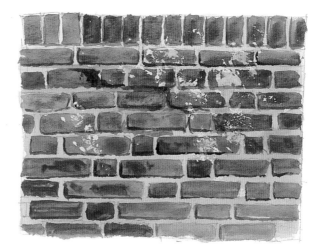

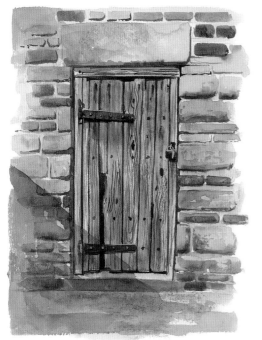

A rustic door

When you look at some doors, you can tell straight away that they are ancient. They might be an original feature of the building, and how nice it is to see these have not been replaced with a modern alternative. To make this door look weathered and old, I have made the top and bottom uneven, removed some of the wood panels to reveal the dark gap and painted the door panels with an uneven, knotted texture. Using the wizard brush creates the wood grain effect. The top hinge was painted at a slight angle with rust stains around the metalwork.

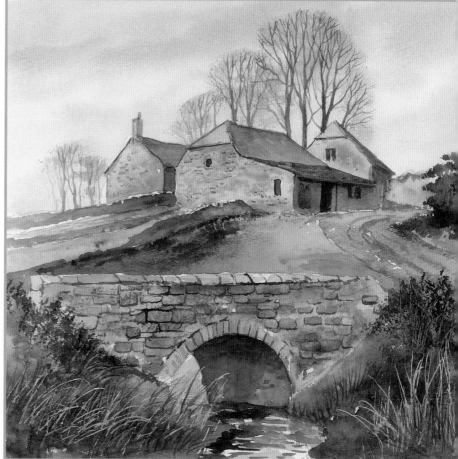

Country Bridge

This scene features wet into wet techniques in the rusty roof as well as the suggested texture of stonework in the middle distant buildings. The foreground bridge has more detailed stonework.

Summer Doorway

OUTLINE

The beauty of this subject is in the vibrant colours and warm sunlight, reminiscent of hot summer days. This is a simple scene with a strong, bright feel about it. The door and stonework have a rustic look.

YOU WILL NEED

300gsm (140lb) Rough watercolour paper

Colours: raw sienna, burnt sienna, burnt umber, shadow, sunlit green, country olive, midnight green, cobalt blue, ultramarine, permanent rose, cadmium red

Brushes: golden leaf, medium detail, large detail, foliage, half-rigger

Masking tape

Masking fluid, masking brush and ruling pen

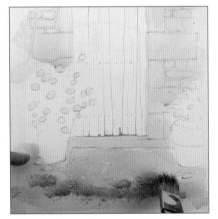

1 Transfer the image from the outline on to watercolour paper. Apply masking tape to the edges. Mask off the flowers using masking fluid. Paint over the stonework with the golden leaf brush and a pale wash of raw sienna.

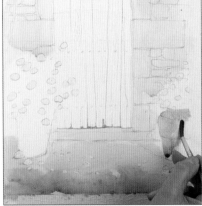

2 While the paint is still wet, dab into it with a stronger mix of raw sienna with a touch of burnt sienna, to create a mottled effect.

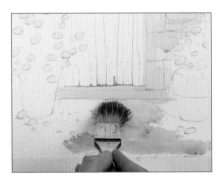

3 Paint the gravel with raw sienna and a touch of burnt umber.

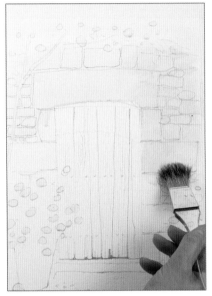

4 Mix burnt sienna and burnt umber and stipple the lower half of the gravel, working wet into wet.

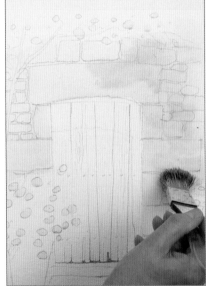

5 Use the medium detail brush to paint a pale wash of burnt sienna on the right-hand plant pot.

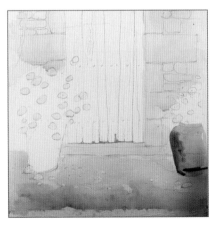

6 Shade the left-hand side of the pot wet into wet with shadow.

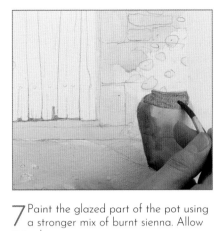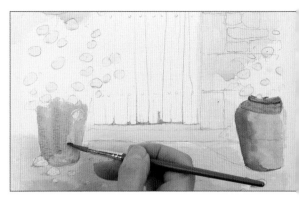

7 Paint the glazed part of the pot using a stronger mix of burnt sienna. Allow it to dry.

8 Paint shadow colour under the rim of the pot.

9 Paint the second pot with a stronger mix of burnt sienna than the first, still using the medium detail brush.

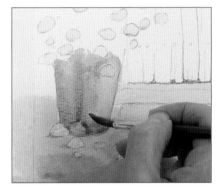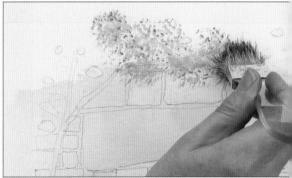

10 Drop raw sienna into the sunlit side of the pot, wet into wet. This will push the other colour away, creating an interesting textural effect.

11 Drop shadow colour into the left hand side of the pot, still working wet into wet.

12 Begin creating the foliage on the climbing plant by stippling on sunlit green paint with the golden leaf brush.

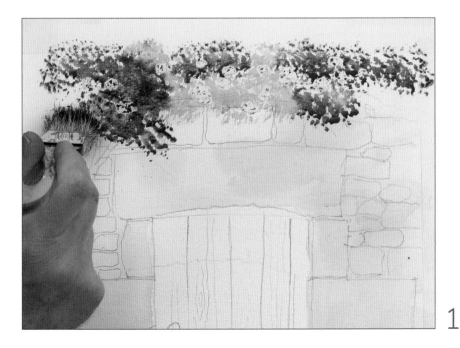

13 Continue stippling on foliage wet into wet, adding country olive.

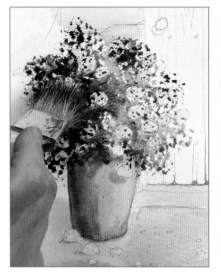

14 Paint the foliage in the pots in the same way, starting with sunlit green on the right-hand side, then adding midnight green on the left.

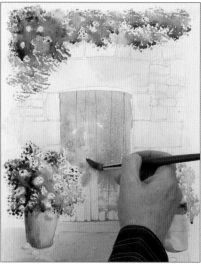

15 Use the large detail brush to apply a cobalt blue wash to the door. Paint roughly to suggest an old, rustic door.

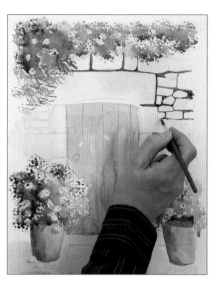

16 Change to the medium detail brush and paint the outlines of the stones with a mix of burnt sienna and shadow.

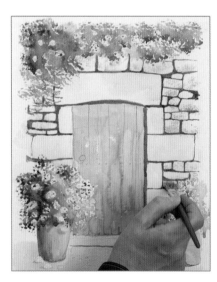

17 Use the foliage brush to stipple texture on to the stonework with burnt sienna.

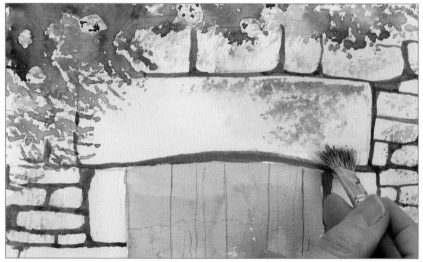

18 Stipple texture on to the large stone above the door in the same way with the colour shadow.

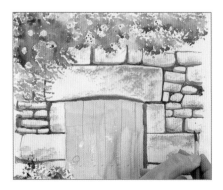

19 Still using the colour shadow, shade the undersides and left-hand sides of the stones.

20 Mask off the ground in front of the doorstep and stipple texture on to the riser of the step.

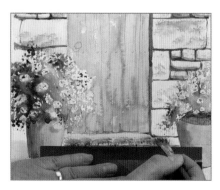

21 Paint in the stem of the vine with the medium detail brush and a strong mix of country olive and burnt umber.

22 Add detail to the pot plants with a few brushstrokes for the outer leaves, using the medium detail brush and country olive.

23 Use the foliage brush and burnt sienna to stipple texture on to the gravel.

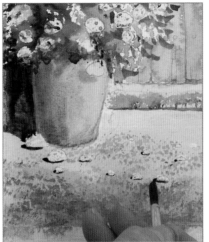

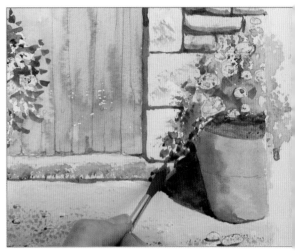

24 Add a deep shadow behind the left-hand pot using the medium detail brush and shadow mixed with burnt sienna.

25 Use the same mix and the tip of the brush to paint shadows under the stones.

26 Paint a shadow to the left of the right-hand pot.

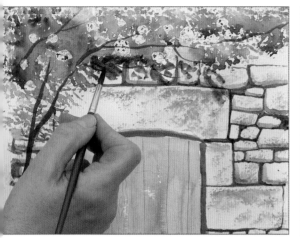

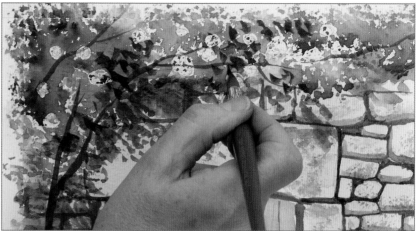

27 Paint shadows under the vine, reflecting the shapes of the foliage.

28 Use the large detail brush to add leaf shapes to the foliage on the vine with midnight green.

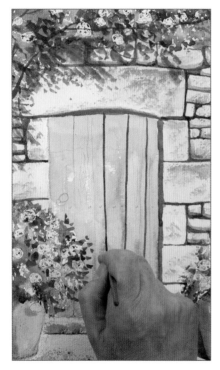

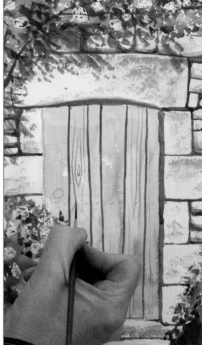

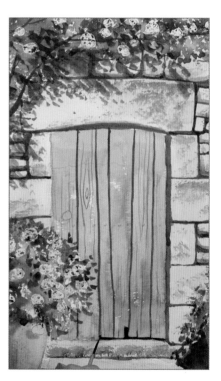

29 Paint in the panels on the door using the half-rigger and shadow mixed with cobalt blue.

30 Use a pale mix of shadow to paint the grain of the wood.

31 Mix ultramarine and burnt umber to paint the dark details at the bottom of the door.

32 Use the cobalt blue and shadow mix with the large detail brush to paint the shadow on the door.

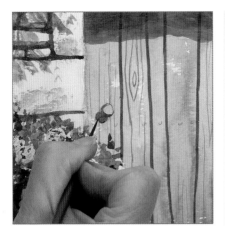

33 Use the same colour and the half-rigger to paint the doorknob.

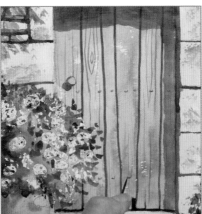

34 Paint in rows of rivets.

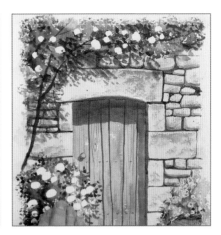

35 When the painting is dry, rub off all the masking fluid with clean fingers.

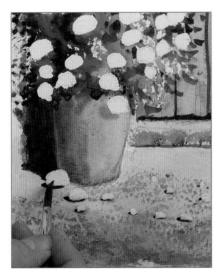

36 Paint a light wash of raw sienna over the stones with the medium detail brush.

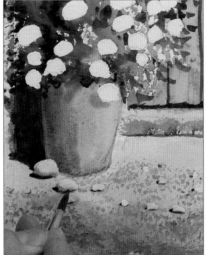

37 Drop in shade on the bottom and left-hand sides of the stones using a stronger mix of raw sienna and burnt sienna.

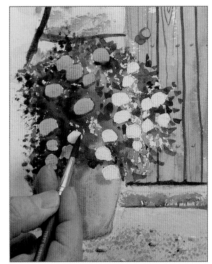

38 Paint a pale wash of permanent rose over the flowers using the medium detail brush and allow it to dry.

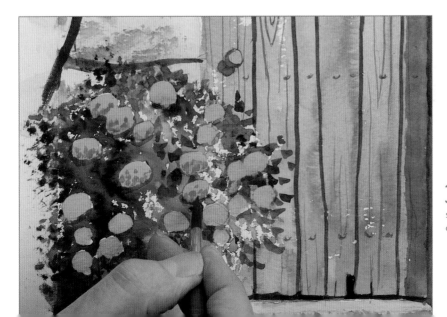

39 Make a stronger mix of permanent rose and, painting wet on dry, add shade and texture on the bottom halves of the flower heads.

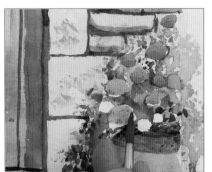

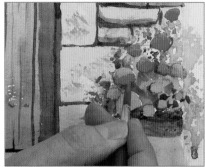

40 Paint a light wash of cadmium red over the flowers in the right-hand pot.

41 Drop in a stronger mix at the bottom, wet into wet this time.

42 Paint a light wash of permanent rose over the flowers of the climbing plant, using the medium detail brush.

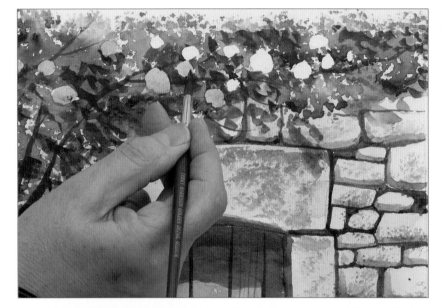

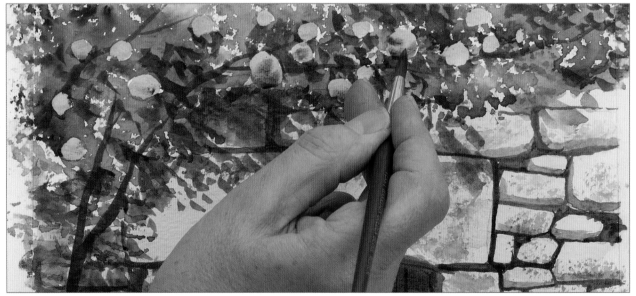

43 Drop in a mix of cobalt blue and permanent rose wet into wet on the lower parts of the flowers.

Opposite
The finished painting.

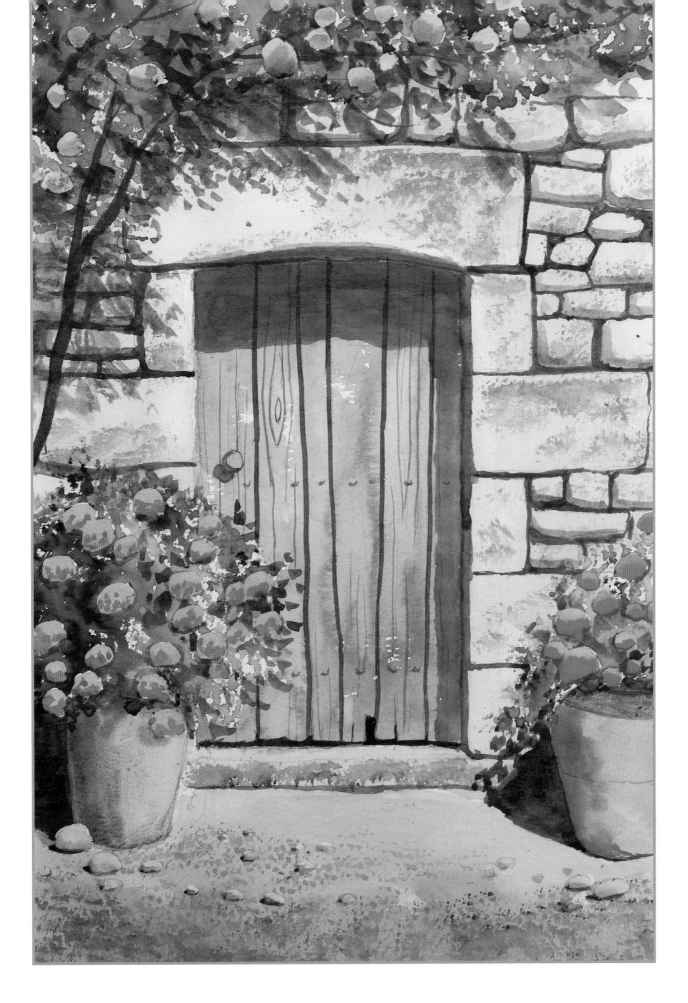

Dunguaire Castle

OUTLINE
11

Dunguaire Castle must be the most photographed castle in Ireland. This 16th-century tower house is situated on the south-east shore of Galway Bay near Kinvara. I have used the tower as a focal point which is just off-centre in the painting. The castle is surrounded on three sides by water, which is a great excuse to use reflections in the foreground.

Tip

To scrape out the rocks on the moat shoreline, use either the clear acrylic resin handle of your paintbrush, or the corner of a plastic card.

YOU WILL NEED

300gsm (140lb) Rough watercolour paper

Colours: raw sienna, ultramarine, burnt umber, Hooker's green, cobalt blue, green gold, olive green, burnt sienna, permanent rose

Brushes: large squirrel mop, no. 8 round, no. 16 round, 10mm (³⁄₈in) one-stroke, rigger, 13mm (½in) flat with clear acrylic resin handle, no. 4 round

Masking fluid, masking brush and ruling pen

Paper mask

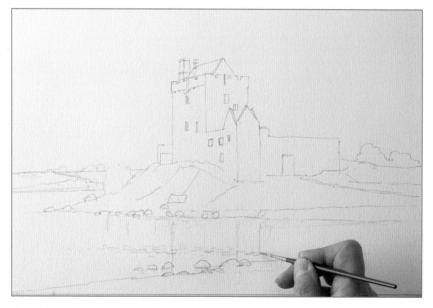

1 Transfer the scene on to watercolour paper. Mask the ripples in the water with masking fluid and a no 4. brush.

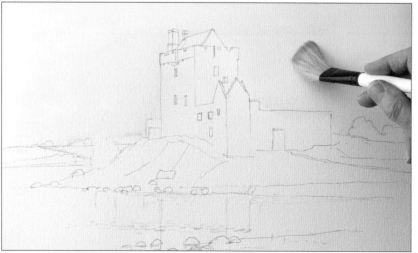

2 Wet the sky area with the large mop brush. Drop in raw sienna.

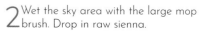

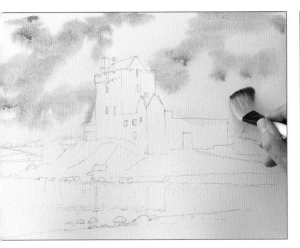

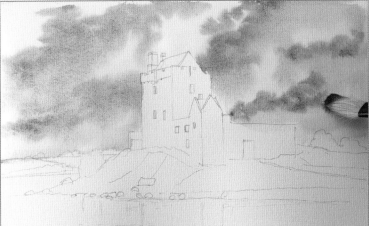

3 Paint the blue of the sky with ultramarine, leaving spaces for clouds.

4 Still working wet into wet, drop in the darker parts of the clouds with a mix of burnt umber and ultramarine. Allow to dry.

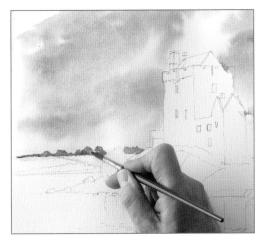

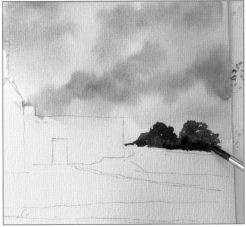

5 Paint the trees in the background with the no. 8 round and a mix of Hooker's green and cobalt blue. While this is wet, drop in green gold.

6 Paint the trees on the right with a mix of olive green and ultramarine.

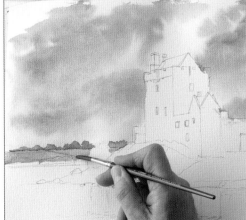

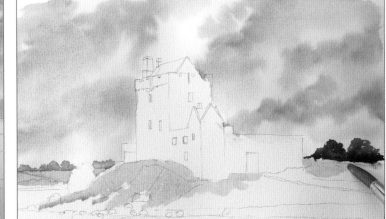

7 Paint below the trees with olive green and raw sienna.

8 Use the no. 16 round to paint the hillock with olive green and raw sienna. Continue painting the fields on the right.

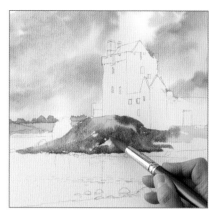

9 While the wash is still wet, drop in a mix of olive green and burnt umber.

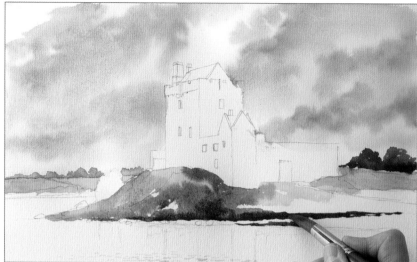

10 Still working wet into wet, mix Hooker's green and burnt umber and run this along the base of the hillock.

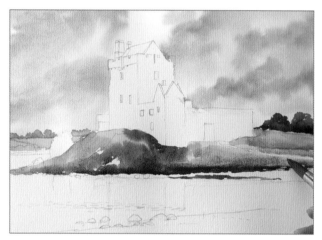

11 Paint grass on the hillock with olive green.

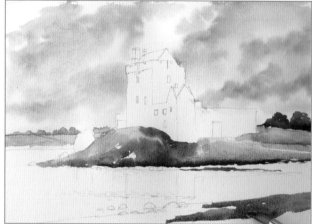

12 Paint the foreground with olive green and drop in burnt umber wet into wet.

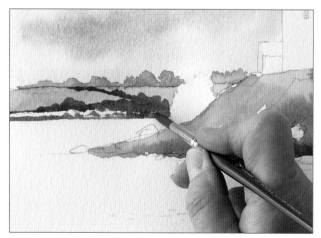

13 Use the no. 8 round to paint hedgerows in the background with olive green and ultramarine.

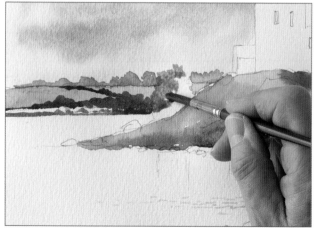

14 Paint the distant bush with green gold.

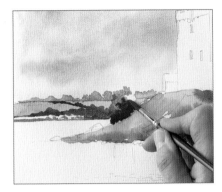

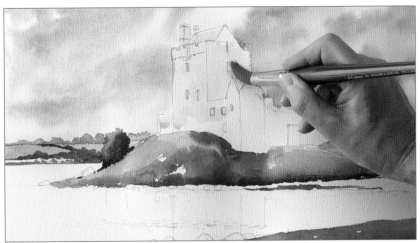

15 Paint the right-hand side of the bush with a darker mix of Hooker's green and burnt umber. Allow to dry.

16 Change to the no. 16 brush and paint a pale wash of raw sienna and burnt sienna over the castle.

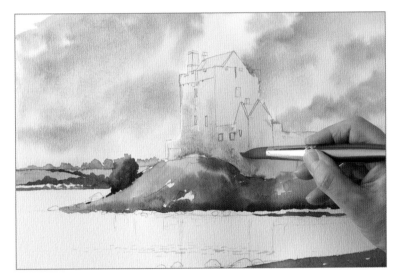

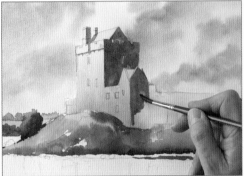

18 Change to the no. 8 brush and paint the shaded parts of the castle with ultramarine, burnt sienna and permanent rose.

17 While this wash is wet, drop in a mix of cobalt blue and burnt sienna to create texture.

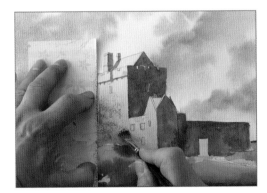

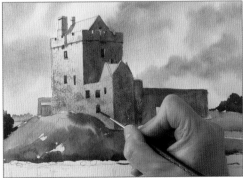

19 Pick up the same shadow mix with the 10mm (³⁄₈in) one-stroke brush. Place a paper mask with a straight edge over the sky area and stipple texture on to the castle.

20 Paint the details of the castle with the rigger brush and a mix of ultramarine and burnt umber.

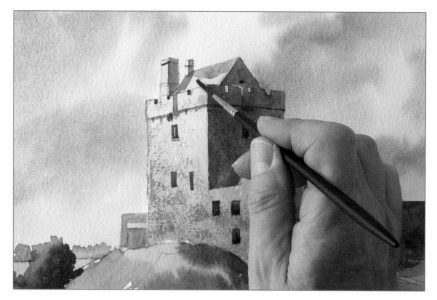

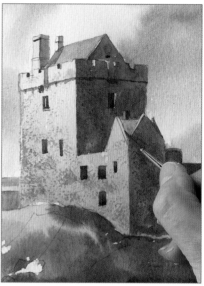

21 Darken the side of the sloping roof with a mix of cobalt blue and raw sienna.

22 Use the same mix to paint other shaded details of the castle.

23 Wet the water area with a no. 16 brush and clean water. Then paint a wash of ultramarine, starting at the bottom, with horizontal strokes. As you go further up, the water will dilute the wash and the colour will be paler.

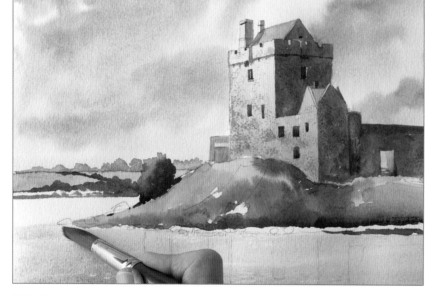

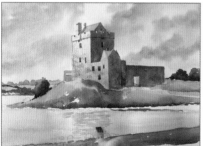

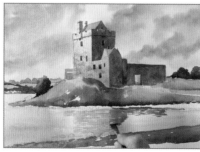

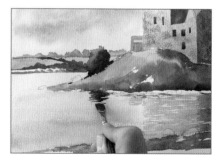

24 Mix raw sienna and cobalt blue and use the 10mm (⅜in) one-stroke brush to paint the reflection of the castle with horizontal strokes.

25 Make a darker mix of the same colours and paint the reflection of the shaded part of the castle in the same way.

26 Mix olive green and ultramarine and paint the reflection of the bush.

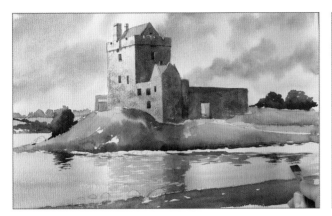

27 Paint reflections of the darker greens with Hooker's green.

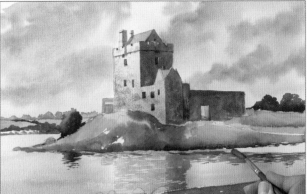

28 Use the no. 8 brush to paint a wash of raw sienna around the waterline.

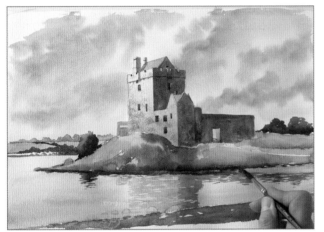

29 While the raw sienna wash is wet, drop in ultramarine and burnt umber on top.

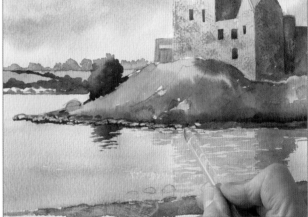

30 Use the end of the clear acrylic resin brush handle to scrape out rock shapes around the waterline.

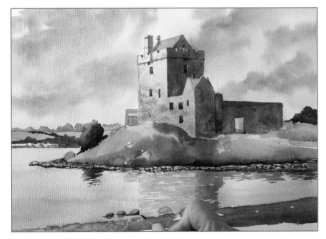

31 Paint the rocks in the foreground with the no. 4 round brush and raw sienna. Add shade and ripples with burnt umber and ultramarine.

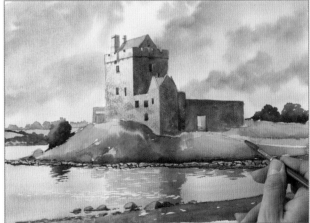

32 Use a no. 8 brush to paint raw sienna on the path leading to the castle. Allow the painting to dry naturally.

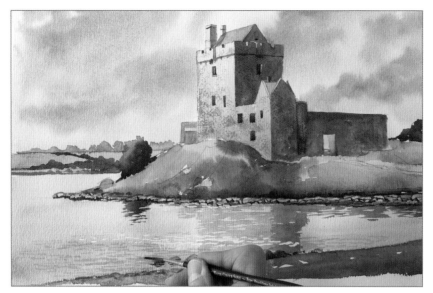

33 Rub off the masking fluid with a clean finger. Paint ripples on the foreground water with the rigger and ultramarine.

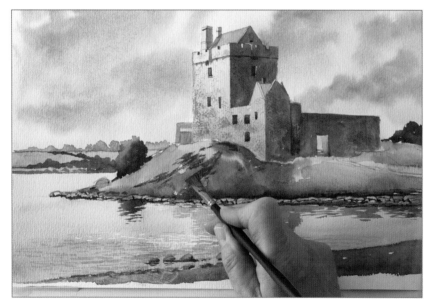

34 Use the 10mm (⅜in) one-stroke brush to paint detail on the hillock with a dry mix of burnt umber and olive green.

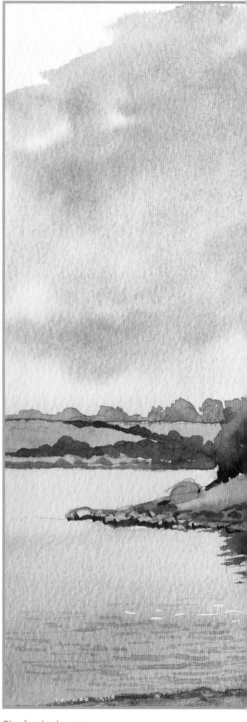

The finished painting.

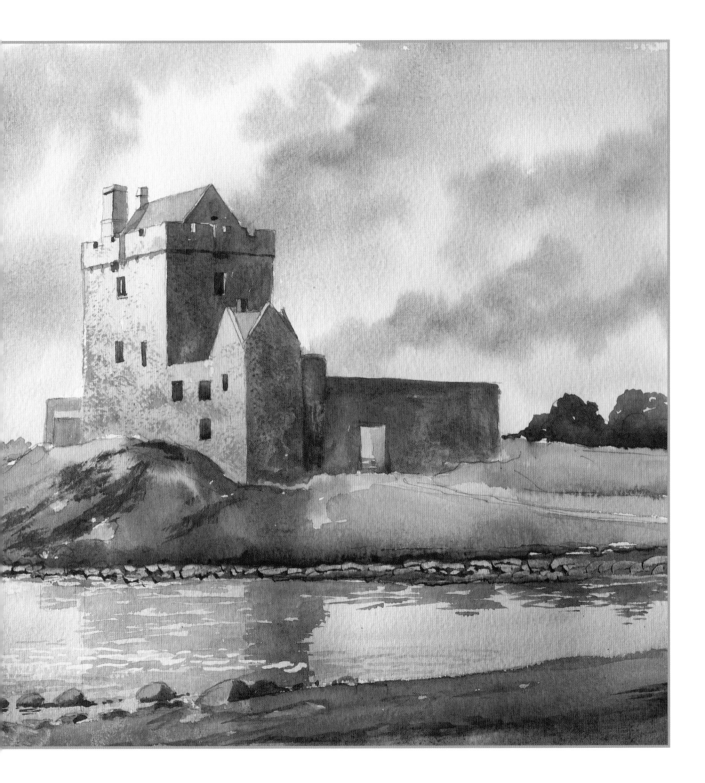

Dublin Doorway

In Dublin's fair city, where the doors are so pretty, many a true word is spoken in jest! But seriously, an outstanding feature of the Dublin streets is the many magnificent Georgian doorways, some of which are very ornate. This presents a different challenge from painting rustic buildings, with not quite so much texture but more architectural detail - and straighter lines!

YOU WILL NEED

300gsm (140lb) Rough watercolour paper

Colours: raw sienna, cobalt blue, burnt sienna, ultramarine, burnt umber, permanent rose, green gold, permanent sap green, olive green, Hooker's green, cadmium red

Brushes: no. 16 round, no. 12 round, no. 4 round, no. 8 round, rigger

Masking fluid, masking brush and ruling pen

Ruler

1 Transfer the scene on to watercolour paper and mask the window and door details and the flowers with masking fluid.

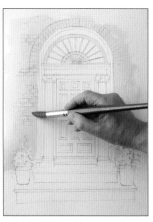

2 Use the no. 16 round to paint a wash of raw sienna over the walls.

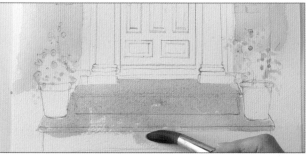

3 Mix a light grey from cobalt blue and burnt sienna and wash it over the steps.

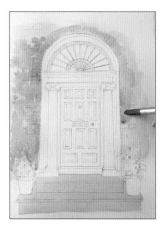

4 Wash burnt sienna over the brickwork, keeping it loose to create texture and leaving some of the first wash showing through.

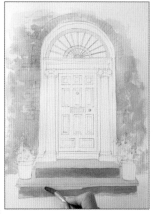

5 Use the no. 12 round and a mix of ultramarine and burnt umber to paint the shaded parts of the steps.

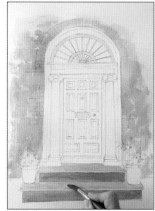

6 Use a lighter wash of the same colours to add tone on the flat parts of the steps. Leave a lighter line at the edge of each step.

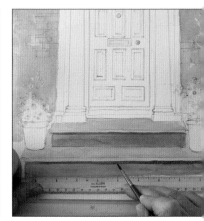

7 Use a no. 4 brush and a ruler to paint shadow under the edge of each step with the ultramarine and burnt umber mix.

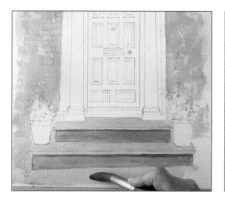

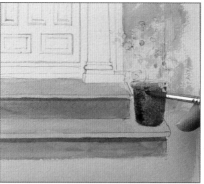

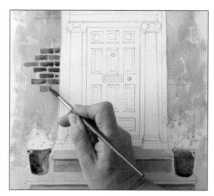

8 Paint a light wash on the pavement with the no. 16 brush and burnt sienna with cobalt blue.

9 Paint the terracotta pots with the no. 8 round and burnt sienna. Drop in ultramarine and permanent rose on the left-hand side wet into wet.

10 Paint in some bricks with burnt sienna, then change to burnt sienna with cobalt blue for variety.

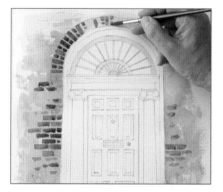

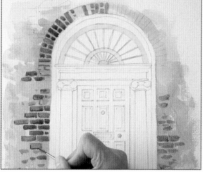

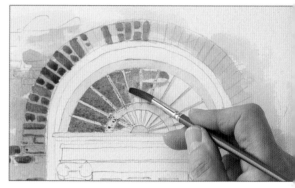

11 Paint a few individual bricks on the right of the door, then continue, painting bricks in a variety of shades around the semicircular window above the door.

12 Use the rigger and a mix of burnt umber and ultramarine to paint shadow to the left and at the bottom of the bricks, to make them look three-dimensional.

13 Paint over the masked details of the semicircular window with the no. 8 brush and ultramarine.

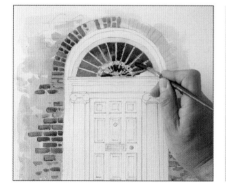

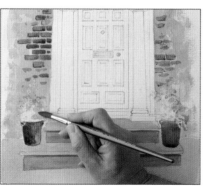

14 Add burnt umber to the ultramarine and paint the rest of the window while the first wash is wet.

15 Paint the foliage in the pots with the no. 12 round and green gold.

16 Mix a darker green from permanent sap green and burnt sienna and dab this in to the first wash wet into wet.

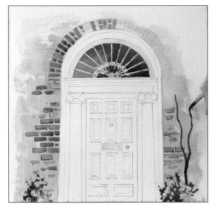

17 Paint the stem of the ivy on the wall with burnt umber and olive green.

18 Begin to paint the foliage of the ivy with the no. 12 brush and green gold.

19 Paint the darker parts of the foliage wet into wet with Hooker's green and burnt umber.

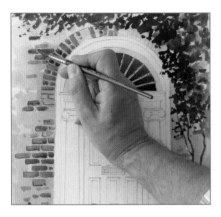

20 Add a few more bricks with burnt sienna.

21 Paint the shaded parts of the white paintwork around the window with cobalt blue and burnt sienna, then drop in a darker mix at the top of the arch, wet into wet.

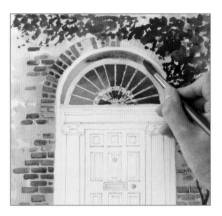

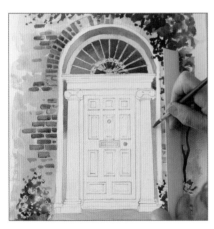

22 Use the no. 8 brush with a ruler and the same colours to paint the white paintwork at the sides of the pillars. Paint the lighter mix first, then drop in the darker one.

23 Repeat for the shaded paintwork on the other sides of the pillars. Allow to dry.

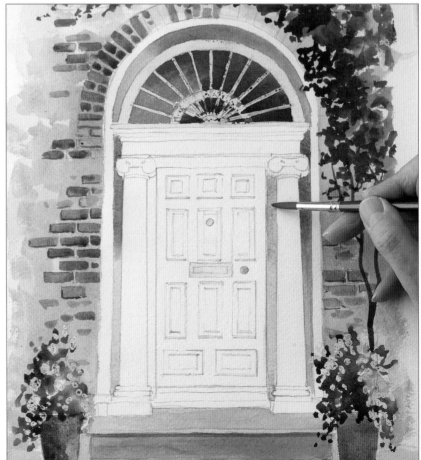

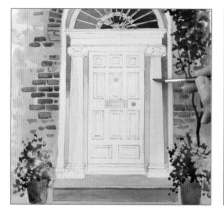

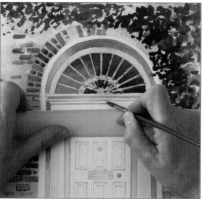

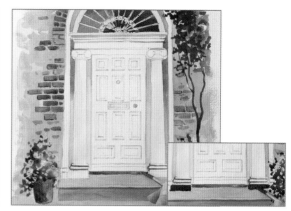

24 To paint the columns, wet a column with the no. 8 brush and clean water, then run a thin wash of cobalt blue down the left-hand side. Repeat for the other column. Allow to dry.

25 Paint the paintwork above the door with the same colour, using a ruler to help you.

26 Use a darker mix of the same colours to paint details at the bottom of the pillars and the dark line under the door. Paint the black bases of the columns with ultramarine and burnt umber.

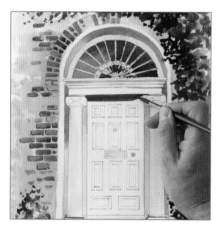

27 Paint the underside of the porch with cobalt blue, burnt sienna and a touch of cadmium red. Allow to dry.

28 Use the no. 12 brush and cadmium red to paint the door. Use the ruler to help with straight edges.

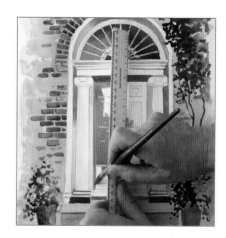

29 While the first wash is wet, drop in ultramarine at the top of the door to create shadow. Allow to dry.

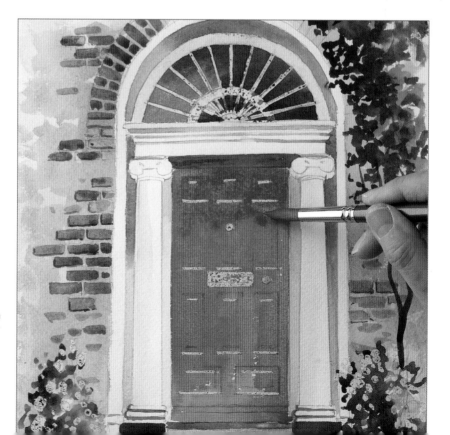

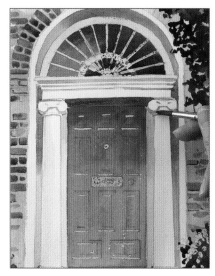

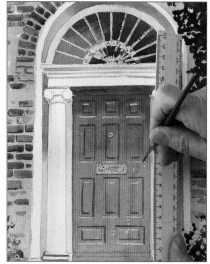

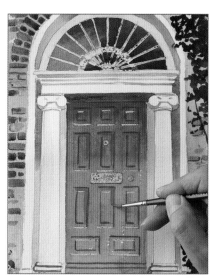

30 Paint details at the top of the columns with the no. 8 brush and burnt sienna with ultramarine.

31 Use the no. 4 brush with a mix of ultramarine and cadmium red and a ruler to paint the darker details on the door.

32 Put some more red into the door panels with cadmium red. Allow to dry.

33 Use the no. 8 brush to paint a shadow under the ivy with a mix of cobalt blue, permanent rose and a touch of burnt sienna. Use the same mix to paint the shadow of the ivy stem.

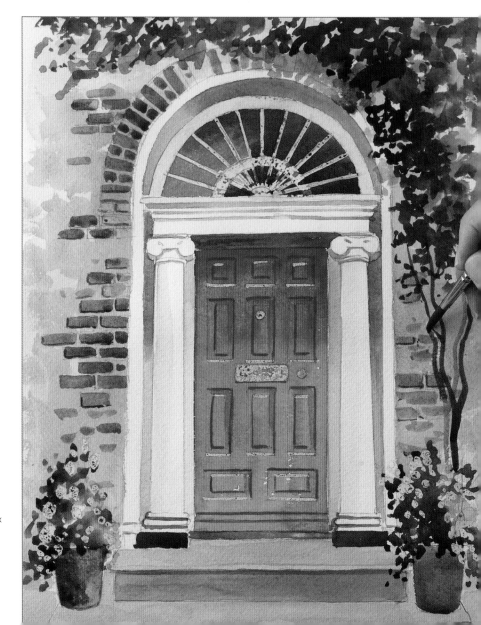

34 Use the same mix to add shade around the pot plants. Allow to dry.

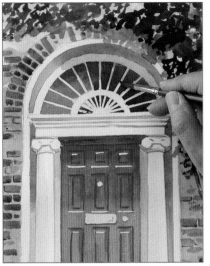

35 Remove the masking fluid with clean fingers. Use the no. 8 brush and cobalt blue with burnt sienna to shade areas of the window frame.

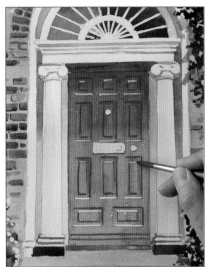

36 Using a very pale wash of cadmium red, go over the white areas left by the masking fluid.

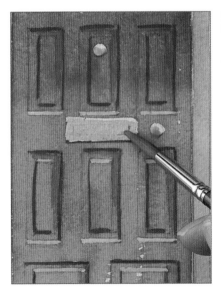

37 Paint the brass doorknobs and the letterbox with raw sienna.

38 While the raw sienna wash is wet, drop in cobalt blue.

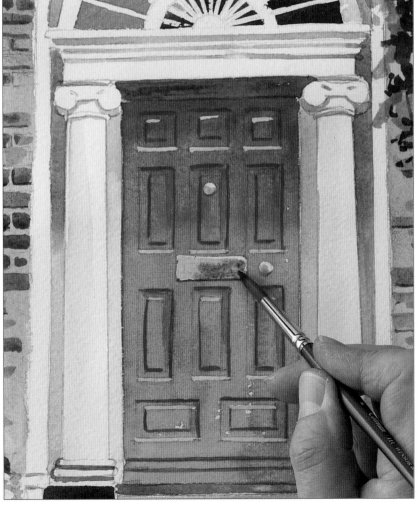

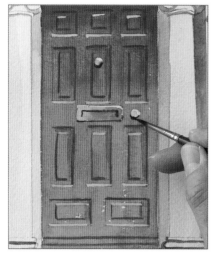

39 Paint the dark details on the brass door ornaments with the no. 4 brush and ultramarine with burnt umber.

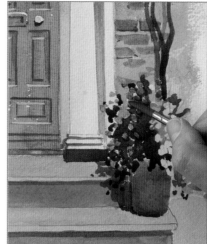

40 Paint the flowers on the left of the right-hand pot with the no. 8 brush and permanent rose.

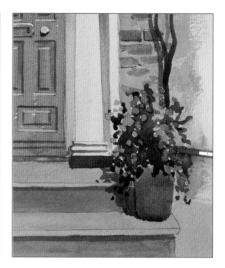

41 Add cobalt blue to the mix to paint the flowers on the right.

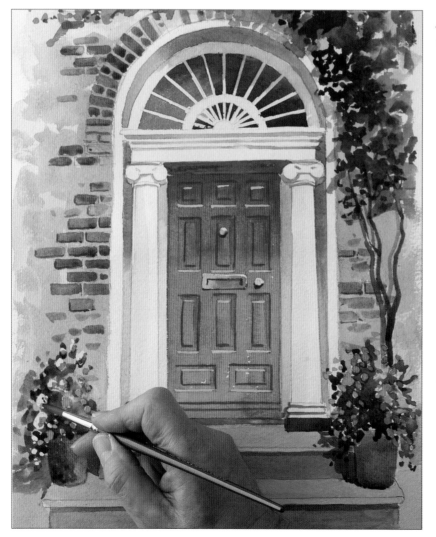

42 Paint some pink flowers in the left-hand pot, then add shade to the white flowers with a wash of cobalt blue.

Opposite
The finished painting.

Chicken Barn

OUTLINE
13

This ramshackle pair of barns makes a fabulous subject to paint. If the scene were a well-kept model farm, it would be a boring subject, but by removing some of the weatherboards and adding an uneven tiled roof, then throwing in some chickens, (not literally of course), we give it some character and appeal.

YOU WILL NEED
.
300gsm (140lb) Rough watercolour paper

Colours: ultramarine, burnt umber, raw sienna, burnt sienna, ultramarine violet, olive green, green gold, permanent sap green, cobalt blue

Brushes: large squirrel mop, no. 12 round, no. 8 round, rigger, 10mm (³⁄₈in) one-stroke

Masking fluid, masking brush and ruling pen

1 Transfer the scene on to watercolour paper. Apply masking fluid to the fence posts, the flowers and the vertical timbers of the barn.

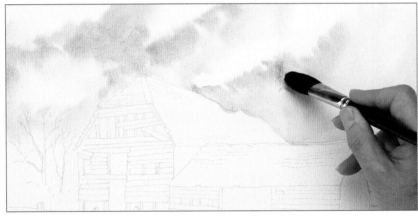

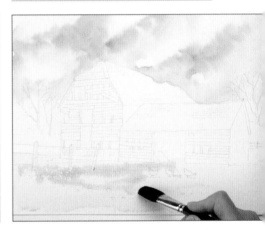

2 Wet the sky area with clean water and the squirrel mop brush and apply a wash of ultramarine, leaving white paper for clouds. Drop in a mix of ultramarine and burnt umber wet into wet.

3 Paint the foreground with clean water, then a wash of raw sienna. Drop in burnt sienna.

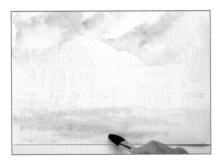

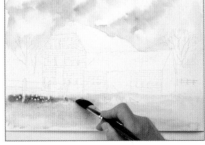

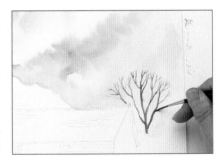

4 Drop in ultramarine violet at the bottom of the painting while the previous washes are still wet.

5 Mix ultramarine violet with burnt umber and run this mix along the bottom of the fence posts, wet into wet.

6 Paint the trees with the rigger brush and a mix of olive green and burnt umber.

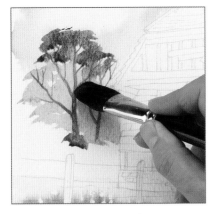

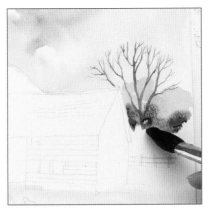

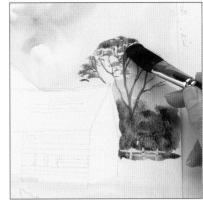

7 Mix green gold and raw sienna and paint a background wash over the left-hand trees. Drop in a darker green mixed from olive green and burnt umber wet into wet.

8 On the right-hand side of the barn, paint green gold first, then drop in permanent sap green mixed with burnt sienna lower down.

9 At the top of the right-hand tree, dab on the permanent sap green and burnt sienna mix for foliage.

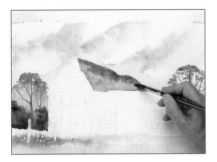

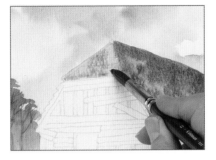

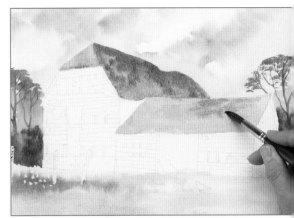

10 Paint the roof of the barn with the no. 12 round brush and burnt sienna. While this is wet, drop in ultramarine violet at the top and let it bleed into the first colour.

11 On the hip part of the roof, paint a lighter wash of burnt sienna and drop in a little cobalt blue to create texture. Allow to dry.

12 Paint a light wash of burnt sienna on the roof of the small barn and drop in ultramarine violet.

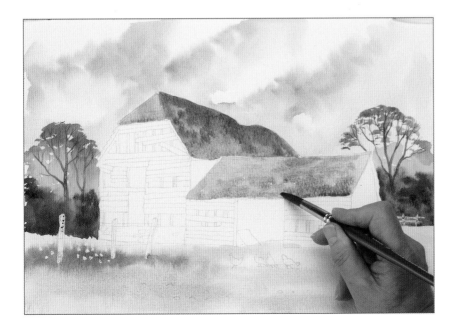

13 Drop in green gold at the bottom of the roof, wet into wet.

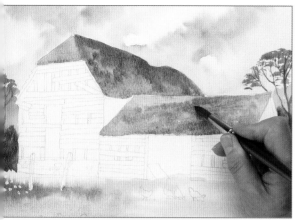

14 Drop in more ultramarine violet, wet into wet.

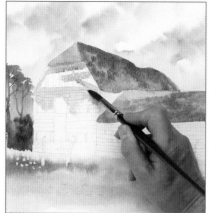

15 Paint the front of the barn with a light mix of cobalt blue and burnt umber.

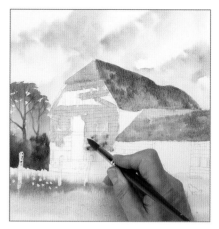

16 While this is wet, touch in raw sienna, then green gold.

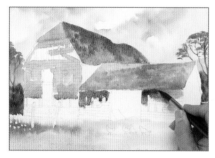

17 Paint the second barn with cobalt blue and burnt umber, then drop in a stronger mix of the same colours.

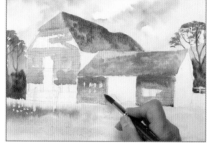

18 Bring the colours down to the base of the barn and drop in raw sienna to create texture.

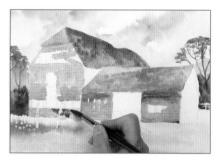

19 Paint the brick base of the taller barn with burnt sienna, then drop in cobalt blue. Allow to dry.

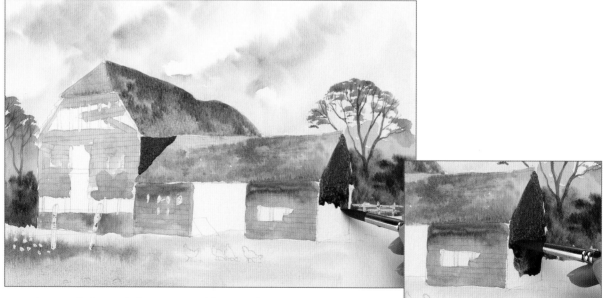

20 Paint a dark mix of ultramarine and burnt umber on to the side wall of the main barn and the end of the smaller barn. Add green gold to the mix and finish off the end wall at the bottom.

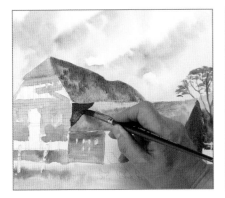

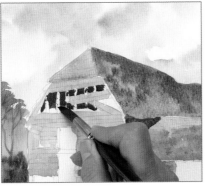

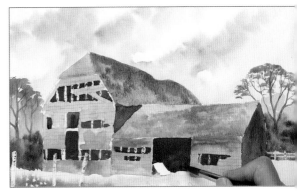

21 Drop raw sienna into the dark triangle on the first barn while it is still wet to lighten it and create texture.

22 Use ultramarine and burnt umber to paint the dark parts where the weatherboarding is broken. Paint over the masked vertical timbers.

23 Paint the dark insides of both barns with the same mix. Allow to dry.

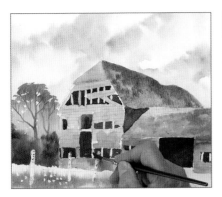

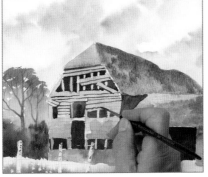

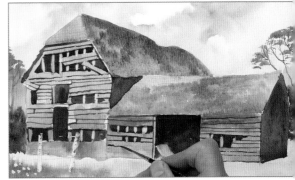

24 Remove the masking fluid. Paint the woodwork with a very pale wash of cobalt blue with burnt umber.

25 Paint the woodwork details on the main barn with the rigger and burnt umber with ultramarine.

26 Paint the details on the right-hand barn in the same way.

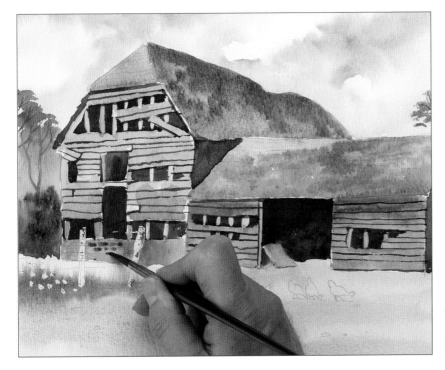

27 Change to the no. 8 round brush and use a mix of burnt sienna and burnt umber to hint at brickwork at the base of the main barn.

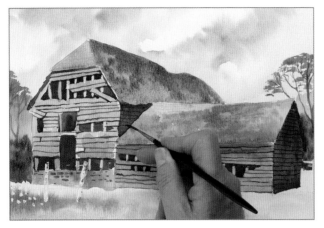

28 Use the rigger and the same mix of burnt sienna and burnt umber to paint the weatherboarding on the end of the second barn and the side of the main barn.

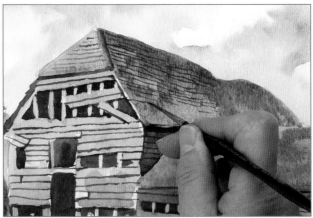

29 Still using the same brush and mix, suggest tiles on the main barn roof.

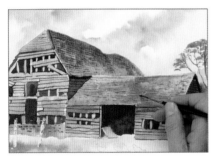

30 Continue painting roof details on the second barn.

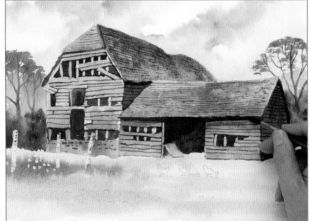

31 Paint a dark shadow under the eaves with the no. 8 round and a mix of ultramarine and burnt umber.

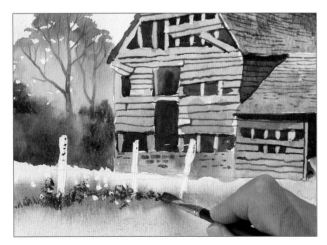

32 Take a 10mm (⅜in) one-stroke brush and pick up fairly dry burnt umber. Flick and dab this along the fence line.

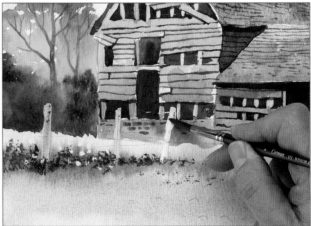

33 Paint the fence posts with the no. 8 round and a light wash of olive green and burnt umber. Allow to dry.

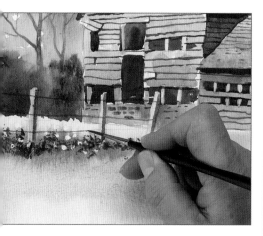

34 Use the rigger to paint a stronger mix of the same colours on the shaded sides of the fence posts. Paint in the wires.

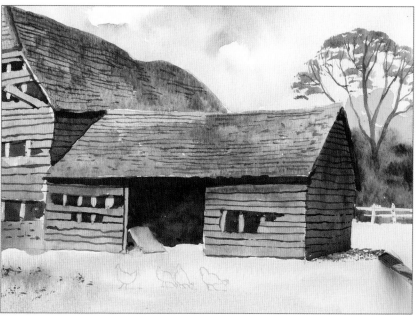

35 Use the 10mm (³⁄₈in) one-stroke to stipple dark shade at the base of the right-hand barn with burnt umber and olive green.

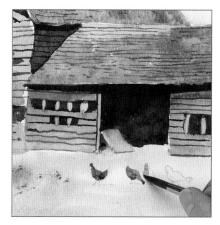

36 Paint the chickens with burnt sienna and the no. 8 brush.

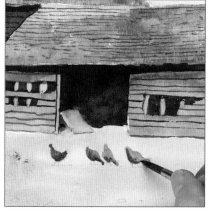

37 Add burnt umber to the burnt sienna and paint in the shadowed parts of the chickens.

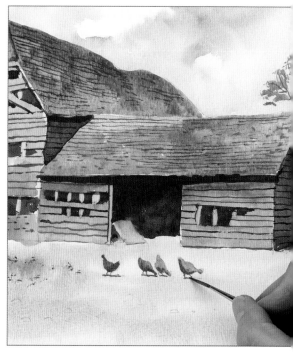

38 Use the rigger and the same mix to add legs and cast shadows under the chickens.

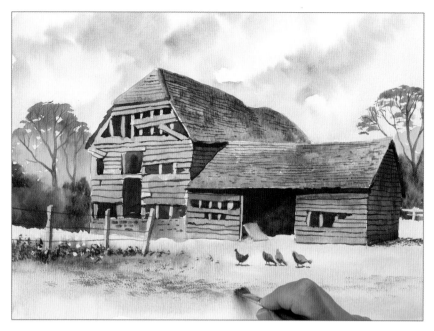

39 Stipple texture in the foreground with the 10mm (⅜in) one-stroke brush and burnt umber.

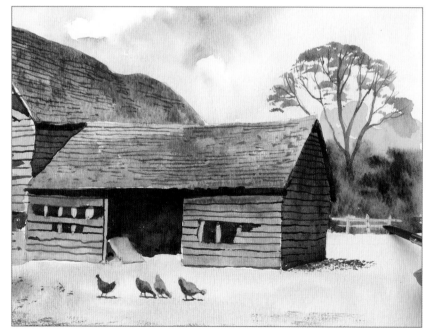

40 Paint the fence in the background with the no. 8 brush and a pale mix of burnt umber and green gold.

The finished painting.

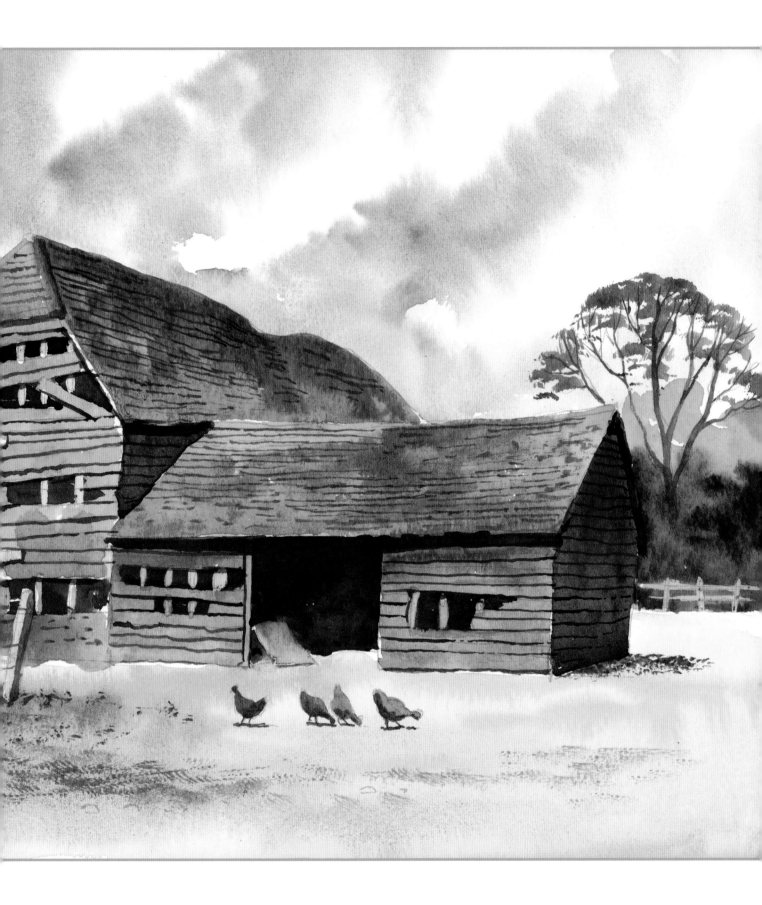

Seascapes

The two seascapes in this section show you how to mask surf, then create the sea with horizontal strokes in a variety of blue and green shades. Ripples are painted in several ways: masked out with masking fluid, left white by careful brushwork and painted on wet on dry. Create foamy looking surf by painting a pale blue shadow beneath the preserved white of the paper. You will learn how to create the varied colours and textures of cliffs, how to suggest recession into the distance, and also how to paint convincing rocks and beaches.

Masking fluid ripples

Masking fluid is used to capture the sunlight on the water. The ripples in the far distance are painted in first with small horizontal brushstrokes. These become broader and larger as they reach the foreground.

Plastic card rocks

The surface of the paper will create the textured effect so choosing the right paper is important. Choose Rough paper for this technique.

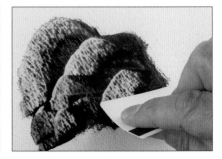

1 Take a stiff-haired brush such as the fan stippler and apply the lightest colour, raw sienna, first. The mix should be very thick. Add country green for moss.

2 Paint a thick mix of ultramarine and burnt umber on top.

3 Scrape an old credit card or other plastic card over the surface to remove paint to create rock shapes. Start with the furthest rocks and come forwards.

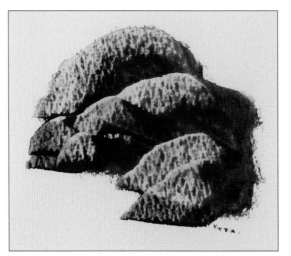

The finished rocks.

Plastic card cliffs

To achieve the best results when painting cliffs, use Rough paper, don't have the paint too wet, and scrape the paint off with what is best described as a short, sharp, downward motion of the plastic card.

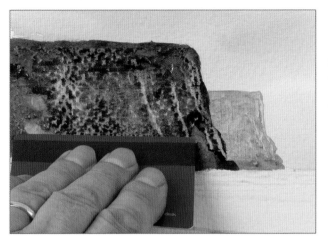

1 Draw the scene and mask the surf at the base of the cliffs with a brush and masking fluid. Use the wizard brush to wet the sky area, then paint it with raw sienna. Paint in clouds with ultramarine, wet into wet. Allow to dry. Paint the distant cliff with the large detail brush and a pale mix of ultramarine and burnt umber, then use a plastic card to scrape out texture. Paint the nearer cliff with a stronger mix, then scrape out texture with a card in the same way.

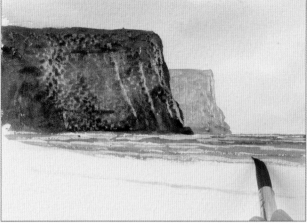

2 Use a mix of ultramarine and midnight green and a side-to-side motion of the brush to paint the sea.

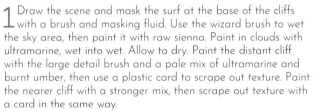

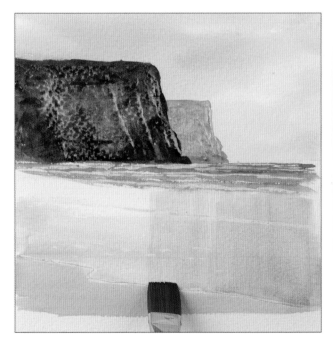

3 Paint the foreground beach with raw sienna and a little burnt sienna. Wet the area between this and the sea and use the 19mm (¾in) flat brush to stroke down a pale mix of ultramarine to suggest wet sand.

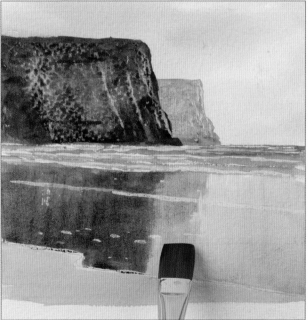

4 Stroke down a strong mix of ultramarine and burnt umber below the cliff, and a paler mix below the more distant cliff to create reflections in the wet sand. Allow to dry and remove the masking fluid.

Keem Bay

OUTLINE
14

Keem Bay in County Mayo is to the west of Achill Island, the largest island in Ireland. The old cottage sheltered in the bay makes a stunning subject to paint. The temptation is to change the tin roof for a traditional thatched roof, but maybe that could be a project for you in the future. This scene includes a stream as well as the sea itself, and a beach in the middle distance. You will need a plastic card to create the cliffs on the headland and the rocks in the foreground. I know this technique is tricky to achieve straight away, so I suggest you have a little practice first.

YOU WILL NEED
.
300gsm (140lb) Rough watercolour paper

Colours: raw sienna, ultramarine, permanent rose, burnt sienna, burnt umber, cobalt blue, green gold, olive green, permanent sap green, Hooker's green

Brushes: no. 4 round, no. 16 round, no. 8 round, 10mm (⅜in) one-stroke, hog fan brush

Masking fluid, masking brush and ruling pen

Plastic card

1 Transfer the scene on to watercolour paper. Mask the shoreline under the cliffs and the crests of the waves using a no. 4 brush and masking fluid. Wet the sky area and paint raw sienna in the lower part of the sky with the no. 16 brush.

2 While the raw sienna wash is wet, drop in ultramarine, leaving spaces for cloud shapes. Allow to dry.

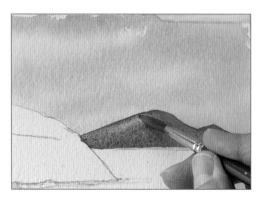

3 Mix ultramarine, permanent rose and a touch of burnt sienna to paint the distant headland with the no. 8 brush. While this is wet, drop in raw sienna to suggest sunlit areas.

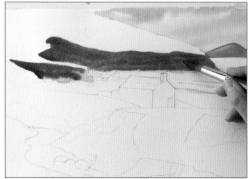

4 Use the no. 16 brush to paint the cliff face with a thick mix of raw sienna. While this is wet, paint a thick mix of burnt umber and ultramarine over the top.

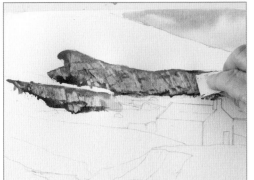

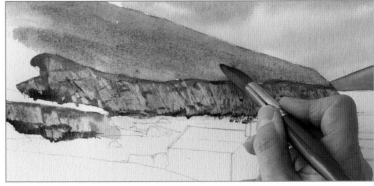

5 Use the edge of a plastic card to scrape out colour, creating the rocky texture of the cliffs.

6 Paint the top of the headland with the no. 16 brush and cobalt blue and burnt sienna. Drop in green gold wet into wet.

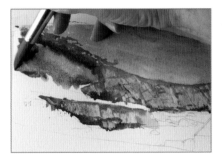

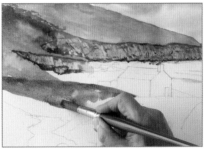

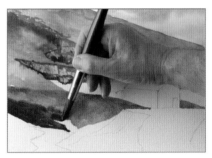

7 Paint the grassy area coming forwards with olive green, then while this is wet, drop in a darker green mixed from olive green and raw sienna.

8 Paint a mix of permanent sap green and burnt sienna coming forwards towards the cottage.

9 Further forwards, darken the area with a mix of permanent sap green and burnt umber. Allow to dry.

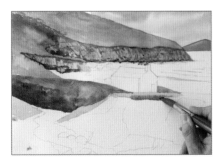

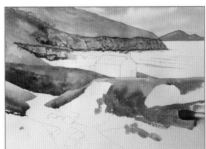

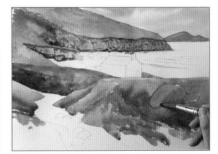

10 Paint the top edge of the greener area further forwards with raw sienna and green gold, then drop in olive green wet into wet.

11 Continue painting the grassy area with a mix of olive green and burnt umber.

12 Mix a grey from cobalt blue and burnt sienna and wash this over the white areas to create rocks.

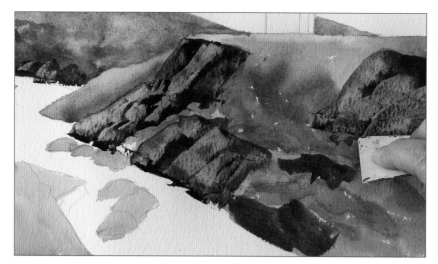
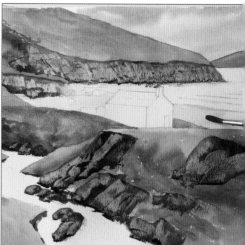

13 Paint the rocks in the stream with the same mix. Then paint a thick mix of burnt umber and ultramarine over the lighter rock colour. Before this dries, scrape out rock texture with a plastic card.

14 Paint the sand on the beach with a wash of raw sienna. Allow to dry.

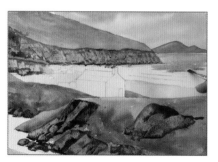
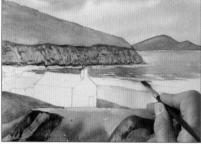
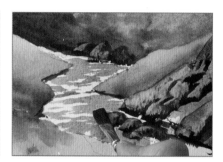

15 Change to the 10mm (⅜in) one-stroke brush and paint the sea with horizontal strokes in ultramarine. Add a touch of permanent sap green to the mix coming further forwards.

16 Bring the horizontal strokes forwards, going over the masked area and leaving some white paper as well.

17 Paint the stream with the same brush and ultramarine, leaving white for ripples. Allow to dry.

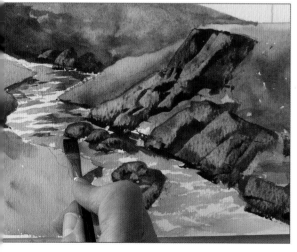
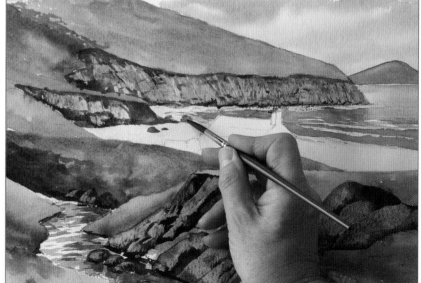

18 Paint darker brushstrokes in the water with a mix of ultramarine and burnt umber.

19 Use the no. 8 brush to paint details of the cliffs and rocks with a dark mix of ultramarine and burnt umber.

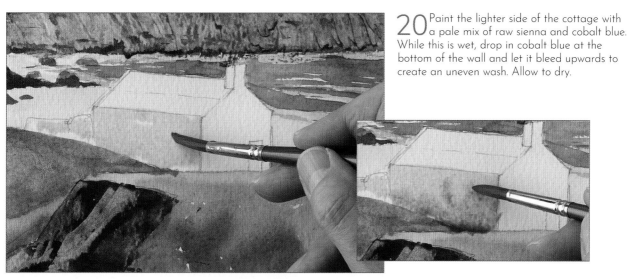

20 Paint the lighter side of the cottage with a pale mix of raw sienna and cobalt blue. While this is wet, drop in cobalt blue at the bottom of the wall and let it bleed upwards to create an uneven wash. Allow to dry.

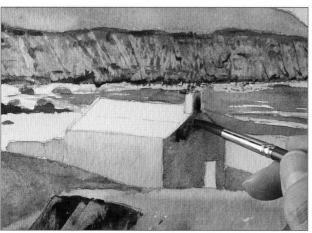

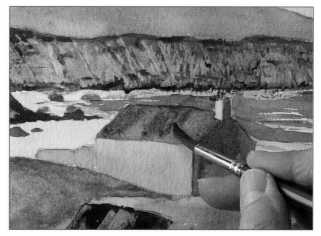

21 Mix cobalt blue and burnt sienna and use the no. 8 brush to paint the shaded end of the cottage. While this is still wet, drop in a darker mix of the same colours at the top and let it bleed down.

22 Paint the left-hand side of the roof with burnt sienna. While this is wet, add a touch of cobalt blue.

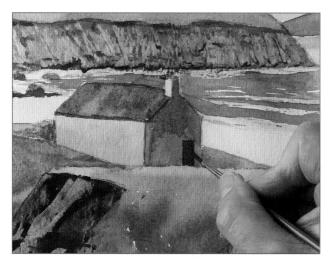

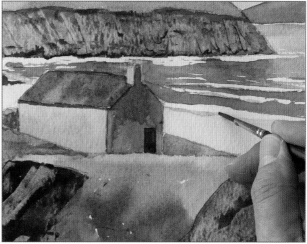

23 Use the no. 4 round and ultramarine with burnt umber to paint the darks of the doorway and the roof details. Allow the painting to dry.

24 Remove the masking fluid with a clean finger. Use the no. 4 brush to paint shade under the surf with a pale wash of cobalt blue. This helps to give it a foamy three-dimensional appearance.

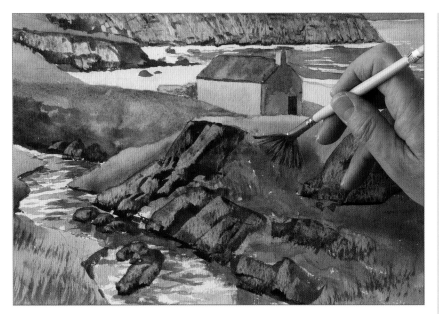

25 Use the hog fan brush with Hooker's green and burnt umber to flick up grasses in the foreground.

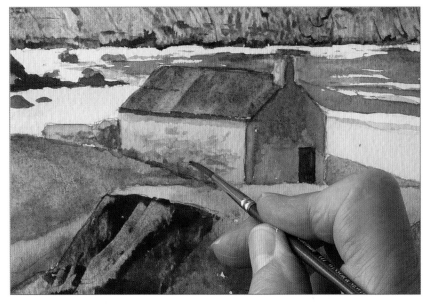

26 Use the no. 4 brush and a mix of ultramarine and burnt umber to paint texture on the side of the cottage.

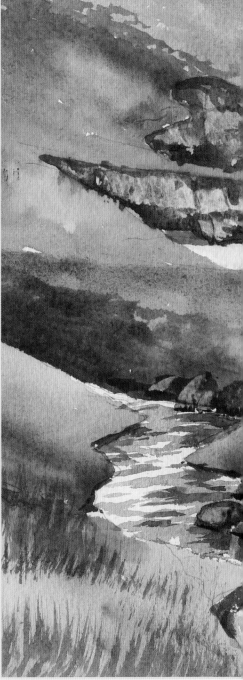

The finished painting.

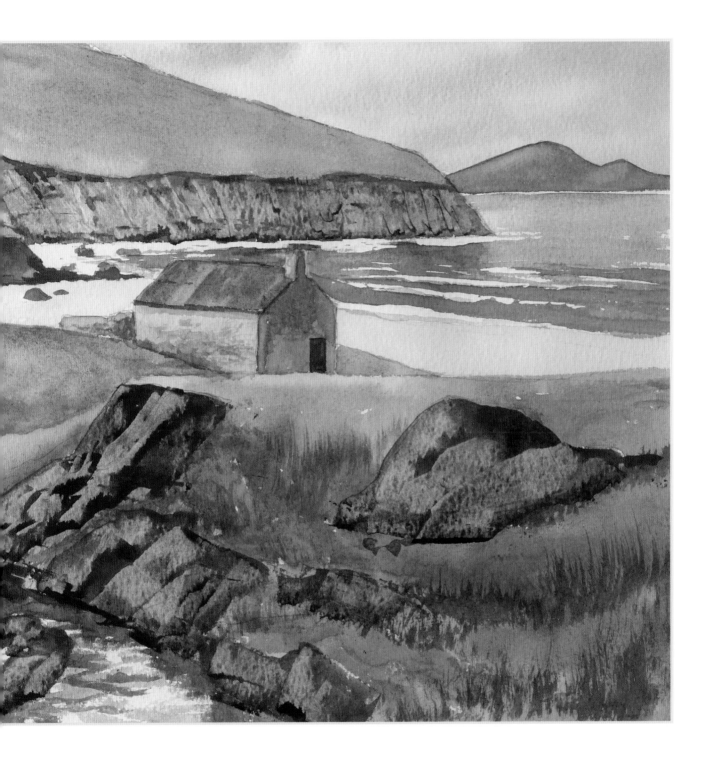

The Cliffs of Moher

These cliffs are located near Doolin in County Clare on the west coast of Ireland, and are one of the country's top visitor attractions. The cliffs are 214m (702 ft) high at the highest point and extend for 8km (5 miles).

This view is a fairly simple composition: the cliffs stretch out along the coast, gradually reducing in size and becoming lighter and bluer in colour, giving the impression of distance.

YOU WILL NEED

(300gsm 140lb) Rough watercolour paper

Colours: raw sienna, ultramarine, burnt umber, cobalt blue, burnt sienna, olive green, permanent sap green, green gold, permanent rose

Brushes: no. 4 round, large mop, 10mm (³⁄₈in) one-stroke, no. 16 round, no. 8 round, 19mm (³⁄₄in) flat, hog fan brush, rigger

Masking fluid, masking brush and ruling pen

Plastic card

Ruler

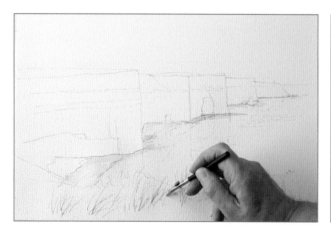

1 Transfer the scene on to watercolour paper. Mask off the surf at the base of the cliffs with masking fluid and the no. 4 brush. Use a ruling pen to mask the grasses in the foreground.

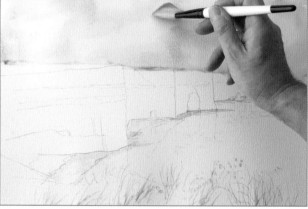

2 Wet the sky with a large mop brush and clean water. Paint on a thin wash of raw sienna. While this is wet, drop in ultramarine, leaving spaces for cloud shapes.

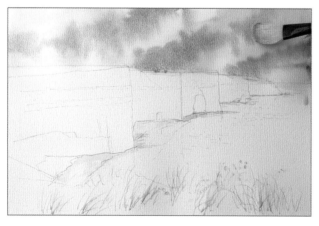

3 Mix ultramarine and burnt umber and paint the darker parts of the clouds wet into wet. Allow to dry.

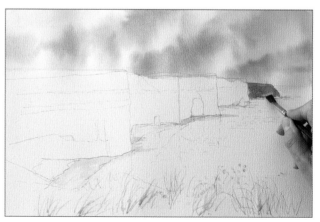

4 Paint the most distant cliffs with the 10mm (³⁄₈in) one-stroke brush and a mix of cobalt blue with a touch of burnt sienna.

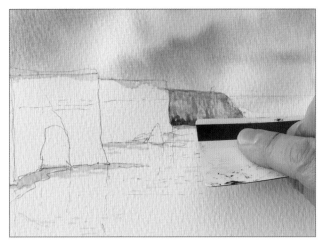

5 While the paint is still wet, use a plastic card to scrape out texture.

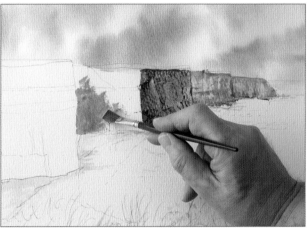

6 Use a slightly darker mix of the same colours to paint the next section of cliff coming forwards. Scrape out with a plastic card as before.

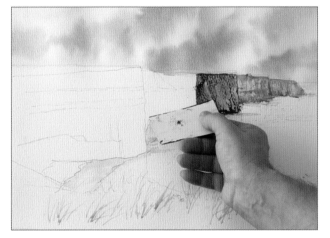

7 Further forwards, continue painting with a slightly darker, browner mix of the same colours, and scrape out again.

8 Paint the next section with a thick wash of raw sienna.

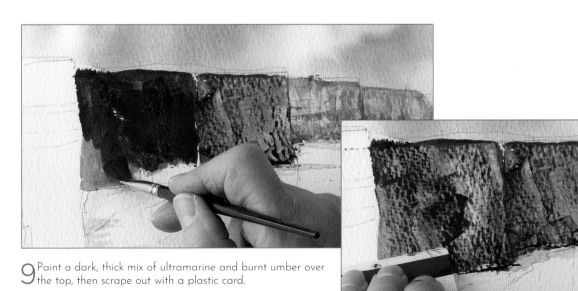

9 Paint a dark, thick mix of ultramarine and burnt umber over the top, then scrape out with a plastic card.

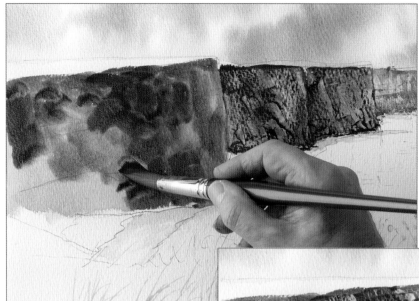

10 Use the no. 16 brush to paint raw sienna on the nearest cliffs, then add a dark mix of burnt sienna and cobalt blue. Mix the two colours on the page, then scrape out the area with a plastic card.

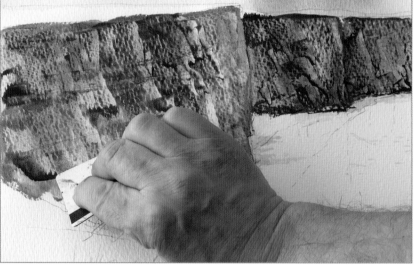

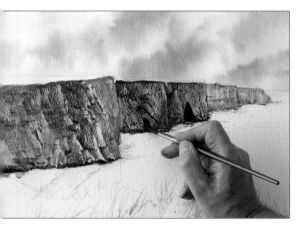

11 Paint caves in the cliffs with the no. 8 round brush and a mix of ultramarine and burnt umber.

12 Paint in horizontal lines to suggest the different strata of rock in the cliff face.

13 Paint the tops of the distant cliffs with a mix of olive green and cobalt blue.

14 Paint the grass at the top of the nearer cliffs with olive green.

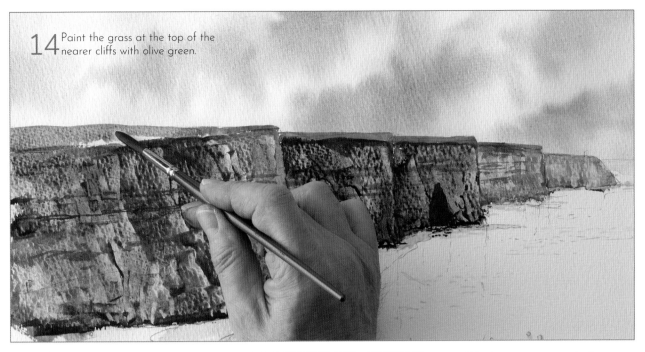

15 Wet the water area with clean water. Use the 19mm (¾in) flat brush and a pale mix of ultramarine to paint the water, starting with the horizon. Use a ruler to help you paint a straight line as shown.

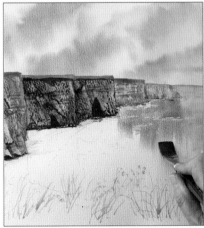

16 Add a touch of permanent sap green to the ultramarine and stroke the wash downwards.

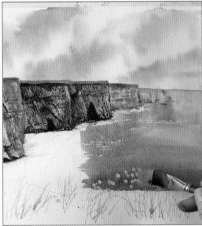

17 Paint the sea further forwards with horizontal strokes and strengthen the mix towards the foreground.

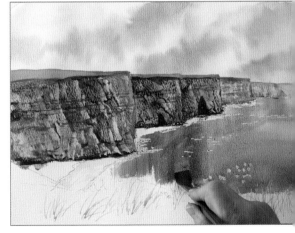

18 Make the mix stronger still as you paint up to the foreground cliff face.

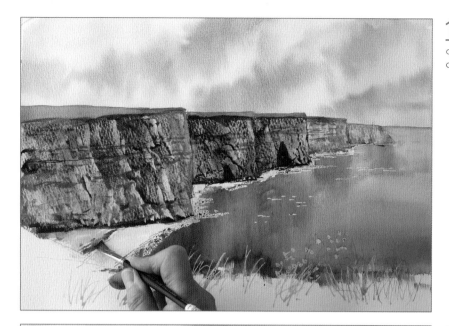

19 Using the same brush, paint the beach below the cliffs with a wash of raw sienna, then, while this is wet, drop in burnt umber and ultramarine.

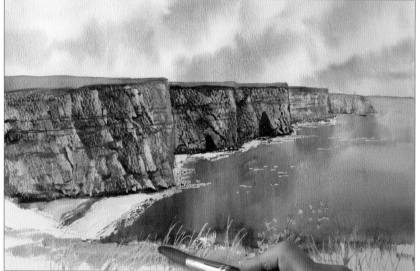

20 Paint the foreground clifftop with the no. 16 round brush and green gold.

21 Mix a darker green from permanent sap green and burnt umber and paint this in wet into wet.

22 Use the hog fan brush and the same green to flick up grasses over the masked area. Allow to dry.

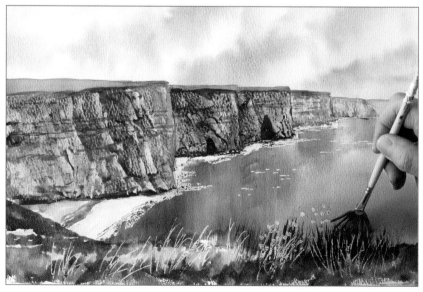

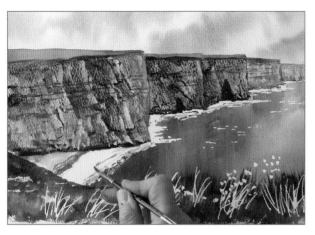

23 Rub off the masking fluid with clean fingers. Take the no. 4 round brush and add shade to the surf with a mix of cobalt blue and permanent sap green.

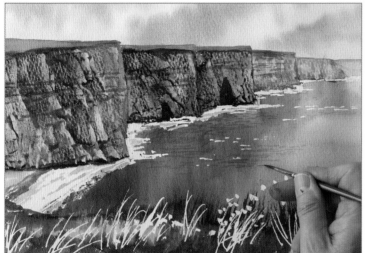

24 Paint some ripples on the sea with the same brush and colour.

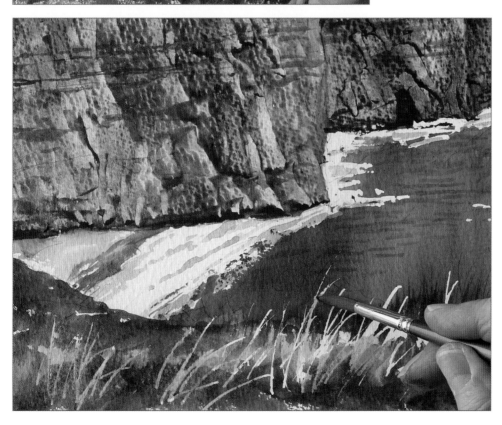

25 Use the no. 8 round to paint green gold over the foreground grasses.

26 Paint the flower heads in the foreground with permanent rose.

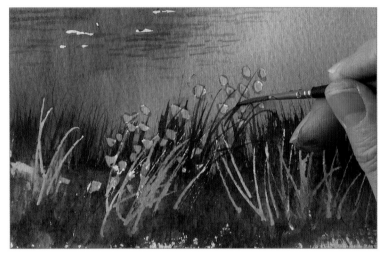

27 Use the rigger to paint darker grasses among the flower heads with permanent sap green and burnt umber.

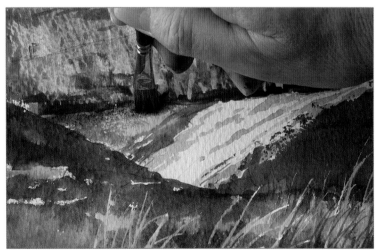

28 Stipple detail on the beach with the 10mm (⅜in) one-stroke brush and burnt umber with ultramarine.

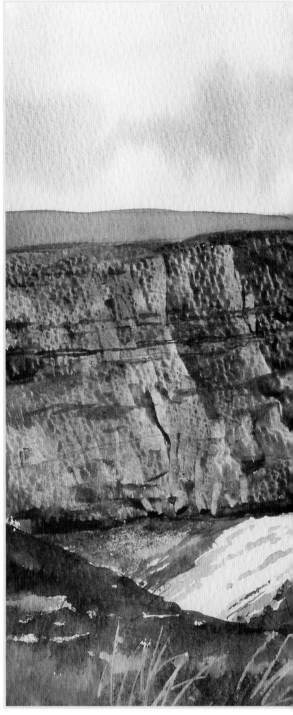

The finished painting.

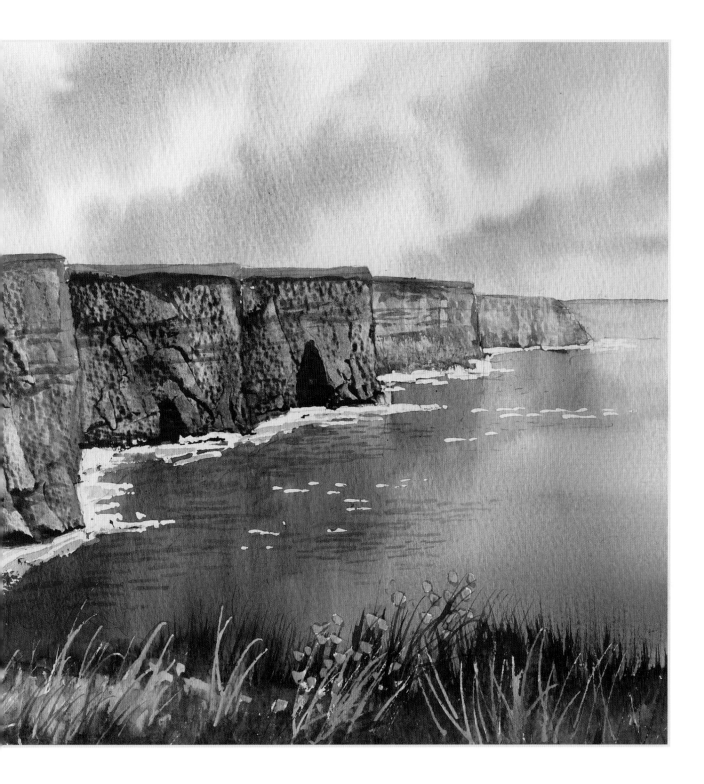

Index

background 13, 14, 18, 35, 48, 56, 62, 95, 105, 106, 121, 126
barn(s) 24, 25, 26, 32, 33, 70, 73, 75, 86, 87, 88, 89, 90, 91, 94, 120, 121, 122, 123, 124, 125
beach 129, 130, 132, 140, 142
blossom 20, 38, 40, 43
bluebell(s) 46, 48, 51
brick 82, 94, 95, 112, 113, 114, 123
bridge 54, 56, 57, 58, 59, 62, 63, 65, 66, 67, 95
brushes 9, 22, 30, 38, 48, 54, 62, 73, 78, 86, 96, 104, 112, 120, 130, 136
brushstrokes 58, 99, 128, 132
buildings 13, 21, 94, 95, 112

castle 94, 104, 107, 108, 109
chickens 120, 125
cliff(s) 11, 128, 129, 130, 131, 132, 136, 137, 138, 139, 140
cloud(s) 13, 18, 22, 23, 30, 38, 54, 73, 79, 105, 120, 129, 130, 136
cockling 12
colours 22, 30, 38, 48, 54, 62, 73, 78, 86, 96, 104, 112, 120, 130, 136
contrast 30, 57, 86
cottage 80, 81, 82, 130, 131, 133, 134

depth 21, 47
 varying the tone of trees to add 47
distance 17, 21, 31, 32, 35, 38, 47, 49, 54, 128, 130, 136
door 73, 82, 89, 91, 95, 96, 98, 100, 112, 113, 115, 116, 118, 133
dropping in 13, 20, 22, 23, 25, 26, 30, 33, 38, 39, 41, 55, 59, 62, 63, 64, 73, 74, 79, 80, 81, 87, 94, 101, 102, 104, 105, 106, 107, 109, 113, 114, 115, 117, 120, 121, 122, 121, 122, 130, 131, 133, 136, 140
dry brush 15, 88

fence 20, 25, 26, 28, 30, 32, 34, 41, 43, 44, 70, 72, 73, 75, 76, 84, 86, 90, 92, 120, 124, 125, 126
field(s) 17, 20, 21, 22, 23, 31, 38, 39, 40, 54, 76, 105
flower(s) 22, 27, 30, 35, 38, 41, 43, 54, 57, 59, 96, 101, 102, 112, 118, 120, 142
focal point 30, 38, 54, 62, 104
foliage 9, 13, 18, 22, 23, 24, 26, 28, 30, 31, 32, 33, 38, 39, 40, 44, 46, 48, 51, 52, 54, 55, 56, 60, 62, 63, 65, 66, 67, 73, 74, 79, 81, 95, 96, 97, 98, 99, 100, 113, 114, 121
footbridge 46, 54, 55, 56, 59, 62
footpath 22, 25, 38, 49, 56
foreground 17, 21, 22, 25, 30, 34, 35, 38, 41, 47, 49, 55, 57, 64, 66, 67, 70, 71, 76, 78, 83, 90, 95, 104, 106, 109, 110, 120, 126, 128, 129, 130, 134, 136, 139, 140, 141, 142
forest 46, 62

gate 20, 30, 32, 34
granulation 26
grasses 9, 16, 22, 25, 27, 28, 30, 34, 35, 38, 40, 41, 42, 51, 54, 55, 57, 58, 60, 62, 65, 67, 70, 71, 75, 78, 82, 91, 106, 131, 134, 136, 139, 140, 141, 142
 growing through snow 71

headland 130, 131
hedgerow(s) 17, 20, 23, 30, 31, 38, 39, 54, 74, 88, 106
 using a paper mask to paint 17
highlights 18, 23, 64, 67
hillock 105, 106, 110
horizon 23, 31, 38, 54, 73, 88, 139

impact 70, 86
Ireland 4, 104, 130, 136
ivy 50, 81, 114, 116

lifting out 18, 23, 54, 78, 79

masking fluid 9, 11, 16, 17, 20, 22, 27, 30, 34, 38, 40, 42, 54, 58, 62, 64, 67, 70, 71, 72, 73, 74, 75, 76, 78, 82, 83, 86, 90, 92, 96, 101, 104, 110, 112, 117, 120, 123, 128, 129, 130, 133, 136, 141
 applying with kitchen paper 17
 applying with a brush 16
 applying with a ruling pen 16
masking fluid ripples 128
masking fluid snow 70
 adding volume to 72

paper mask 11, 16, 17, 20, 22, 23, 30, 31, 32, 38, 39, 54, 62, 73, 74, 86, 88, 104, 107
path 41, 50, 51, 63, 75, 84, 91, 109
poppies 19, 20, 22, 27, 28, 35
post box 78, 81, 82, 83

reflection(s) 9, 42, 43, 46, 51, 54, 57, 58, 66, 67, 104, 108, 109, 129
 dragging down 46
ripples 57, 62, 64, 66, 104, 109, 110, 128, 132, 141
river 38, 40, 41
rock 11, 13, 104, 109, 128, 130, 131, 132, 138
 plastic card rocks 128
roof 14, 24, 25, 26, 32, 33, 73, 74, 78, 83, 89, 90, 94, 95, 108, 120, 121, 124, 130, 133
 pan-tiled roof 14
ruling pen 11, 16, 22, 30, 38, 54, 62, 70, 73, 78, 136

scraping out 71, 104, 109, 129, 131, 132, 137, 138
sea 128, 129, 130, 132, 139, 141
shadow(s) 8, 14, 18, 20, 22, 23, 25, 26, 27, 28, 30, 33, 34, 43, 48, 51, 62, 65, 66, 70, 72, 73, 75, 76, 78, 79, 80, 81, 82, 83, 84, 88, 90, 95, 96, 97, 98, 99, 100, 107, 112, 113, 115, 116, 124, 125, 128
sky 12, 13, 17, 18, 22, 30, 38, 54, 62, 67, 73, 78, 79, 86, 104, 105, 107, 120, 129, 130, 136
 wet into wet sky 13
snow 17, 70, 71, 72, 73, 74, 75, 76, 78, 79, 82, 83, 86, 89, 90, 91, 92
 warming up a snow scene 71
stile 20, 22, 27, 30, 43, 72
stipple(-ing) 9, 23, 24, 26, 28, 31, 32, 33, 34, 38, 39, 40, 41, 44, 48, 49, 50, 51, 52, 54, 55, 56, 60, 62, 63, 64, 65, 73, 74, 79, 81, 88, 95, 96, 97, 98, 99, 107, 125, 126, 142
stonework 95, 96, 98
straight edge 12, 17, 88, 107, 115

stream 55, 57, 130, 132
sunlight 32, 96, 128

textural 9, 13, 26, 97
texture 8, 11, 14, 15, 27, 33, 41, 44, 51, 56, 64, 65, 70, 75, 87, 94, 95, 98, 99, 101, 107, 112, 121, 122, 123, 126, 129, 131, 132, 134, 137
transferring the outline 19, 22, 30, 48, 54, 78, 86, 96, 104, 112, 120, 130, 136
tree(s) 14, 15, 17, 18, 23, 24, 26, 28, 30, 31, 32, 33, 34, 35, 38, 39, 40, 42, 43, 44, 46, 47, 49, 50, 51, 52, 54, 55, 56, 57, 62, 63, 64, 66, 67, 70, 71, 72, 73, 74, 75, 76, 81, 82, 83, 86, 88, 89, 91, 92, 105, 120, 121
 texture on tree bark 15

wall 78, 81, 82, 83, 91, 94, 95, 114, 122, 133
 painting a detailed brick wall 95
 painting a rustic stone wall 95
wash(es) 8, 9, 11, 12, 13, 14, 15, 16, 22, 23, 25, 27, 33, 34, 35, 38, 39, 42, 46, 48, 50, 54, 59, 63, 66, 67, 70, 73, 74, 75, 76, 78, 79, 81, 83, 90, 92, 94, 96, 98, 101, 102, 106, 107, 108, 109, 112, 113, 115, 117, 118, 120, 121, 123, 124, 130, 131, 132, 133, 136, 137, 139, 140
 graded wash 12
 variegated wash 12
watercolour paints 8, 11, 22, 30, 38, 48, 54, 62, 73, 78, 86, 94, 96, 104, 112, 120, 130, 136
watercolour paper 8, 11, 17, 19, 22, 30, 38, 48, 54, 62, 73, 78, 86, 96, 104, 112, 120, 130, 136
 preparing paper for painting 12
waves 130
wet into wet 12, 13, 14, 18, 20, 23, 25, 26, 27, 30, 40, 46, 48, 49, 55, 56, 57, 63, 73, 78, 79, 80, 81, 86, 94, 95, 96, 97, 102, 105, 106, 113, 114, 120, 121, 122, 129, 131, 136, 140
wet on dry 14, 26, 49, 55, 59, 65, 94, 101, 128
window(s) 33, 70, 80, 83, 84, 112, 113, 114, 117
woods 46, 48, 54, 62

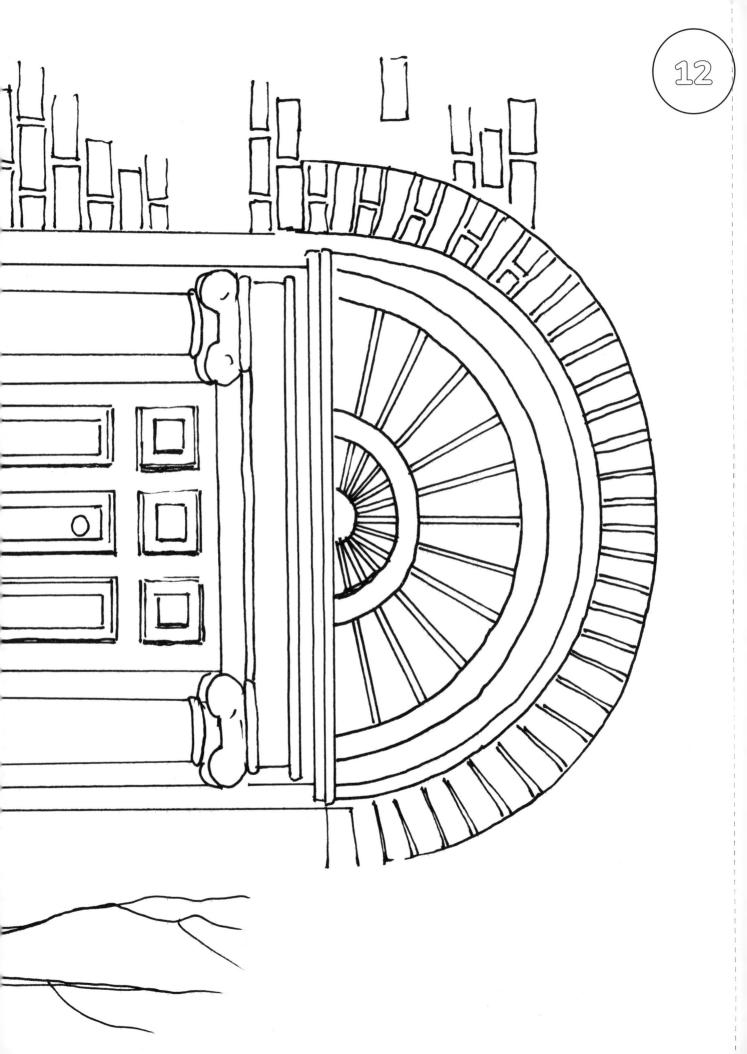

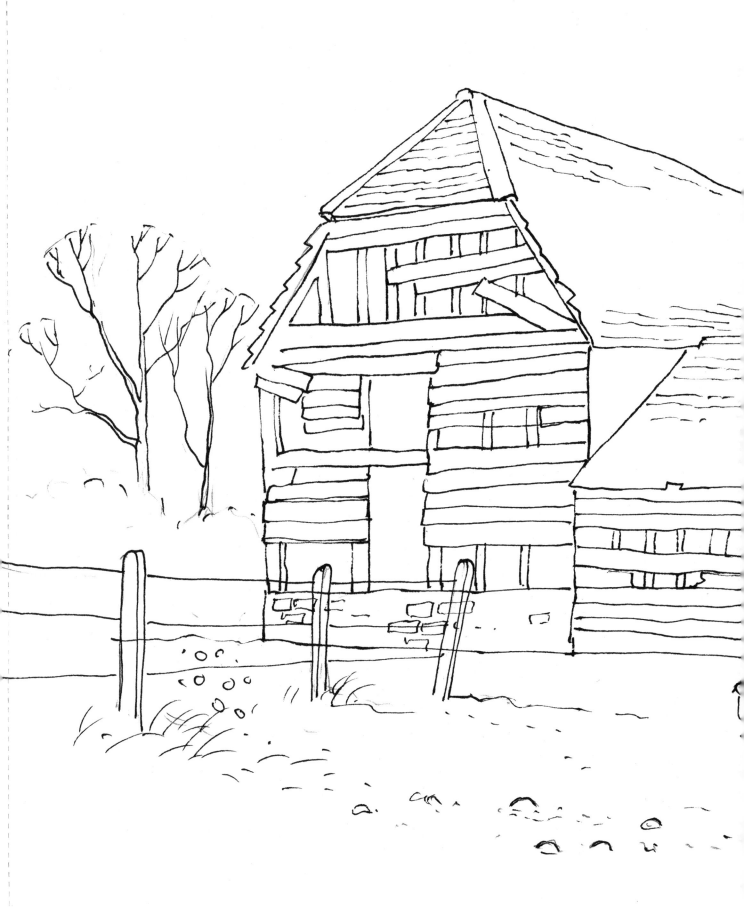

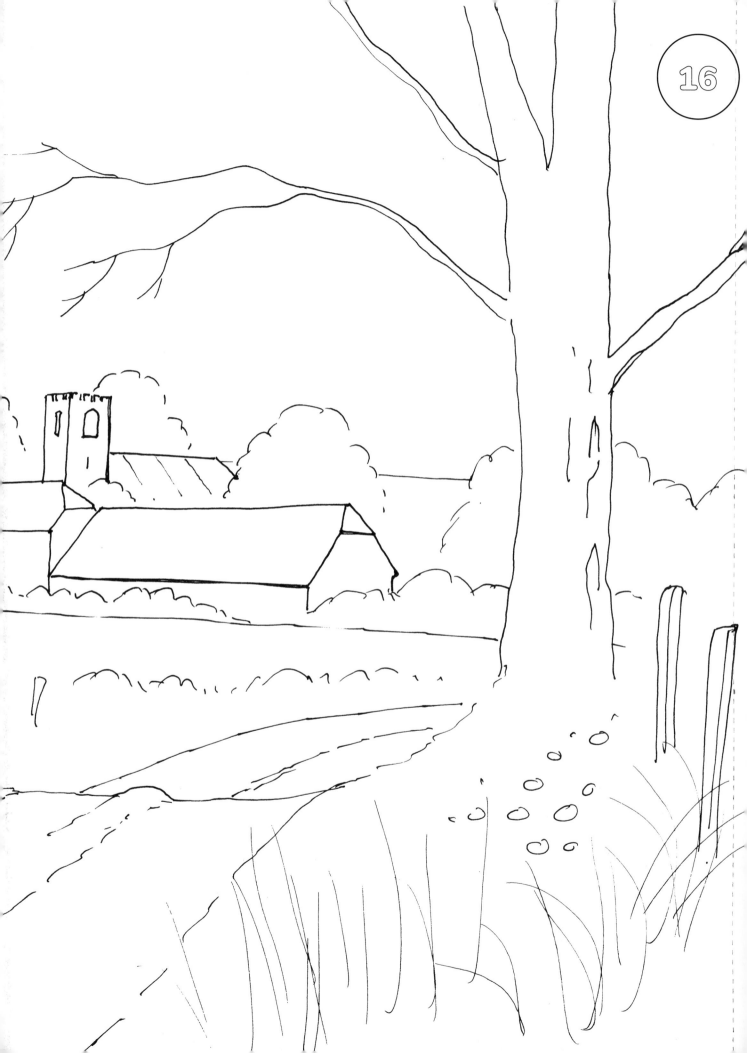